ON LOCATION

A FILM AND TV L♥VER'S TRAVEL GUIDE

LISA IANNUCCI

Globe Pequot

GUILFORD, CONNECTICUT

Globe
Pequot

An imprint of Rowman & Littlefield

Distributed by NATIONAL BOOK NETWORK

British Library Cataloguing in Publication Information available

Library of Congress Cataloging-in-Publication Data available

ISBN 978-1-4930-3085-9 (paperback)
ISBN 978-1-4930-3086-6 (e-book)

∞™ The paper used in this publication meets the minimum requirements of American National Standard for Information Sciences—Permanence of Paper for Printed Library Materials, ANSI/NISO Z39.48-1992

Printed in the United States of America

CONTENTS

ACKNOWLEDGMENTS xi

THE FILM & TV LOVER'S TRAVEL GUIDE xii

SOUTHWEST

ARIZONA 2
Flintstones Bedrock City* 2
Old Tucson Movie Set 3
Andy Devine 4
Rex Allen Museum 4
Easy Rider 6
Gammons Gulch Movie Set & Museum 6

NEVADA 9
Pawn Stars 9
Star Trek 10
The Mob Museum 10

NEW MEXICO 14
Breaking Bad 14
White Sands National Monument 16
Billy the Kid Museum 16

TEXAS 19
Library of Entertainment History at The Ransom
 Center 19
The Texas Chainsaw Massacre Gas Station Gift Shop and
 Motel 19
Dallas' Southfork and Ewing Mansion Tours 20
Larry Hagman and Mary Martin Exhibit 21

WEST

CALIFORNIA 23
American Graffiti Festival 23
George Lucas Museum of Narrative Art 24
Rancho Obi-Wan 25
Alfred Hitchcock Walking Tour 26

San Francisco Silent Film Festival 27
The Niles Essanay Silent Film Museum 27
The Mary Pickford Theatre 28
Fess Parker 29
The William S. Hart Park and Museum 30
*M*A*S*H* 31
The Walt Disney Family Museum* 33
Peanuts: Charles M. Schulz Museum and Research
 Center 34
Paramount Ranch 35
La La Land 35
Television Hall of Fame 37
The Paley Center for Media 38
The Hollywood Museum 39
Grauman's Chinese Theatre 39
Hello Kitty 40
Museum of Western Film History 41
Autry Museum of the American West 42
Francis Ford Coppola 43
Lawrence Welk Museum 44
California Museum 44
Shirley Temple at the Santa Monica History
 Museum 45
Forest Lawn Cemetery 48
Hollywood Forever Cemetery 48

MOVIE STUDIO TOURS
 Sony Pictures Studios 49
 Paramount Studio Tour 49
 Warner Brothers Studio Tour 49
 Universal Studios Tour 50

COLORADO 53
Dennis Weaver Memorial Park 53
The Shining's Stanley Hotel 54
Molly Brown House Museum 54
Indiana Jones Bed and Breakfast 55
The Rio Grande Scenic Railroad 55

WYOMING 57
Devils Tower from *Close Encounters of the Third
 Kind* 57

HAWAII 58
Gilligan's Island 58
Magnum, P.I. 59

UTAH 62
Gunsmoke 62
Moab Museum of Film and Western Heritage 62

EAST

NEW YORK 66
American Museum of Natural History 66
Seinfeld 67
Ghostbusters 68
Jim Henson and the Muppets at the Museum of the
 Moving Image 68
Roxbury Motel* 69
Eloise at the Plaza Hotel 70
More Food Stops for Film Lovers 71
Serendipity Skating Rink 75
On Location Tours 76
The Tour at NBC Studios 76
The Paley Center for Media 76
Film Festival Fun 77
All Things Oz 78
Doctor Who 81
Lucille Ball and the Lucy Comedy Fest* 81
Havana Cuban Cafe & Pizzeria 84
It's a Wonderful Life Museum 85

NEW JERSEY 88
Lou Costello Memorial Park* 88

VERMONT 94
The Sound of Music's Trapp Family Lodge 94

NEW HAMPSHIRE 96
Boat Cruise *On Golden Pond* 96

RHODE ISLAND 97
Rosecliff Mansion 97

MAINE 98

Stephen King Tour 98

CONNECTICUT 100

The Barker Character, Comic & Cartoon
 Museum 100
The Witch's Dungeon Museum 101
The Kate: Katharine Hepburn Theater and
 Museum 103

PENNSYLVANIA 105

The Princess Grace Museum 106
Mack Truck Historical Museum 107
Mister Rogers 107
The Jimmy Stewart Museum 109
The Stoogeum 110
James A. Michener Art Museum 110

MASSACHUSETTS 112

Cheers 112
Dr. Seuss Gardens and Museum 114
On Location Tours 115

SOUTH

ARKANSAS 118

The Old Mill from *Gone with the Wind* 118
Chaffee Barbershop Museum 119

MISSISSIPPI 120

Elvis Presley's Birthplace 120

FLORIDA 121

Pippi Longstocking 121
Star Wars Celebration 121
Cruise *The African Queen* 122
Humphrey Bogart Film Festival 123
The Truman Show 123
Tallahassee Automobile Museum 124
I Dream of Jeannie 125
Bob Hope Tribute at the Naval Aviation Museum 126
The Norman Studios Silent Film Museum 127
Amusement Parks 127

TENNESSEE 130
Roots' Alex Haley Museum and Interpretive
 Center 130
Graceland 131
Rusty's TV and Movie Car Museum 132
Titanic Museum 132
Crockett Tavern Museum 133

GEORGIA 135
Jim Henson Collection 135
Forrest Gump Props at the Savannah History
 Museum 135
Laurel & Hardy Museum 136
Margaret Mitchell House and Museum 137
Gone with the Wind Museum 137
My Cousin Vinny 139
The Walking Dead 140
 The Touring Dead Walking Tour 140
 Walking Dead Tour 141
Hunger Games House 142

MIDWEST

MICHIGAN 146
Somewhere in Time Weekend 147

NEBRASKA 148
Boys Town Hall of History 148
Bess Streeter Aldrich House and Museum 148
Henry Fonda's Childhood Home 149

MISSOURI 151
Laura Ingalls Wilder Historic Home & Museum 151
Celebrity Car Museum 153

INDIANA 154
Hoosiers Memorabilia 154
Hall of (Super)Heroes 155
The James Dean Gallery 155
A League of Their Own Stadium 157
Red Skelton Museum of American Comedy 158

WISCONSIN　160

OKLAHOMA　162
Will Rogers Dog Iron Ranch & Birthplace Home　162
Tom Mix Museum　163
Gene Autry Oklahoma Museum　164
Twister Museum　165

NORTH DAKOTA　166
Lawrence Welk Birthplace (Ludwig and Christina Welk
　　Homestead)　166

SOUTH DAKOTA　167
Dances with Wolves Film Set　167

MINNESOTA　168
Purple Rain Tour　168
Judy Garland Museum　170
Wizard of Oz Festival　171
Laura Ingalls Wilder Museum　171

IOWA　173
Johnny Carson's Childhood Home　173
Donna Reed Museum　173
The Music Man Square　174
Field of Dreams Farm　175
Star Trek's Captain James T. Kirk's Future
　　Birthplace　176
The Bridges of Madison County Tour　176
John Wayne Birthplace & Museum　177

OHIO　179
A Christmas Story House/Museum　179
The Shawshank Redemption Driving Trail*　181
Clark Gable's Childhood Home　183
Dean Martin's Hometown　184

KANSAS　187
Buster Keaton Museum　187
Dorothy's House and Land of Oz　187
OZtoberFEST!　188

Oz Winery 188
Evel Knievel Museum 189

ILLINOIS 191
Jack Benny's Boyhood Home 191
Oz Park 192
Museum of Broadcast Communications 192
Volo Museum 193
Groundhog Day Walking Tour and Annual Event 193

SOUTHEAST

NORTH CAROLINA 196
Andy Griffith Museum 196
Ava Gardner Museum 197
Land of Oz 198

SOUTH CAROLINA 201
House of Cards Photo Op 201

KENTUCKY 202
Rosemary Clooney Home Tour 202
The Big Lebowski Annual Festival 202

LOUISIANA 204
Steel Magnolias Bed & Breakfast 204

ALABAMA 206
To Kill a Mockingbird Courthouse Tour 206

VIRGINIA 208
Dirty Dancing Weekends at Mountain Lake
 Lodge* 208
Poe Museum 209

WEST VIRGINIA 211
Don Knotts' Hometown 211
Mothman Museum 211

MARYLAND 213
Sleepless in Seattle Library 213

NORTHWEST

WASHINGTON **216**

Northern Exposure Memorabilia at the Roslyn
 Museum 216
Bing Crosby House 216
Twilight's Forks Festival 217

OREGON **218**

OzCon International 218
Goonies Tour 219
Oregon Film Museum 219

IDAHO **221**

Farnsworth TV and Pioneer Museum 221

PHOTO CREDITS 222

ABOUT THE AUTHOR 223

ACKNOWLEDGMENTS

When a writer writes a book, they really don't do it alone, even if their name is the only one on the cover. For me, I couldn't have written my book without my family, who understands why I work long hours to accomplish what I love to do. So, to my children—Nicole Brinkley, Travis Brinkley, and Samantha Brinkley (Sami bugged me all the time to put something about *iZombie* in this book, so there you go!)—you are my love, my heart, and my motivation. Thank you for, once again, being by my side throughout this long process. I love you. To my honey, Ej Garr, thank you for making me laugh, showing me how to de-stress, and, most importantly, loving me. To my mom, Patricia Quaglieri, thank you for helping out again—cooking my fave foods on nights I was working on deadline and always pushing me to do better. You all mean everything to me. Last, but not least, thank you to my editor at Rowman & Littlefield, Rick Rinehart, who has been there for me every step of the way. You are amazing—thank you.

To my readers, I've written 17 books and almost all of them were with a coauthor. This particular book was my own idea and my labor of love. It combines my passions—film, television, and travel—and I'm extremely proud of what's here. I hope you enjoy it too.

—*Lisa Iannucci*

THE FILM & TV LOVER'S TRAVEL GUIDE

FILM AND TELEVISION, for the most part, are meant to be an escape. Movies are written by storytellers who want to share an adventure with you. Writers on television shows often build worlds and storylines that draw you in day after day or week after week. As fans of the movies and television, we want to become even closer to our favorites. We want to see where they were filmed and visit the hometowns of our favorite actors and actresses. We also want to spend our hard-earned money on collecting memorabilia.

In addition, just like there are sports and music fans who follow around their favorite sports teams and bands, there are also film and TV buffs who obsessively travel every year to share in the love of their favorite shows and movies. Just think about how many people have visited Philadelphia to run up the same steps that Rocky Balboa did in *Rocky*.

In Jamestown, New York, the home of the legendary comedian Lucille Ball, The Lucy Comedy Fest attracts thousands of fans every year who tour the home and town where Lucy was born just to feel closer to the redhead. They also enter look-alike contests, enjoy comedy shows, and even stomp a grape or two all in the name of being an *I Love Lucy* fan.

Throughout the United States, there are museums devoted to the careers of some of our favorite legendary actors, such as Andy Griffith, John Wayne, and Ava Gardner, as well as re-creations of movie scenes such as The Land of Oz. There are also conventions where you can meet others who love films and television as much as you do.

We have become so emotionally connected to our favorite characters that we hope that we too could become one of them. We have come to love our movies and television shows so much that cosplay, where we dress up like them, has become a fast-growing industry. It has even spawned its own conventions and television shows, such as Syfy's *Cosplay Melee*.

I remember, as a little girl, wanting to stand where Gene Kelly stood when he danced the famous umbrella scene in *Singin' in the Rain*. When Disney World in Orlando created a ride that took us behind the scenes of many famous movies, I couldn't wait to get there. I'd do anything to get closer. I was also a huge fan of Lucille Ball and Abbott & Costello. I wanted to know more about their lives. I read books on them and watched television documentaries, but I always wanted to go to Jamestown (Lucy's hometown) and see Cianci Street in Lou Costello's hometown of Paterson, New Jersey. (I've done both now.)

Kelly Thompson loves movies so much that when she travels she does what she can to see where her favorite films were made. For example, when she visited Sonoma County, California, she made sure to visit The Schoolhouse on Bodega Lane, the site for Alfred Hitchcock's famous horror movie, *The Birds*. She also visited the California settings for scenes in Hitchcock's *North by Northwest*, as well as the New York City apartment building seen in *Ghostbusters*.

"I'm fascinated with how filmmakers tell a story and seeing the places they used in real life," she told me. "I always pay attention when I'm watching and want to see how the place translated to film."

Author Sandra Hume has traveled throughout the United States, visiting locations related to her favorite books and television show, *Little House on the Prairie*.

Lindsey Rickert loved movies, specifically drive-in theaters, so much that she spent two months in her car and drove more than 12,000 miles around the United States looking for these disappearing American landmarks. Her book, *Drive-In America*, documents her travels, the changes in the industry and the future of drive-in movie theaters. I think film fans will love this nostalgic look back. For more information visit lindseyrickert.com.

In New York City, you can find Seinfeld Tours by the "real" Kenny Kramer or take a tour of *The Sopranos* locations. For the more retro viewer, there are 3-hour Gilligan's Island tours in Hawaii and a campground in Arizona, just outside of the Grand

Canyon that honors *The Flintstones* (don't forget to slide down the back of the life-size dinosaur when the quitting time bell rings!).

What's your favorite television show? Your favorite movie? Where do *you* want to go? In this book, all you have to do is flip to that state and see what you can tour and enjoy. Check out the table of contents and see what's available to you. Keep in mind that one movie, say *The Wizard of Oz*, has tourist spots all over the country, so do I see a road trip in your future to check them all out? Other movies have multiple spots you can visit as well.

Keep in mind that this book is only focused on what you can see and do in the United States. Trust me, there's an entire world of possibilities out there where you can enjoy tours related to *Game of Thrones*, *Lord of the Rings*, and *Harry Potter*. For now, we're focusing on the United States, but hope to expand. In the meantime, this is an amazing start.

Would you like to vacation with stars from your favorite television shows or movies? Today, you can. Specialized pop culture cruises are becoming more popular every year. There have been cruises with *Knight Rider*'s David Hasselhoff, HGTV's *The Property Brothers*, Jonathan and Drew Scott, and with the cast from AMC's *The Walking Dead*. There is also a *Beauty and the Beast*-themed cruise that travels along Europe's Rhine River and visits villages and cultural sites that inspired the *Beauty and the Beast* films. Coming up in 2018, there are cruises with *Jeopardy* and *Star Trek*. Want to know if your favorite television show or movie has a cruise? Just search the name of your favorite show and cruise online.

Once you look at this book, you will probably say, "Why didn't she include this or that?"

An entire book can be written just on locations in every state where both movies and television shows have filmed scenes. I didn't want to just write about a street corner where a movie was filmed. But if that street corner had a statue, a museum, or some other way that the movie was honored, I tried to include it. I'm sure I missed some. I focused on places were there was something to see or do. I did make some exceptions, however. For example, Wyoming's Devil's Tower in *Close Encounters of the Third Kind* is iconic. It's worth a trip there anyway, but knowing the significance in this movie of that structure, I had to include it. But I wasn't going to include every street or park or other

destination where a movie filmed. Like I said, I'd be here forever. On that note, I'm sure I missed a few places and I'd like you to let me know so that when it comes time to update the book, I have more information to include. Feel free to email me at lisawriter@ msn.com.

As for me, I had so much fun putting this book together. I learned about museums and statues that I didn't know existed. I was also disappointed when I didn't find something that honored some of favorite actors, films, and television shows. For example, there was nothing on Gene Kelly except temporary exhibits. I hope one day that will change.

Enjoy and let me know where you go!

—Lisa Iannucci

SOUTHWEST

ARIZONA

Known for its desert climate, deep canyons and hot weather, Arizona is a trip to the Old West, and when film and television directors need to step back in time, this is the place that they do it.

Many westerns have been filmed in Arizona throughout the years, including *The Lone Ranger* TV show (1949–1957), *Stagecoach* (1939), *Arizona* (1940), *The Outlaw* (1943), *3:10 to Yuma* (2007), *The Outlaw Josey Wales* (1976), and *Fort Apache* (1948), just to name a few. Scenes in many other films and television shows have also been shot in the Grand Canyon State, including *Star Wars* (1977) and *Return of the Jedi* (1983), *A Star Is Born* (1954), *Raising Arizona* (1987), *Bill & Ted's Excellent Adventure* (1989), *Waiting to Exhale* (1995), *Casablanca* (1942), and *Thelma & Louise* (1991).

Just in the Old Tucson area alone, more than 400 film and television projects have been made since 1939, including *Geronimo* (1993), *Buffalo Soldiers* (1997), and *Billy the Kid* (1989), as well as the *Three Amigos* (1986), which starred Chevy Chase, Steve Martin, and Martin Short.

There are plenty of things in Arizona for the film and television buff to see and experience, especially for those of you who yearn for the golden days of westerns and, well, cavemen.

★ LISA'S PICK ★
FLINTSTONES BEDROCK CITY

When I first saw the sign for the Flintstones Bedrock City Campground, located on the Grand Canyon Highway in Williams, Arizona, I immediately made the turn into the parking lot, jumped out of the car, almost threw my money at the cashier, and ran onto the campground. After all, *The Flintstones* was my favorite cartoon as a child. The original episodes ran from 1960 to 1966, but I saw them in reruns for years and loved them. I adored Fred, Wilma, Betty, Barney, Dino, and of course the kids, Pebbles and Bamm-Bamm, so it was only natural for me to see what it felt like to be a part of Bedrock. To this day, I can still sing the "Way Out" song.

Flintstones Bedrock City Campground is adorable for kids of all ages and absolutely worth a stop, especially if you were

a fan of the show or your kids have caught *The Flintstones* fever on cable. A note of caution, though: I wouldn't exactly call it a theme park like they do. Most travelers associate a theme park with a Six Flags or a Universal Studios.

Website: www.bedrockaz.com

Info: Cost of admission is $5, but look for a $1 discount coupon on the website. Summer hours are 6 a.m. to sunset and winter hours are 7 a.m. to sunset.

Contact: Flintstones Bedrock City, Junction 64 & 180, Grand Canyon Highway, 101 S Hwy 180, Williams, AZ 86046; (928) 635-2600.

What *does* the Flintstones Bedrock City have? Remember the end scene of every episode of *The Flintstones* where the 5pm whistle sounds and Fred slides off the back of the dinosaur, screaming "Yabba Dabba Do"? You or your kids can recreate that—I did—with the life-size dinosaur equipped with a slide down its tail. Flintstones Bedrock City also had a train ride and a few other small rides for the wee ones, but the best part of the campground was just the look of the land. You could walk into the recreated Bedrock Post Office, and the Flintstones' bedroom and kitchen, and just feel like you lived back with the cavemen.

They even have a Fred's Diner where you can order, believe it or not, a Bronto Burger, Chickasaurus Dinner, or Fishasaurus Sandwich, and end your meal with a piece of Gravelberry Pie. There's a gift shop and, of course, a campground where you can park your RV.

Note: At one time, there was another Flintstones Campground in Custer, South Dakota, but that has since closed. There was rumor of a new owner and a possible remodel, but nothing has been confirmed to date.

OLD TUCSON MOVIE SET

As I said, Old Tucson, Arizona, has been used as the movie set of more than 400 films, first starting with the 1939 movie *Arizona*, which starred William Holden and Jean Arthur. It was also the set for *The Bells of St.*

Website: http://oldtucson.com

Info: Cost of museum admission: adults, $18.95; children ages 4 to 11, $10.95. The park has different hours throughout the year, so check the website for the most up-to-date information.

Contact: Old Tucson Movie Set, 201 S. Kinney Rd., Tucson, AZ, 85735; (520) 883-0100.

Mary's (1945), which starred Bing Crosby and Ingrid Bergman, *The Last Roundup* (1947) with Gene Autry, and *Gunfight at the OK Corral* (1956) with Burt Lancaster and Kirk Douglas. Today, you can tour the Old Tucson Movie Set and walk where some of your old-time movie favorites have walked, including Clint Eastwood, Elizabeth Taylor, and John Wayne. While you are there, stop by the Old Tucson Story Museum to see the original costumes worn by the stars of several legendary television series, including *Little House on the Prairie* and *Bonanza*.

But wait, there's more!

If you're a fan of *Little House on the Prairie*, there are several museums to see and tours to take throughout the country. Keep reading!

ANDY DEVINE

If you are old enough to remember the black-and-white television show *Adventures of Wild Bill Hickok* (1951–1958), then you should remember Andy Devine, who portrayed Hickok's trusty sidekick, Jingles P. Jones.

> **Website:** www.mohavemuseum.org
>
> **Info:** Cost of admission: $4 for adults. The museum is open Monday through Friday 9 a.m. to 5 p.m.; Saturday 1 p.m. to 5 p.m.
>
> **Contact:** Mohave Museum of History and Arts; 400 West Beale St.; Kingman, AZ; 86401; (928) 753-3195.

Born in Flagstaff, Arizona, and raised two hours away in Kingman, Arizona, Devine was a chubby man with a distinctive voice who appeared in more than 400 films in his career, including *The Spirit of Notre Dame* (1931), *A Star Is Born* (1937), *Stagecoach* (1939), *Island in the Sky* (1953), and *The Man Who Shot Liberty Valance* (1962). Ten of these films were with Roy Rogers where Devine played his sidekick, Cookie. He also hosted his own children's television show, *Andy's Gang*, from 1955 to 1960.

You can find a tribute on the life and career of the Kingman hometown hero at the Mohave Museum of History and Arts in Kingman. The city also hosts an annual "Andy Devine Days Parade," typically held in September.

REX ALLEN MUSEUM

It was in the 1950s when western films were what everyone was watching and cowboy actors such as Roy Rogers, Gene Autry, and John "The Duke" Wayne, were extremely popular. Rex

Statue Alert! Rex Allen

Get out your camera and take a statue selfie! There is a statue of cowboy actor Rex Allen right across the street from the Rex Allen Museum on Railroad Avenue in the park. It is said that the sculpture's creator, Buck McCain, put a molded bronze heart with arteries inside the statue of Allen, which symbolizes that Rex's heart remains in his hometown of Willcox. Right at the foot of Rex's statue is where his horse, KoKo, is buried.

Allen, who was known as the "Arizona Cowboy" and "Mister Cowboy," was also one of those singing cowboys. He would appear in 19 western movies between 1950 and 1954, including *The Arizona Cowboy* (1950), *South Pacific Trail* (1952), and *Down Laredo Way* (1953). For those of you who loved the 1973 film version of the children's classic *Charlotte's Web*, Allen was the voice of the narrator.

He was a hometown hero from Willcox, Arizona, although he was born in Mud Springs Canyon, a town only a short distance away. Willcox hasn't forgotten Allen because it's here where you will find the Rex Allen Museum.

You can visit the Rex Allen Museum on your travels through Arizona any time of the year or you can time your visit to the annual Rex Allen Days, which have been held in October since 1951. The Rex Allen Days started as a benefit for a local hospital, which included an appearance by Rex Allen himself. Allen passed away in 1999, so today's fund-raiser includes a variety of rodeos, the Annual Cowboy Hall of Fame Banquet, mock gunfights, antique tractor pulls, Cowboy Poetry entertainers, parades, a Rex Jr. Celebrity Panel Q&A, showings of old Rex Allen movies, and more.

Website: www.rexallenmuseum.org

Info: Cost of admission: $2 per person, kids under 10, free. The museum is open Monday 10 a.m. to 1 p.m. with live music, and Tuesday through Saturday 11 a.m. to 3 p.m. It is closed on major holidays.

Contact: Rex Allen Museum, 150 N. Railroad Ave., Willcox, AZ 85643; (520) 384-4583.

EASY RIDER
"What the hell is wrong with freedom?"

Nothing, especially if you're easy riding down Route 66 and make a stop at the Pine Breeze Inn RV Park and Campground. It is located eight miles west of Flagstaff, Arizona, off Interstate 40 in Bellemont, Arizona. One scene from the 1969 movie, *Easy Rider*, which is responsible for that question of freedom, was filmed here and put the park on the map, so to speak. This American road movie was written by and starred Peter Fonda, Dennis Hopper, and Terry Southern. It's about two bikers (played by Fonda and Hopper) who make a huge cocaine score and then travel through the American Southwest and South.

Website: www.pinebreezeinnrvpark.com

Info: If you have an RV, there are daily and monthly rates as well as storage rates.

Contact: Pine Breeze Inn RV Park; 10520 W. Route 66, Flagstaff, AZ, 86001; (928) 853-9363.

GAMMONS GULCH MOVIE SET & MUSEUM

Who the heck is Jay Gammons? Jay Gammons' father was a range deputy and served as a security guard when John Wayne was filming his westerns in the Arizona area. Gammons' father was Wayne's personal bodyguard, and Jay would often tag along with his father to the movie sets. Jay ultimately became a bodyguard for legendary actress Ava Gardner, and he worked as an extra in such films as *Rio Bravo*, *McLintock*, and *El Dorado*. Jay had a dream of one day owning and operating his own movie location set, so he opened Gammons Gulch, which has become part movie site and part ghost town and is a must-see if you're in the area.

Website: www.gammonsgulch.com

Info: Gammons Gulch is open from September through May, Wednesday through Sunday by reservation only, and from June through August by reservation only. There is a nominal admission fee charged per project, tours, or party.

Contact: Gammons Gulch Movie Set & Museum, 331 W Rockspring Ln., Benson, AZ, 85602; (520) 212-2831.

GRAND CANYON: Flintstones Bedrock City is located only about 30 miles outside of the Grand Canyon, one of the most beautiful places in this country, so add a day in (at least) to see this natural wonder. The Grand Canyon National Park in Arizona is 277 river miles long, up to 18 miles wide, and a mile deep. If you're the adventurous type, try the Glass Skywalk where, for a fee, you can walk out over the canyon and view the Colorado River.
Website: www.nps.gov/grca/index.htm
Info: Most of Grand Canyon Village is wheelchair accessible. There are some exceptions, however, including Kolb Studio and Lookout Studio.
Contact: Grand Canyon, PO Box 129, Grand Canyon, AZ 86023; (928) 638-7888.

PENSKE RACING MUSEUM: Located in Phoenix, the Penske Racing Museum is a collection of cars, trophies, and racing memorabilia from 400 major race wins, highlighted by 16 Indianapolis 500-mile race victories.
Website: www.penskeracingmuseum.com
Info: Cost of admission is free. Museum hours are Monday through Saturday 8 a.m. to 4 p.m., Sunday noon to 5 p.m.
Contact: Penske Racing Museum, 7125 East Chauncey Ln., Phoenix, AZ 85054; (480) 538-4444.

THE MUSICAL INSTRUMENT MUSEUM: Also located in Phoenix, this museum is home to more than 15,000 musical instruments from almost 200 countries. It is absolutely amazing. It will take a lot of time to get through this museum, especially if you stop and watch all of the footage of the musicians and their appearances on television shows and in films.
Website: https://mim.org
Info: Cost of admission ranges, starting at $20 for adults. Open daily 9 a.m. to 5 p.m.
Contact: The Musical Instrument Museum, 4725 E. Mayo Blvd., Phoenix, AZ 85050; (480) 478-6000.

SUNSET CRATER VOLCANO: The Sunset Crater Volcano in Flagstaff is unassuming from a distance, but when you get closer to it, it is a monstrous area of hardened lava fields and a volcano—yes, a volcano—right in the middle.
Website: www.nps.gov/sucr

Info: Cost of admission: free. The Sunset Crater Volcano is open November to June 9 a.m. to 5 p.m. From June through October, it is open 8 a.m. to 5 p.m.

Contact: Sunset Crater Volcano, 6400 US 89, Flagstaff, AZ 86004; (928) 526-0502.

PIMA AIR & SPACE MUSEUM: Located in Tucson, the Pima Air & Space Museum is the largest privately funded aviation and aerospace museum in the world and the third-largest aviation museum in the United States. It displays more than 300 of the most significant aircrafts in the history of flight.

Website: www.pimaair.org

Info: Cost of admission (for one day—two-day passes are available too): adult (ages 13 and up), $15.50; senior (65+)/military, $12.75; junior (ages 5–12), $9.00; 1 child (4 and under), free. The museum is open 9 a.m. to 5 p.m., but the last admittance is at 3 p.m.

Contact: Pima Air & Space Museum, 6000 E Valencia Rd., Tucson, AZ 85706; (520) 574-0462.

NEVADA

Producers love Nevada. If it's not for its desert landscape, ghost towns, and scenic roads, it's for the state's largest—and most entertaining city—Las Vegas. Numerous feature films have been shot in Nevada, including *Jason Bourne* (2016), *The Hangover* (2009), *Think Like a Man Too* (2014), *Now You See Me* (2013), *Last Vegas* (2013), *The Muppets* (2011), *Here Comes the Boom* (2012), *Lucky You* (2007), and *Knocked Up* (2007). Nevada is also home to many reality shows, such as *Bridezillas*, *Sister Wives*, *The Real World*, *Hell's Kitchen*, and more.

PAWN STARS

If you're a fan of Rick, Chumlee, Corey, and the Old Man and you can't get enough of the History Channel's popular show *Pawn Stars,* then head out to Las Vegas where you can actually visit their World Famous Gold & Silver Pawn Shop. Unlike on

Website: http://gspawn.com

Info: Cost of admission to the shop is free, but the VIP tour is $125 per person. The shop is open every day 9 a.m. to 9 p.m. but closed on Christmas and Thanksgiving.

Contact: World Famous Gold & Silver Pawn Shop, 713 S Las Vegas Blvd., Las Vegas, NV 89101; (702) 385-7912.

the television show, there is no guarantee that you will see any of the cast of characters when they aren't filming, but they have

Foodie Fact!

Pawn Stars' Rick Harrison also owns Rick's Rollin Smoke BBQ and Tavern in Las Vegas, Nevada, and you can see him bartending often. Enjoy a signature cocktail made by the man himself or a slow-smoked barbecue meal.

WEBSITE: http://rrsbbq.com

INFO: Restaurant hours are 10 a.m. to 10 p.m. and the tavern is open 11 a.m. until 2 a.m.

CONTACT: Rick's Rollin Smoke BBQ and Tavern, 725 S Las Vegas Blvd., Las Vegas, NV 89101; (702) 462-9880.

been known to go on the floor from time to time. However, it is believed that most weekends you can find Rick bartending at his bar, Rick's Rollin Smoke BBQ and Tavern (see the Foodie Fact! for more information). If you want a guaranteed meet-and-greet experience, *Pawn Stars* offers a 4½-hour tour where you will meet either Rick, the Old Man, Chumlee, or Corey, take pictures, ask questions, and get autographs. On this tour, guests will also visit Jeremy Brown's Ultimate Sports Cards & Memorabilia (Jeremy is often seen on *Pawn Stars*) and the homes of the shows *Counting Cars, American Restoration,* and *Tanked.*

STAR TREK

Are you a Trekkie? Then make plans for the Creation Entertainment's Annual Las Vegas Official *Star Trek* Convention where you will meet fans who love the show just as much as you do. In addition, you'll also have the chance to meet the show's actors and others associated with the production. In 2017, the *Star Trek* Convention took place in August and the convention welcomed "The Man" himself, the legendary actor William Shatner, otherwise known as Captain James T. Kirk, as well as George Takei (Hikaru Sulu), Kate Mulgrew (Captain Kathryn Janeway), and Sir Patrick Stewart (Captain Jean-Luc Picard).

Website: www.creationent.com/cal/st_lasvegas.html

Contact: Creation Entertainment, 217 S. Kenwood St., Glendale, CA 91205; (818) 409-0960.

Did you know?
Creation Entertainment also hosts several other fan conventions for such shows as *Supernatural, The Vampire Diaries, Once Upon a Time,* and *General Hospital.* Visit www.creationent.com/calendar.htm for a list of conventions coming up in 2018 and beyond.

THE MOB MUSEUM

If you like incredibly well-written crime shows like *Breaking Bad* or mob flicks like *The Godfather* trilogy, you will love The Mob Museum, the National Museum of Organized Crime and Law Enforcement, located in Las Vegas, Nevada. Okay, to be honest, it's an odd museum that gives space to people who have killed others, but there is something absolutely fascinating

about it at the same time. The true stories, and the movies that were made about them, are documented as their part in history. When I visited in 2015, I was fortunate to be able to talk to the museum's director of content, Geoff Schumacher, after my tour, and I asked him why this museum was so popular. "Everybody seems to have a story about someone in their family or someone they knew," he said. "They have a connection and want to learn more."

The museum also offers audio tours, which is a great way to self-tour and listen to stories along the way.

For the movie and television lover in you, there is one section of the museum dedicated to *The Sopranos* and a whole wall of the different mob and crime movies that have

been made. It will probably take you a few hours to get through the entire museum if you really want to read everything, and it is seriously cool. It's recommended that kids under 12 probably won't enjoy the gory photos and probably won't comprehend the exhibits in a bigger historical context.

OTHER THINGS TO SEE OR DO IN NEVADA

LAS VEGAS: Everybody's heard that what happens in Vegas stays in Vegas, but who cares, baby, you're in Vegas! The energy in this city is unending. There's so much to do—you can try your luck at the many casinos, see a traditional magic show like David Copperfield's at the MGM Grand, or explore the quirky nightlife at Fremont Street in downtown Vegas.
Website: www.lasvegas.com for more information

THE NATIONAL AUTOMOBILE MUSEUM: Located in Reno, the National Automobile Museum is perfect for anyone who loves cars. Can't get enough of *The Fast and the Furious* franchise? Love looking at whatever luxury car James Bond is driving? Staring at the background of *The Godfather* movies just to see the classic cars? Then you'll love this museum. There are more than 200 cars that you can see up close and personal.
Website: www.automuseum.org
Info: Cost of admission: $12 for adults, $10 for seniors, and $6 for children 6 to 18 years. Children age 5 and younger are free. The museum's hours are Monday to Saturday 9:30 a.m. to 5:30 p.m., and Sunday 10 a.m. to 4 p.m.
Contact: National Automobile Museum, 10 South Lake St., Reno, NV 89501; (775) 333-9300.

HOOVER DAM: Formerly called Boulder Dam, this is an impressive sight to see on your Nevada travels. Located on the Arizona/Nevada border, the dam and the power plant can be toured every day. The dam tour is an hour and the power plant tour is about 30 minutes.
Website: https://www.usbr.gov/lc/hooverdam
Info: Cost of admission: adults (ages 17–61), $15; seniors (62+), $12; juniors (ages 4–16), $12; US military, $12; US military (in uniform), free; children (ages 0–3), free. The Hoover Dam Visitor's Center is open 9 a.m. to 5 p.m. (Tickets must be purchased by 4:15 p.m. for access.)

Contact: Hoover Dam, Boulder City, NV 89005; (702) 494-2517.

NEON MUSEUM: Who would've thought that looking at neon signs could be so much fun? The people at the Neon Museum in Las Vegas did, of course! The organization collects and exhibits iconic neon Las Vegas signs and you can see these in an outdoor space creatively called the Neon Boneyard. The signs come from back in the 1930s all the way up to the present day.
Website: www.neonmuseum.org
Info: Cost of admission for day tours is $15 to $19; night tours are from $22 to $26; and late-night tours are $24 to $28. The Neon Museum Boneyard is only available to the public through an hour-long guided tour. Tours are available seven days a week, and tour times vary based on the season.
Contact: The Neon Museum, 770 Las Vegas Blvd. North, Las Vegas, NV 89101; (702) 387-6366.

LAKE TAHOE: Would you prefer boating and fishing to slot machines and roulette tables? Then Lake Tahoe, Nevada, is the perfect place for you to visit. Lake Tahoe is a 22-mile-long lake that is also second deepest lake in the United States.
Website: www.visitinglaketahoe.com

NEW MEXICO

What makes New Mexico a director's dream is the fact that there are more than 360 days of sunshine. Its topography is absolutely wonderful and has been featured in so many famous movies and television shows, including the 1969 Paul Newman and Robert Redford classic *Butch Cassidy and the Sundance Kid*. Others include *The Grapes of Wrath* (1940), *The Avengers* (2012), *Transformers* (2007), *Indiana Jones and The Last Crusade* (1989), and *Manhattan* (1979).

More recently, New Mexico was prominently featured in the Netflix original *Longmire* and the hit television show *Breaking Bad* and is home to various *Breaking Bad* tours.

Foodie Fact!

You do not have to take any of the *Breaking Bad* tours just to sit in the same booth at the fictional Los Pollos Hermanos where Walter White once did. My Twisters was used as the restaurant in the show—specifically their Isleta Boulevard location—and you can stop by, sit in the same booth where Walter White sat and made his shady deals, and, of course, grab something to eat.

WEBSITE: www.mytwisters.com

INFO: Hours are 5:30 a.m. to 9:00 p.m. (at most locations).

CONTACT: My Twisters, 4275 Isleta Blvd. SW, Albuquerque, NM 87105; (505) 877-2727.

BREAKING BAD

Speaking of AMC's *Breaking Bad*, it's considered to be one of the best television shows in recent history (and Lisa adamantly agrees). *Breaking Bad* was created by Vince Gilligan and ultimately won 16 Primetime Emmy Awards, including winning for Outstanding Drama Series in both 2013 and 2014. The

Website: www.breakingbadrvtours.com

Info: Cost of tickets: $75 per person including a light breakfast or lunch at, where else, Los Pollos Hermanos. The website sometimes offers a discount code. The tour company is closed Tuesdays and Wednesdays.

Contact: Phone message line and recorded information is (505) 205-7292. You can also email the company at breakingbadrvtours@aol.com.

Did you know?
Want to explore on your own? You can also take a self-guided *Breaking Bad* tour. The Albuquerque Convention & Visitors Bureau offers a *Breaking Bad* map on their website, which shows you the filming locations of the show and you can check them out yourself at your own pace.

Website: www.visitalbuquerque.org

Contact: Albuquerque Convention & Visitors Bureau, 20 First Plaza NW, Suite 601, Albuquerque, NM 87102; (800) 284-2282.

show also had 58 other nominations. Bryan Cranston brilliantly portrays Walter White, a chemistry teacher who lives in New Mexico with his wife Skylar, and son Walter Jr. When Walter is diagnosed with lung cancer, he decides to start selling meth to make money that he will leave behind for his family. He turns to a former troubled student, Jesse Pinkman (also brilliantly played by Aaron Paul), to help him, but the two of them descend into a dangerous world of drugs and crime.

The show ran for five years, ending in spectacular fashion in 2013, but it's not forgotten, especially since *Breaking Bad* fans can travel to New Mexico and take a three-hour location tour in the RV that looks just like the one from the show. You know the one—it's where Jesse and Walter cooked up their meth. On this tour, you will visit 20 locations around New Mexico where Gilligan and his crew filmed the show. These sites include Jesse's House, The Dog House, Tuco's, Combo's Corner, The Railyard, RV Junkyard, the restaurant that was used for Los Pollos Hermanos, Crossroads, Jane's, Denny's, Danny's, The Car Wash, Walt's House, The Super Lab, and more.

But wait, there's more!

There is more than one *Breaking Bad* tour in New Mexico. In Albuquerque, you can also take the 3.5 hour 'BaD Tour' on ABQ Trolley X. You'll travel 38 miles where you will see the exterior of Walter White's house and condo and Jesse Pinkman's house and duplex, Gus' house, The Car Wash, The Laundry, Saul Goodman's law office, Tuco's headquarters, The Railyards, The Crossroads Motel, Los Pollos Hermanos, and more.

Website: www.abqtrolley.com/page/bad

Info: Cost for these tours is $65 per person.

Contact: ABQ Trolley X, 800 Rio Grande Blvd. NW, Albuquerque, NM 87104; (505) 200-2642.

WHITE SANDS NATIONAL MONUMENT

This beautiful landscape, with its white gypsum sand that is constantly moving into changing dunes, is located in the Tularosa Basin in southern New Mexico. You can see the monument for yourself and just take in its beauty. As a film buff, you'll completely understand why the White Sands has been used as a backdrop for scenes in many movies as well as documentaries, television shows, and music videos, including Clint Eastwood's *Hang 'Em High* (1958), David Bowie's film *The Man Who Fell to Earth* (1976); and *Transformers* (2007, 2009).

Website: www.nps.gov/whsa/index.htm

Info: Cost of admission: adults, $3; children 16 and under, free. The monument is open 8 a.m. to 7 p.m. (May 15 to August 15) and 8 a.m. to 4:30 p.m. (August 16 to May 14).

Contact: According to the park, the visitor's center and Dunes Drive located directly off of US 70, between the cities of Alamogordo and Las Cruces. The entrance to the monument is between mile markers 199 and 200 on US 70. (575) 479-6124.

BILLY THE KID MUSEUM

The infamous gunfighter Billy the Kid has been the subject of many movies, including *The Kid From Texas* (1950), *The Left Handed Gun* (1958), *Pat Garrett & Billy the Kid* (1973), *Billy the Kid* (1989), and *Young Guns* (1988). Here, in Fort Sumner, New Mexico, which is Billy's resting place, there is a museum that is dedicated to this wrong arm of the law. The museum has one of

Website: www.billythekidmuseumfortsumner.com

Info: Cost of admission: adults, $5; senior citizens (ages 62 and up), $4; children 7-15, $3; children 6 and under, free. The museum is open daily May 15 to October 1, 8:30 a.m. to 5 p.m. October 1 to May 15, the museum is open Monday to Saturday 8:30 a.m. to 5 p.m. No tours after 4:30 p.m.; closed Christmas and January 1 through January 15.

Contact: Billy the Kid Museum, 1435 East Sumner Ave., Fort Sumner, NM 88119; (575) 355-2380.

Billy's rifles, as well as the door he backed through the night he was shot, a large rock he carved his name on, his chaps, spurs, and so much more.

OTHER THINGS TO SEE OR DO IN NEW MEXICO

CARLSBAD CAVERNS NATIONAL PARK: The park has nearly 120 known underground caves to be explored and is a must-see if you're in New Mexico. You can tour the caves and even take a bat tour.

Website: www.nps.gov/cave/index.htm

Info: Cost of admission: adults, $10; children 15 and under, free. The park is open 8 a.m. to 7 p.m. during the summer and 8 a.m. to 5 p.m. in the winter.

Contact: Carlsbad Caverns National Park, 727 Carlsbad Caverns Hwy., Carlsbad, NM, 88220; (575) 785-2232.

FOX CAVES: There are so many oversized and odd things to see in New Mexico and this huge collection of just, well, odd things is actually pretty cool to see. There is so much to look at here that you could spend hours exploring, but make sure you check out the memorabilia from Marie Antoinette and Billy the Kid as well as the space alien section. When you're done exploring you can mine for gems.

Website: www.foxcavenm.com

Info: The cave is open daily 10 a.m. to 5 p.m.

Contact: Fox Caves, 101 Mechem Dr., Ruidoso, NM; (575) 378-9954.

MEOW WOLF: George Raymond Richard Martin, also known as GRRM, is a science-fiction and horror writer, but he's mostly known for his fantasy novels that became HBO's *Game of Thrones*. GRRM is also a big supporter of Meow Wolf in Santa Fe, New Mexico, a place where you can feel like you have fallen into different universes, or through Alice's rabbit hole, or into one of the author's stories. *The House of Eternal Return* is a 20,000-square-foot art exhibit designed by the Meow Wolf collective, with dozens of rooms, secret passages, and interactive light and musical objects with which guests can play for hours or investigate a "murder."

Website: https://meowwolf.com

Info: Cost of admission: adults, $20; children, ages 12 and under, $14; seniors/military, $18. New Mexico residents receive a reduced rate.

Contact: Meow Wolf, 1352 Rufina Cir., Santa Fe, NM; (505) 395-6369.

TEXAS

You know the expression, go big or go home? Well, when you get to Texas, you'll want to do it all and, maybe, you won't want to go home. Or maybe you will. Texas was home to the filming of the *Texas Chainsaw Massacre*, but it was also home to one of the most popular shows on television in the 1980s, *Dallas*.

LIBRARY OF ENTERTAINMENT HISTORY AT THE RANSOM CENTER

No, this isn't a place in Liam Neeson's *Taken* trilogy. Instead, it's the Harry Ransom Center at The University of Texas at Austin, and it has some fantastic film and television exhibits as well as a library of entertainment history. They currently own the manuscripts of David Foster Wallace, Julia Alvarez, and Gabriel García Márquez, as well as the hat that accompanied the green curtain dress worn by Vivien Leigh in *Gone with the Wind*. They also bought the personal collection of actor Peter O'Toole, best known for his role in the 1962 film *Lawrence of Arabia*. The bulk of the Harry Ransom Center's collection concerns mainstream Hollywood filmmaking from the silent era through the present day. In 2018, one of their temporary exhibits will focus on vaudeville.

Website: www.hrc.utexas.edu

Info: Admission is free. A donation supports the Ransom Center's exhibitions and public programs. Exhibition galleries are open 10 a.m. to 5 p.m. Monday, Tuesday, Wednesday, and Friday; 10 a.m. to 7 p.m. Thursday; noon to 5 p.m. Saturday and Sunday. Tours daily.

Contact: Harry Ransom Center, The University of Texas at Austin, 300 West 21st St., Austin, TX 78712; (512) 471-8944.

THE TEXAS CHAINSAW MASSACRE GAS STATION GIFT SHOP AND MOTEL

If you're into horror movies, especially *The Texas Chainsaw Massacre*, then make a pit stop to this, well, pit stop. This gas station in Bastrop, Texas, was used as part of the filming in the cult classic horror film that came out in 1974. The movie starred Marilyn Burns, Paul A. Partain, Edwin Neal, Jim Siedow, and Gunnar

Website: http://texasgasstation.com

Info: The cabins start at $79 per night.

Contact: The Gas Station, 1073 SH 304, Bastrop, TX 78602; (512) 321-SAWS.

Hansen and follows friends who fall victim to a family of cannibals. If you dare, you can go into The Gas Station, which is open for business as a gift shop and a motel as well, under a new owner, Roy Rose. When Rose reopened the business, he had Ed Neal and Ed Guinn, who had parts in the movie, at the opening.

DALLAS' SOUTHFORK AND EWING MANSION TOURS

The Ewing family captured prime time television audiences when they hit the CBS airwaves in 1978. Viewers tuned in every Sunday night to watch Dallas oil magnate J.R. Ewing and his family backstab and feud with anyone in their path. The one-hour drama ran for 14 seasons and become one of the most popular shows in television history. It also spawned the spin-off series *Knots Landing* in 1979, which also lasted 14 seasons. One of the most famous cliffhangers in television was *Dallas'* "Who Shot J.R.?"

The Texan family lived on Southfork, which was actually a real location in Parker, Texas, and became a tourist attraction in 1985. Southfork is open daily for guided tours of the ranch and

Website: www.southforkranch.com

Info: Open 10:00 a.m. to 5:00 p.m. Tour schedule: Daily tours start at 10:15 a.m. and run every 45 minutes. The last guided tour of the day begins at 4:15 p.m. every day. Admission rates, general admission: adults, $15.00 plus tax; senior citizens (60+), $13.00 plus tax; children (6–12), $9.00 plus tax; children 5 and under, free.

Contact: Southfork Ranch, 3700 Hogge Rd., Parker, TX 75002; (972) 442-7800.

Did you know?
J.R. Ewing's famous Stetson hat can be found at the Old Red Museum, located at 100 S Houston St., in Dallas, Texas.

Website: www.oldred.org

Info: General museum admission, $10; seniors, $8; students, $8; military, $8; children (ages 3–16), $7. The museum is open 9 a.m. to 5 p.m. daily, but closed on Thanksgiving, Christmas Eve, and Christmas Day.

Contact: 100 S. Houston St., Dallas, TX 75202; (214) 745-1100.

tours of the famed Ewing Mansion. Visitors will see an array of memorabilia from the series, including the gun that shot J.R., Lucy's wedding dress, the *Dallas* family tree, and Jock's Lincoln Continental. Fans can also eat at Miss Ellie's Deli and purchase a two-hour horseback ride, which includes a tour, lunch, and more.

LARRY HAGMAN AND MARY MARTIN EXHIBIT

If you're looking for more things to see on the man behind J.R. Ewing, Larry Hagman, head over to The Doss in Weatherford, Texas. Here you'll find a permanent exhibit on Larry and his mother, legendary film and stage actress Mary Martin. Martin was known for her portrayal as Nellie Forbush in *South Pacific* and Maria von Trapp in *The Sound of Music*. The exhibit explores Martin's early childhood in Weatherford and her successes on Broadway and in film. The exhibit also includes some items from Hagman.

Website: http://doss center.org

Info: The Doss is open Tuesday through Saturday 10 a.m. to 5 p.m. Extended evening hours on Thursday 10 a.m. to 8 p.m. Free admission.

Contact: Doss Heritage and Culture Center, 1400 Texas Dr., Weatherford, TX 76086; (817) 599-6168.

WEST

CALIFORNIA

It's been a little over 100 years since the advent of the motion picture and the industry took off in California. You can read entire books just on the history of the movies in California and how these cities were where would-be actors and actresses dreamed about going to get their big break. They would pack up and leave their homes to venture out and, hopefully, be discovered by some talent agent while they sat and ate at an ice cream counter. (That is exactly what happened to actress Lana Turner.)

Hollywood and Los Angeles are both home to the earliest and most affluent film companies, including Warner Brothers Pictures, Paramount, RKO, Metro Goldwin Meyer, and 20th Century Fox. The 1930s were considered the Golden Age of Hollywood, and even though movies are made all over the world today, Tinseltown is always going to be known as the place where it all started.

It's impossible to talk about all of the movies that were made in California in just a few paragraphs, but if you are a fan of film and television, a trip to the Golden State is a must. From the early days of silent films and the museums dedicated to the works and the actors who made them great, to the studio tours, movie festivals, other museums, and statues, you're going to need more than one trip to see it all, but that's okay!

AMERICAN GRAFFITI FESTIVAL

American Graffiti was a 1973 coming-of-age movie that was written and directed by George Lucas, the man who would soon after become known for the *Star Wars* and *Indiana Jones* franchises. Lucas wrote *American Graffiti* based on his teenage years growing up in Modesto, California. It starred some of the biggest names in show business back then, including Richard Dreyfuss (who also starred in *Close Encounters of the Third Kind)*, Ron Howard

Website: www.americangraffiti
festival.com

Info: Cost of admission: adults, $10;
children 12 and under, free. There is
no charge to view the parade.

Contact: Email through the North
Modesto Kiwanis website: http://
northmodestokiwanis.org.

(*Happy Days*), Mackenzie Phillips (*One Day at a Time*), and Cindy Williams (*Laverne & Shirley*).

Every year, typically in June, Modesto pays homage to the film that put it on the map, with an annual, family-friendly *American Graffiti* Festival. There's a parade, vendors, food, music, and over 1,000 cars of all styles and ages.

GEORGE LUCAS MUSEUM OF NARRATIVE ART

Speaking of George Lucas, The George Lucas Museum of Narrative Art will open in (approximately) 2021, but it will not be a museum based on *Star Wars* or *Indiana Jones*, nor will it be a tribute to this talented film director's life (hang on though). Opening in Los Angeles at Exposition Park, The George Lucas Museum of Narrative Art will be a museum that "features fine

art and popular art from illustration to comics, an insider's perspective on the cinematic creative process and the boundless potential of the digital medium."

> **Website:** http://lucasmuseum.org
>
> **Info:** Isn't scheduled to open until approximately 2021. Currently this is all the information we have.

Star Wars fans won't be completely disappointed though, because Lucas has said that there will be *some* of his memorabilia from the movie on display, but it is not known yet what that will be. The museum will also include some of Lucas' personal art collection. The museum's interior spaces are estimated to be between a whopping 265,000–275,000 square feet, and the galleries will be approximately 90,000–100,000 square feet. The museum will be shaped like a spaceship and will cost $1 billion to build.

RANCHO OBI-WAN

Are you a die-hard *Star Wars* fan? Have you seen every *Star Wars* movie? Hey, even if you haven't, you will still want to visit Rancho Obi-Wan, located in, well, you will have to book a tour to find out where it is actually located. That's how Rancho Obi-Wan owner Steve Sansweet wants it to be. What I will say about it here is that Rancho Obi-Wan is located in rural Sonoma County, just west of Petaluma, California.

Sansweet owns one of the coolest and largest *Star Wars* collections around, with action figures and props that were actually

Statue Alert! Yoda
"Judge me by my size, do you?"

Yoda, the wise legendary Jedi Master from *Star Wars*, has been spotted at Imagination Park in San Anselmo, California! Well, at least a statue of this popular 900-year-old character has been spotted, and it makes a great photo op for every *Star Wars* fan. The statue is at the park's fountain, and he's located right next to Indiana Jones.

WEBSITE: www.sananselmopark.org

INFO: There is no fee to enter Imagination Park.

CONTACT: Imagination Park, 535 San Anselmo Ave., San Anselmo, CA, (415) 454-2510.

used in the movies. His collection is so big that he opened his own personal museum for those who want private tours. On the website, he suggests booking your tour out about 6 to 8 weeks in advance, and—this is important—you must be a member of Rancho Obi-Wan before you can book.

ALFRED HITCHCOCK WALKING TOUR

Film director and producer Alfred Hitchcock was referred to as the "Master of Suspense," and there's good reason why. He has provided moviegoers with some of the most spine-chilling flicks ever made, including *Spellbound* (1945), *Rear Window* (1954), *Vertigo* (1958), *Psycho* (1960), and *The Birds* (1963). He was also famous for his just-as-suspenseful television show, *Alfred Hitchcock Presents*, which ran from 1955 to 1965 and aired on CBS and then NBC.

For many of his films, Hitchcock used locations throughout San Francisco as the backdrop for the scenes. Hitchcock said that he first fell in love with the Bay Area in 1939 while he was filming Daphne du Maurier's *Rebecca* in Monterey County. Later, he bought a ranch and vineyard in Scotts Valley, which is about an hour away from the Bay Area. To honor Alfred Hitchcock and his love of the area, San Francisco offers a walking tour where you can see the hotels, clubs, retail stores, and other locations that the famous director featured in *Vertigo* as well as other locations used in Hitchcock classics.

Of course, Alfred Hitchcock wasn't the first director to use San Francisco as a location

for movies. As a matter of fact, the Golden City was the setting for hundreds of films dating back to the silent era in the 1890s. These films starred such legends as Charlie Chaplin, Buster Keaton, Mary Pickford, Lon Chaney and Rudolph Valentino. San Francisco City Guides also offers a Silent Film walk that goes through the Barbary Coast, Chinatown, and the Financial District and Union Square areas.

SAN FRANCISCO SILENT FILM FESTIVAL

Shhhh . . . Speaking of silent films, California is also home to the San Francisco Silent Film Festival, which started over 20 years ago and has been a regular showcase of silent-era films. Over the last 20 years, the festival has presented more than 230 rare and classic silent film programs, all with live music performed by the most accomplished composers and musicians in the field. Each year, more than 25,000 people attend and dozens of films are screened.

Website: http://silentfilm.org

Info: The annual Silent Film Festival takes place in June and is presented at San Francisco's landmark movie palace, the Castro Theatre.

Contact: San Francisco Silent Film Festival, 145 Ninth St., Suite 230, San Francisco CA 94103; (415) 777-4908.

THE NILES ESSANAY SILENT FILM MUSEUM

If you still can't get enough of silent films and such greats as Charlie Chaplin and Buster Keaton, then you need to visit The Niles Essanay Silent Film Museum, located in Fremont. Here you will enjoy looking at photographs, posters, books, and artifacts about some of the greatest

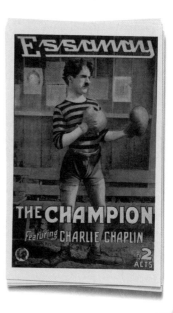

Charlie Chaplin made a total of 14 one- and two-reelers for the Essanay Silent Film Studio in 1915—one in Chicago, five in Niles, and the remainder in Los Angeles.

Website: http://nilesfilmmuseum.org

Info: Museum hours are noon to 4 p.m., Saturday and Sunday only.

Contact: The Niles Essanay Silent Film Museum, 37417 Niles Blvd., Fremont, CA 94536; (510) 494-1411 or (510) 796-1940.

performers and directors of the black and whites and, of course, watch some of the best silent films. They also host events, such as Charlie Chaplin Days, so check their online event calendar before you venture out. The museum hosts movie nights with live piano accompaniment on Saturdays.

But wait, there's more!

Buster Keaton was a silent film actor and comedian, starring in many movies, such as *The Goat* (1921), *The General* (1926) and *Steamboat Bill Jr.,* (1928). He had such a stoic expression about him that he became known as Buster "Stone Face" Keaton. There is a museum dedicated to the work that he's done in Piqua, Kansas. Go to page 187 for more information on this museum.

THE MARY PICKFORD THEATRE

Website: http://dplaceentertainment .com/mary-pickford

Info: The movie theater hosts first-run as well as older movies and occasionally hosts panels that include Q&A with celebrities.

Contact: Mary Pickford Theatre, 36850 Pickfair St., Cathedral City, CA 92234; (760) 328-7100.

This theater opened its doors on May 25, 2001, and was named after the famed silent film actress Mary Pickford. The museum displays several posters of Pickford, "Americas Sweetheart," also known as the "girl with the curls." Way back in the early 1900s, Pickford, D.W. Griffith, Charlie Chaplin, and Douglas Fairbanks formed the independent film production company United Artists. Pickford appeared in many, many movies, including the 1920s film *Pollyanna, Little Lord Fauntleroy* (1921), *Rosita* (1923), and *My Best Girl* (1927).

The theater was operated by North American Cinemas, then SR Entertainment until 2011 when Ultrastar Cinemas took over. In 2016 it changed hands again and has been operated by D'Place Entertainment.

FESS PARKER

Fess Parker was best known for his portrayal of Davy Crockett in a TV miniseries (1955–1956) as well as Daniel Boone in a television series that ran from 1964 to 1970. He also appeared in *The Great Locomotive Chase* (1956) *Westward Ho, the Wagons!* (1956), *Old Yeller* (1957), and *The Light in the Forest* (1958). He also starred in the TV show *Mr. Smith Goes to Washington* (1962).

After his career was over, Parker turned his attention to being a winemaker and resort owner-operator. Fess Parker Winery & Vineyard is located in Los Olivos, California. Parker bought a 714-acre ranch back in 1988, and in 1989, he asked his children to join him and they planted a five-acre experimental Riesling vineyard in 1989. Today, the winery and tasting room has a grand stone fireplace, stone floors, and a wraparound veranda with picnic tables. There is plenty of land for outdoor events and, indoors, fans of Parker's can see memorabilia of his days as Davy Crockett and Daniel Boone.

Website: www.fessparker.com

Info: There is an annual SummerFess, as well as other tasting events, a wine club, and more, so check the website's calendar for things to do. There is also a gift shop where, of course, you can buy your own coonskin cap.

Contact: Fess Parker Winery & Vineyard, 6200 Foxen Canyon Rd., Los Olivos, CA 93441; (800) 841-1104; (805) 688-1545.

Foodie Fact!

Jon Huertas, who stars on NBC's hit-drama *This Is Us*, owns Clutch, a Cali-Mex restaurant in Venice, California. It features barbecue, surf and turf, and craft cocktails.

WEBSITE: www.clutchcalimex.com

INFO: The restaurant is open Monday 11:30 a.m. to 10 p.m., Tuesday through Thursday 11:30 a.m. to 11 p.m., Friday 11:30 a.m. to midnight, Saturday 10:30 a.m. to midnight, and Sunday 10:30 a.m. to 10 p.m.

CONTACT: Clutch, 427 Lincoln Blvd., Venice, CA 90291; (310) 396-8749.

Foodie Fact! *Top Gun* Restaurant

It was 1986 when, in downtown San Diego, a big movie put a small restaurant on the map. Kansas City Barbeque became the set for the final scene in the movie *Top Gun*, which starred Tom Cruise, Kelly McGillis, and Anthony Edwards. In this scene where Maverick (played by Cruise) and Charlie (McGillis) reunite, "You've Lost That Lovin' Feelin'" is playing on the jukebox and Carole, played by Meg Ryan, utters those famous words, "Take me to bed or lose me forever."

Kansas City Barbeque is a working restaurant where you can enjoy a meal and even purchase a *Top Gun* souvenir tank top, T-shirt, or hat. The restaurant also has *Top Gun* memorabilia and the original piano that was used in the movie.

WEBSITE: http://kcbbq.net

INFO: The restaurant is open for lunch 11 a.m. to 5 p.m. and dinner 5 p.m. to 1 a.m. The bar is open 11 a.m. to 2 a.m.

CONTACT: Kansas City Barbeque, 600 W Harbor Dr., San Diego, CA 92101; (619) 231-9680.

THE WILLIAM S. HART PARK AND MUSEUM

William S. Hart was 50 years old when he switched from stage acting to film acting, and he proved that it's never too late to make a change. He became one of the most successful silent film actors in the world. It was his role as the lead in *The Bargain* (1914), a western silent film, that put him on the Hollywood

Website: www.hartmuseum.org

Info: There is no cost of admission to the William S. Hart Park and Museum. The Hart Museum Ranch House is self-guided only and maintains the same hours as the Hart Museum Mansion. Visit the website or call for hours–they change seasonally.

Contact: William S. Hart Park, 24151 Newhall Ave., Newhall, CA 91321; Museum Information: (661) 254-4584; Park Information: (661) 259-0855.

map. Hart ultimately produced a series of hit western movies in the early 1900s.

Located in the William S. Hart Park, the museum that honors the man was, at one time, the Spanish Colonial Revival style mansion that he retired in. It includes early mementos of Hart's Hollywood career and many of his personal furnishings and effects. You can also visit Hart's ranch house that includes a collection of farm animals, a herd of American bison, a series of hiking trails, and a Western-themed gift store.

*M*A*S*H*

*M*A*S*H* follows a team of doctors and nurses—the 4077 Mobile Army Surgical Hospital—in South Korea during the Korean War. Developed by Larry Gelbart for CBS, *M*A*S*H* ran from 1972 to 1983 and was one of the highest-rated shows in US television history (the last episode, "Goodbye, Farewell and Amen," drew a total audience of 121.6 million). The show starred Alan Alda, Loretta Swit, Harry Morgan, Gary Burghoff, William Christopher, and an entire cast of characters.

Statue Alert! Bob Hope

Here's your chance to say "Thanks for the memories!" to the legendary Bob Hope, a comedian, vaudevillian, actor, singer, dancer, athlete, and author. There is a statue dedicated to Hope at the USS Midway Museum at Seaport Village in downtown San Diego.

Bob Hope appeared in over 70 feature films and short films, including a series of "Road" movies with Bing Crosby and Dorothy Lamour, including *Road to Singapore* (1940), *Road to Zanzibar* (1941), *Road to Morocco* (1942), and *Road to Rio* (1947). For years, he also entertained the troops.

WEBSITE: www.midway.org

INFO: Cost of admission: adults (18+), $20; seniors (62+), $17; students (13–17 or with college ID), $15; retired military (with valid ID), $10; youth (ages 6–12), $10; children (under 5), free. The museum is open daily 10 a.m. to 5 p.m.

CONTACT: USS Midway Museum, 910 N Harbor Dr., San Diego, CA 92101; (619) 544-9600.

Website: www.malibucreekstatepark.org/MASH.html

Info: There is no fee to enter the park or see the *M*A*S*H* set.

Contact: Malibu Creek State Park, 1925 Las Virgenes Rd. (at Mulholland Hwy.); Cornell, CA 91301; (818) 880-0367.

Malibu Creek State Park in Cornell, which was once the film location ranch of 20th Century Fox, was the set for the outdoor scenes in *M*A*S*H*. It is a beautiful, 8,000-acre site with 15 miles of streamside trails and abundant wildlife, but more importantly, it became the set for the exterior scenes of the show. Watch the opening of the show for a great shot of the mountains when Radar is looking at an incoming helicopter that's carrying casualties.

When you arrive, the park will provide a map to the *M*A*S*H* area, or you can download it from their website. You can sit right where the mess tent used to be and take a photo in one of the Army trucks that was left behind by the studio.

Foodie Fact!

There's a restaurant in Fort Bragg, California, called Egghead's, a little hole-in-the-wall where almost everything on the menu has a *Wizard of Oz* theme. Try the Cowardly Lion breakfast platter or the Flying Monkeys potatoes, the Cyclone Special, the Wicked Witch burger, Elphaba's soup, Auntie Em's griddle cakes, and more. There is also a small museum with memorabilia from the movie as well.

WEBSITE: They do not have a website, but you can find them on Facebook: @eggheadsrestaurant.

INFO: They are only open daily 7 a.m. to 2 p.m. so plan accordingly.

CONTACT: 326 N Main St., Fort Bragg, CA 95437; (707) 964-5005.

★ LISA'S PICK ★
THE WALT DISNEY FAMILY MUSEUM

I love Disney—the movies, the cartoons, the parks, the . . . well, pretty much anything. So when I visited San Francisco, I knew that had to visit The Walt Disney Family Museum. I already had some knowledge of Walt Disney's background and how he created his company, but I wanted to see the memorabilia up close, as well as the notes, sketches, and contracts that were signed by the man himself.

Between 1931 and 1968, Walt Disney won 32 Academy Awards and still holds the record for most individual Academy Awards won. He was presented with two Golden Globe Special Achievement Awards and one Emmy Award, among other honors. One Oscar was given especially for *Snow White and The Seven Dwarfs* (1937). It's adorable that there were seven miniature Oscars made in honor of the dwarves.

The Walt Disney Family Museum hosts various permanent and rotating exhibits, so check the calendar before you go. When I was there, there was an Art of Pinocchio exhibit that included movie stills, notes, sketches and other memorabilia from the movie. It's not even my favorite Disney movie, but I absolutely loved this exhibit.

Here's something cool to know: if you have a teen who loves animation and wants to be the next Walt Disney, the museum offers teen animation programs and a Teen Animation Festival International, afternoon workshops, summer camps, and volunteer opportunities. What a place to learn!

One thing: There isn't much at the museum on Minnie Mouse. That made me sad. Speaking of sad, there is an entire

Website: http://waltdisney.org

Info: Cost of admission ranges from $15 for ages 6 to 17 up to $25 for adults. The museum is open 10 a.m. to 6 p.m. daily. They are closed on Tuesday as well as on January 1, Thanksgiving Day, and December 25. There is a senior discount, and kids under 5 are free. Admission is free year-round for active and retired military, their spouses, and dependents with valid ID. The museum also participates in the Blue Star Families program, which grants all active military free admission for themselves plus five additional guests (six people total) between Memorial Day and Labor Day.

Contact: The Walt Disney Family Museum, 104 Montgomery St. in the Presidio, San Francisco, CA 94129; (415) 345-6800.

wall of drawings from when Walt Disney died on December 15, 1966. If you read everything and learn about his life, you'll definitely shed a few tears about his death.

PEANUTS: CHARLES M. SCHULZ MUSEUM AND RESEARCH CENTER

Charles M. Schulz once said, "All you need is love. But a little chocolate now and then doesn't hurt." Traveling to the Charles M. Schulz Museum and Research Center in Santa Rosa to learn about the artist and his adorable Peanuts characters doesn't hurt either. Snoopy, Charlie Brown, Lucy, and all of their friends have been entertaining audiences since their creator, Charles M. Schulz, started drawing them. They first appeared in newspaper comic strips on October 2, 1950, and then made their television debut in the show *A Boy Named Charlie Brown* in 1969. Now it's hard to imagine any holiday without them on television in such classics as *A Charlie Brown Christmas* (1965), or *It's The Great Pumpkin Charlie Brown* (1966).

Website: https://schulzmuseum.org

Info: Cost of admission: $12 for adults, $8 seniors (62 and over with ID), $5 for youth/students (4–18 or with valid student ID), and free for museum members and youth 3 and under. The museum has different hours for fall and summer, so check their website.

Contact: Charles M. Schulz Museum and Research Center, 2301 Hardies Ln. in Santa Rosa, CA 95403; (707) 579-4452.

Did you know?
There is also a Snoopy Museum in Tokyo, Japan (for more information, check out www.snoopymuseum.tokyo). Hong Kong also has a Charlie Brown Café (www.charliebrowncafe.com).

The Charles M. Schulz Museum and Research Center honors the man who created these legendary characters that we've come to know and love. After Schulz passed away in 2000, his widow, Jean, created this museum to pay tribute to such an extraordinarily talented man. Before you even enter the front doors, you can say hello to a life-size Charlie Brown statue out front—get that selfie!—and then inside the museum you will see a re-creation of Schulz's working area with his drawing board, desk, and other memorabilia. There are permanent and temporary exhibits and, depending on when you visit, there may be other surprises as well.

PARAMOUNT RANCH

There's quite a filmmaking history on the Paramount Ranch, which is now part of the National Park Service's Santa Monica Mountains National Recreation Area. Located in Agoura Hills, Paramount Pictures first leased the ranch back in the early 1920s. From then, many films were produced, including *Ebb Tide* (1937) and Bob Hope's *Caught in the Draft* (1941) among others. Paramount Ranch became the setting for many westerns as well, until it was sold. William Hertz bought part of it in 1953, but sold it in again 1955. The Paramount Racetrack was opened on the site, and you can still see part of the track throughout the park.

Website: www.nps.gov/samo/plan yourvisit/paramountranch.htm

Info: There is no entrance fee for National Park Service sites in Santa Monica Mountains National Recreation Area, but there are fees for camping.

Contact: Paramount Ranch, 2903 Cornell Rd., Agoura Hills, CA, 91301; (805) 370-2301.

Many films and television shows, such as *The Mentalist, Dr. Quinn, Medicine Woman,* and *Weeds,* have used the ranch's Western Town, a real-life motion picture set. You can stand where some of the great actors have filmed scenes and, as part of the National Park Service, you can also go hiking, picnicking, mountain biking, and horseback riding while you are there.

LA LA LAND

The Griffith Park Observatory was a key location in a scene from one of the most popular movies released in 2016. There are few musical motion pictures produced these days, so when *La La Land* hit the screen, it took the world by storm. The romantic movie was visually stunning and had the feel of a bygone era. *La La Land* stars Ryan Gosling and Emma Stone as Sebastian and Mia, a musician and an actress who have big dreams when they arrive in Tinseltown. If you're a fan of this amazing musical movie, there are a few places where you can stand right where the stars stood in pivotal scenes. Now I know I said I wouldn't include places where you can just stand where a particular scene was shot, but when you see the view, especially at night, you'll understand why I included this one. Gaze out at the stars at the planetarium just like Sebastian and Mia did.

Foodie Fact!

Ryan Gosling, the costar of *La La Land*, is also part owner of Tagine, a Moroccan restaurant located in Beverly Hills. But if you're expecting to see the talented actor in the restaurant, you'll be disappointed. While he has an interest in his venture, he doesn't make appearances that often, but who knows, maybe you will be one of the lucky ones who has her "meet-cute" on the one day that he decides to show up. (A meet-cute is a way of introducing two characters in a movie in mostly an awkward and uncomfortable way.)

WEBSITE: www.taginebeverlyhills.com

INFO: The restaurant is open Monday through Sunday 6 p.m. to 10:30 p.m.

CONTACT: Tagine, 132 N. Robertson Blvd., Beverly Hills, CA; (310) 360-7535.

Then, when you're done, it's time to listen to some jazz, so go where Sebastian brought Mia and that's to The Lighthouse Café

Website: www.griffithobservatory.org; www.smokehouse1946.com; http://thelighthousecafe.net

Contact: Griffith Park Observatory, 2800 E Observatory Rd., Los Angeles, CA 90027; (213) 473-0800. The Smoke House, 4420 West Lakeside Dr., Burbank, CA 91505; (818) 845-3731. The Lighthouse Café, 30 Pier Ave., Hermosa Beach, CA 90254; (310) 376-9833.

Did you know?

Speaking of the Griffith Park Observatory: it is one of the best (and most legal) locations to get a long-distance view of the iconic Hollywood sign. Want to see the famous Hollywood sign? Of course you do, but don't get too close! It's actually illegal to get too close to the sign, which is located behind a gate, with security cameras and park rangers protecting it at all times. If you're looking for more of the best sites to take a photo of the sign that was built in 1923, visit the sign's website for some suggested places. It suggests taking a snapshot from the hiking trails of the Santa Monica Mountains.

Website: www.hollywoodsign.com

Info: Located at Mount Lee.

Contact: Griffith Park, Los Angeles, CA 90068; (323) 258-4338.

in Hermosa Beach, the actual club that was used in the movie. Make sure to also visit The Smoke House restaurant too, which goes by the name Lipton's in the film.

TELEVISION HALL OF FAME AT THE ACADEMY OF TELEVISION ARTS AND SCIENCES

The Television Hall of Fame's plaza is a selfie lover's paradise, where you can take photos with the busts of those who have been inducted into their Hall of Fame. There are no tours of the academy's offices, but the outdoor plaza is a must-see if you're in the area. The academy is located at the intersection of Lankershim and Magnolia, right in the heart of the NoHo Arts District which is also full of theaters, restaurants, art galleries, and coffeehouses. The

> **Website:** http://emmys.com
>
> **Contact:** Television Academy, 5220 Lankershim Blvd., North Hollywood, CA 91601; (818) 754-2800.

photo ops include the giant 18-foot Emmy statues. The busts, which are on pedestals, are of such legendary greats as Lucille Ball (Lucy on *I Love Lucy*) and Desi Arnaz (Ricky on *I Love Lucy*), as well as Jean Stapleton (Edith, *All in the Family*) and Carroll O'Connor (Archie, *All in the Family*).

Cheese! Snapping a photo with your favorite performer is encouraged at the Academy of Television Arts and Sciences. Here is a list of busts and full-size statues that are waiting for you outside:

Alan Alda
Desi Arnaz (full-size statue)
Beatrice Arthur
Lucille Ball (full-size statue)
Bob Barker
Jack Benny (full-size statue)
Milton Berle
Carol Burnett
Sid Caesar
Art Carney
Diahann Carroll
Johnny Carson
Dick Clark
Perry Como

Tim Conway
Walt Disney
Phil Donahue
Philo T. Farnsworth
William Frawley
James Garner
Jackie Gleason
Merv Griffin
Andy Griffith
Bob Hope
Ron Howard
Harvey Korman
Ernie Kovacs
Michael Landon

Angela Lansbury	Dinah Shore
Norman Lear	Red Skelton
Chuck Lorre	Jean Stapleton (full-size statue)
Mary Tyler Moore	Ed Sullivan
Bob Newhart	Danny Thomas
Carroll O'Connor (full-size statue)	Dick Van Dyke
	Vivian Vance
Carl Reiner	Betty White
William Shatner	Oprah Winfrey

There are also plaques honoring other entertainment professionals including writer/producer Steven Bochco, Garry Marshall, and many more.

THE PALEY CENTER FOR MEDIA

You might remember the Paley Center for Media under its other names: the Museum of Television & Radio (MT&R) and the Museum of Broadcasting. Founded by William S. Paley, who built up CBS Television, the Paley Center for Media has locations in both New York and Los Angeles, so check out both event calendars before you travel to either. Film and television lovers will enjoy the panels that the center hosts. They bring some of the leading experts in the entertainment industry to talk about the important issues surrounding the future of film, television, and radio. Every year, the Los Angeles location also hosts the PaleyFest, which lets fans to see some of their favorite stars live onstage, from such shows as *Grey's Anatomy, How to Get Away with Murder, Walking Dead, This Is Us,* and more.

Website: https://media.paleycenter.org

Info: Admission to the Paley Center is free and includes 1½ hours of accessing the Paley Archive in the library. However, there is a suggested contribution of $10 for adults, $8 for students and senior citizens, $5 for children under 14; Paley Center members are free. The Paley Center in Los Angeles is open Wednesday to Sunday noon to 5:00 p.m.

Contact: The Paley Center in Los Angeles, 465 North Beverly Dr. (S. Santa Monica Blvd.), Beverly Hills, CA 90210; (310) 786-1000.

THE HOLLYWOOD MUSEUM

Where do you begin at a museum that has more than 10,000 pieces of showbiz memorabilia, from Marilyn Monroe's million dollar dress and Elvis Presley's robe to Rocky's boxing gloves and so much more? You begin at the front door and don't end until you've seen every costume, prop, script, car, and other piece of memorabilia that's inside this museum.

Do you enjoy horror movies? The Hollywood Museum hasn't forgotten about you. Go downstairs—of course—to see Hannibal Lecter's jail cell from *Silence of the Lambs*, Boris Karloff's mummy, Vampira, and Frankenstein and his bride, Elvira—Mistress of the Dark.

Website: http://thehollywood museum.com. The Hollywood Walk of Fame website is www.walkoffame.com.

Info: Cost of admission to the museum: $15 for adults, $12 for students and seniors, and $5 for children ages 5 and under. There is no cost to walk the Hollywood Walk of Fame. The museum is open Wednesday through Sunday 10 a.m. to 5 p.m.

Contact: The Hollywood Museum, 1660 N. Highland Ave., Hollywood, CA 90028 at Hollywood Blvd.; (323) 464-7776.

The Hollywood Museum is also where you will find the Hollywood Walk of Fame (caution: this is not the same as the Grauman's Chinese Theatre Forecourt of Stars—more on that below). The Walk honors the legends of Hollywood, such as Julie Andrews, Jack Lemmon, Fred Astaire, Dennis Quaid, and more. Approximately two stars are added per month.

The Hollywood Museum is located in the old Max Factor Building, which is historic, but who's Max Factor? Max Factor was a Polish-Jewish cosmetician from Poland who was responsible for the looks of such movie starlets as Judy Garland, Mae West, Marilyn Monroe and other back in the days.

GRAUMAN'S CHINESE THEATRE

Put your hands in the handprints and your feet into the footprints that are located outside the Grauman's Chinese Theatre in their Forecourt of the Stars, and see how you measure up against your favorite celebs. Are your hands bigger than those of Tom Hanks? How about compared to *Star Wars'* Darth Vader? Would your feet fit into the boots of John "The Duke" Wayne? There are so many imprints from your favorite celebrities, including Frank

Website: www.tclchinesetheatres .com

Info: Tickets for the 30-minute walking tours are $16 for adults, $13.50 for seniors, and $8 for children. An IMAX movie ticket will cost you between $19 and $21.75 for a nighttime showing, while non-IMAX matinees may be cheaper. You can reserve your seating for select showings by purchasing your tickets online too.

Contact: TCL Chinese Theatre, 6925 Hollywood Blvd., Hollywood, CA 90028; (323) 461-3331.

Sinatra, Charlton Heston, Gene Kelly, Debbie Reynolds, Abbott & Costello, Nicolas Cage, Richard Gere, Denzel Washington, Whoopi Goldberg, Arnold Schwarzenegger, Meryl Streep, and the list goes on. You can spend a lot of time comparing yourself to every one of them.

The theater isn't just about the Forecourt though. Grauman's Chinese Theatre opened in Hollywood on May 18, 1927, when it hosted the premiere of Cecil B. DeMille's *The King of Kings*. The next day it opened to the public. In 1968, it was listed as a historic-cultural landmark, and it has since become one of the most popular destinations for Hollywood to host red carpet film premieres. If you're lucky, you might visit on one of these special days and see A-listers lining the street outside.

There are walking tours of the theater itself, where you can learn about its history and hear stories and fun facts about what goes on here. You can also just buy a ticket to see one of today's feature films.

Today, the theater is known as the TCL Chinese Theatre. On January 11, 2013, Grauman's partnered with one of China's biggest electronics manufacturers, TCL, aka "The Creative Life," in a 10-year naming rights partnership.

HELLO KITTY
written by Jenny Stradling, Owner of fan site HelloKittyCulture.com

Hello Kitty has been around since 1974, including as the star of multiple television shows, so she's a beloved character across multiple generations. And she's not just for little girls anymore. Nowadays, grown-ups aren't ashamed to admit that they're still fans of the characters they grew up with, so the fandom hasn't died down . . . it's intensified. In addition to the usual child-centered products, you can find plenty of products for adults,

like jewelry and designer shoes. Even celebrities like Katy Perry and Lady Gaga have made their Hello Kitty fashion statements.

There are also attractions throughout the world created for Hello Kitty enthusiasts. For those of us here in the United States, these are some places where fans can get their Hello Kitty fix.

You can dine at the Hello Kitty Café in Irvine, California, at the Spectrum Center. They also have a traveling food truck that goes around the country; find out where they'll be stopping next on their Facebook page: www.facebook.com/HelloKittyCafe.

Want a Hello Kitty hotel room? There's a Hello Kitty suite at Maison 140 in Beverly Hills, California.

For offline Hello Kitty shopping, there are several Sanrio stores, mostly around the Los Angeles and San Francisco areas. For online Hello Kitty shopping, visit HelloKittyCulture.com.

MUSEUM OF WESTERN FILM HISTORY

"A fiery horse with the speed of light, a cloud of dust and a hearty "Hi-yo Silver!" The famous masked man, the Lone Ranger, and his faithful Indian companion, Tonto, fought for law and order in the early West on the television show *The Lone Ranger.* The American western drama series aired on ABC from 1949 to 1957 and starred Clayton Moore as the Lone Ranger and Jay Silverheels as Tonto.

The Museum of Western Film History, located about three hours north of Hollywood, honors the legacy of *The Lone Ranger* as well as other western film and television shows. The museum has more than 10,500 square feet of exhibits on singing cowboys and memorabilia and an 85-seat movie theater where you can watch some of the best in Western cinematic films. The museum also hosts an exhibit on the *Lone Ranger* serial, as well as exhibits on Hopalong Cassidy, William Witney, William Wellman and Audie Murphy.

Take note that the museum is located at Mount Whitney where several feature films, such as *Django Unchained* (2012) and the blockbusters *Star Trek* and *Iron Man*, have filmed scenes. The Museum of Western Film History also houses

Website: www.lonepinefilmfestival
.org

Info: Cost of admission: suggested $5 donation to the museum for adults. Children, museum members, and the active military are free.

Contact: The Museum of Western Film History, 701 S. Main St., Lone Pine, CA 93545; (760) 876-9909.

the suit from *Iron Man* that was used exclusively by Robert Downey Jr. and worn when the first *Iron Man* movie was being filmed in Lone Pine. It was used in the opening scenes when Tony Stark gets shot and wounded.

Every Columbus Day, the museum hosts the Lone Pine Film Festival, which honors the heroes and heroines of the silver screen. On the weekends, you can also enjoy a backlot tour where you can see where some of the films were made. A self-guided "Movie Road" tour is also available.

AUTRY MUSEUM OF THE AMERICAN WEST

For 70 years, Gene Autry entertained audiences with his roles in 93 films as well as his 91 episodes of *The Gene Autry Show*. Now add in his many radio appearances and performances in live theater and rodeo. Starting in the early 1930s, he was known as the singing cowboy and one of his most famous songs was "Back in the Saddle Again."

The Autry Museum of the American West, located in Los Angeles, has more than 500,000 pieces of art and artifacts that honor the West, and some of that honors Autry and other famous singing cowboys.

The museum's film collection includes the camera that director Cecil B. DeMille used on the set of *The Squaw Man* (1914), Clayton Moore's costume from *The Lone Ranger* (1949–1961), and the pilot for *Bonanza* (1959–1973). The museum said that it has included almost every iconic cowboy, such as William S. Hart, Bill Pickett, Tom Mix, Roy Rogers, James Arness, John Wayne, and Clint Eastwood. There are some cowgirls represented as well, including Patsy Montana and Betty Hutton. You'll find movie posters and memorabilia representing movies such as *Thelma & Louise* (1991) and *Brokeback Mountain* (2005).

Website: https://theautry.org

Info: The museum is open Tuesday through Sunday 10 a.m. to 4 p.m. and Saturday and Sunday 10 a.m. to 5 p.m. The museum is closed Mondays and a variety of national holidays. Guided tours are offered on weekends.

Contact: The Autry Museum in Griffith Park is located at 4700 Western Heritage Way, Los Angeles, CA 90027-1462; (323) 667-2000.

Did you know?
There is another Gene Autry Museum in Gene Autry, Oklahoma. See Oklahoma's chapter for more information.

Statue Alert! Gene Autry

Singing cowboy Gene Autry was a familiar figure in Palm Springs, California, where he was honored with a statue. You can find it at the Gene Autry Plaza on Ramon Road in Palm Springs.

FRANCIS FORD COPPOLA

It's almost guaranteed that if you love movies, you've seen one, if not several, movies made by five-time Academy Award-winning director Francis Ford Coppola. How about *Apocalypse Now* (1979), *The Godfather* trilogy (starting in 1972), *The Black Stallion* (1979), or *Lost in Translation* (2003)?

Website: www.francisfordcoppola winery.com

Info: The winery is open daily, starting at 11 a.m.

Contact: 300 Via Archimedes, Geyserville, CA 95441; (707) 857-1471.

There isn't a museum, per se, that honors Coppola's life, but you can see some of his memorabilia and enjoy a great glass of wine while you're at it, when you visit the Francis Ford Coppola Winery, located in Geyserville, California. The winery has tasting bars, two restaurants, a full bar, a swimming pool with European-style cabinets, a movie gallery, a performing arts pavilion, and a park area with game tables and bocce courts. It also has a selection of more than 40 wines produced on-site.

So where do Coppola's movies fit in? When you stop by the Francis Ford Coppola Winery, first walk the property. The pavilion, located near the swimming pool on the north side, is inspired by the band shell that was featured in *The Godfather: Part II*. You can also see a vast collection of authentic movie memorabilia on display throughout the property, from props and costumes to awards that Coppola has won throughout his career. You will see the original Tucker automobile from *Tucker: The Man and His Dream* (1988); Don Corleone's desk from *The Godfather* (1972); Academy Award–winning costumes from *Bram Stoker's Dracula* (1992); the neon cocktail glass and bar from movie-musical *One from the Heart* (1982); various props and keepsakes from *Apocalypse Now* (1979); and Oscars won by Coppola for *The Godfather*, *The Godfather: Part II* (1974), and *Patton* (1970).

LAWRENCE WELK MUSEUM

A one and a two and a . . . trip to the Lawrence Welk Resorts Theater in Escondido and you can see a small museum on the entertainer's life and career right in the lobby. Welk was born the sixth of eight children in North Dakota, but he didn't learn to speak English until he was 21 because it was a German-speaking town. He went on to become one of the most beloved television entertainers and hosted his own variety show for 16 years, starting in 1955. It included such favorite acts as the Lennon Sisters, the Champagne Ladies, and the violinist Aladdin.

Website: Welkresorts.com

Info: The theater also hosts musicals and other performances that are open to the public.

Contact: Lawrence Welk Resorts Theater, 8860 Lawrence Welk Dr., Escondido, CA 92026; (888) 802-7469.

Statue Alert! Lawrence Welk

Say it again with me: "A one and a two and a . . ." trip to Escondido's Champagne Boulevard because that's where you'll see a statue of the famous band leader, Lawrence Welk.

CALIFORNIA MUSEUM

Stop by the California Museum, located in Sacramento, California, because, in the words of Forrest Gump, "You never know whatcha gonna get." In addition to the rotating exhibits on California's people and history, there are a variety of

Website: www.californiamuseum.org

Info: Cost of admission: adults (18+), $9; students and seniors (65+) with ID, $7.50; youth (6-17), $6.50; children (5 and under), free. Closed Monday, New Year's Day, July 4, Thanksgiving, and Christmas. Open Tuesday to Saturday 10 a.m. to 5 p.m., Sunday noon to 5 p.m.

Contact: California Museum, 1020 O St., Sacramento, CA 95814; (916) 653-7524.

Foodie Fact! Clint Eastwood's Mission Ranch

Go ahead and make your day—or better yet, make it a few days—at the Mission Ranch in Carmel, California. The history of this ranch is unique. It was once owned by Native American Juan Romero, who then deeded the property to William Curtis, a Monterey storekeeper. It became a creamery at one point and went through a whopping 17 owners before the property was divided up and sold. That's when legendary actor Clint Eastwood, the man known for his roles in *Dirty Harry* (1971), *Million Dollar Baby* (2004), and *Gran Torino* (2008), came to the rescue. He bought the ranch in 1986, before it would be sold as a condominium development. Eastwood renovated the ranch, and it is said that he designed each structure on the property to reflect a different architectural period: from the 1840s feel of the restaurant and dance barn to the century old Martin Farmhouse and Bunkhouse. You can enjoy a romantic getaway or a meal at The Restaurant at Mission Ranch, a spectacular spot to dine on the Monterey Peninsula. You probably won't see Clint Eastwood here, but you can see a special place that he had a hand in creating.

WEBSITE: www.missionranchcarmel.com

CONTACT: Mission Ranch, 26270 Dolores St., Carmel, CA 93923; (831) 624-6436.

entertainment displays as well. The museum has once showcased Harrison Ford's Indiana Jones costume from *Raiders of the Lost Ark* (1981) and George Takei's Hikaru Sulu costume from *Star Trek IV: The Voyage Home* (1986). The California Hall of Fame was established in 2006 by the museum and former First Lady Maria Shriver and honors people who "embody California's innovative spirit and have made their mark on history including in the arts."

SHIRLEY TEMPLE AT THE SANTA MONICA HISTORY MUSEUM

During the 1930s and 1940s, when she was a little girl, Shirley Temple danced and sang her way into the hearts of moviegoers around the world. Known as America's Little Darling, she starred

The Real Griswolds' Vacation

The *National Lampoon's Vacation* movie was released in 1983 and became an instant cult classic. It starred Chevy Chase and Beverly D'Angelo as Clark and Ellen Griswold, who took their children on a road trip from Illinois to Walley World, a California amusement park (it was actually Six Flags Magic Mountain in disguise). So much goes wrong along the way, including Clark's fascination with a blonde in a red Ferrari.

A real Griswold family took the same vacation but, thankfully, the trip wasn't as problematic.

Steve and Lisa Griswold—yes, that's their real name—took their children on a spectacular road trip, recreating the *National Lampoon's Vacation* movie. They traveled across America on Route 66.

"The trek was 10 days from Atlanta, Georgia, to Walley World in California," said Steve, who is a travel agent and owns Pixie Vacations.

The Griswolds took their road trip in a 1984 station wagon that they called, "The Wagon Queen Family Truckster," just like the Griswold family did in the movie. The car is an exact replica of the car in the movie.

"We stopped at the Grand Canyon, participated in the 72-ounce steak eating challenge at the Big Texan, and rode Colossus at Six Flags right before it was scheduled to be closed for good," said Steve. "Colossus is the wooden roller coaster in the *Vacation* movie." The couple documented their trip on their blog.

WEBSITE: http://griswoldfamilyvacations.com

in many movies during the Depression era, including *Bright Eyes* (1934) where she sang her famous "On the Good Ship Lollipop." She also starred in *The Little Princess* (1939), *Baby, Take a*

Website: https://santamonicahistory.org

Info: Cost of admission: general, $10; couple (two adults), $15; seniors & students, $5; children under 12 and museum members, free. The museum is open on Tuesday and Thursday noon to 8 p.m., Wednesday, Friday, and Saturday 10 a.m. to 5 p.m.

Contact: Santa Monica History Museum, 1350 7th St., Santa Monica, CA 90401; (310) 395-2290.

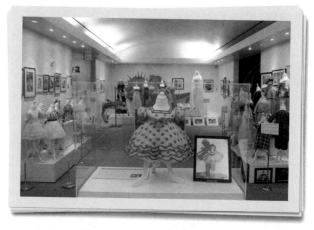

Shirley Temple's famous dress, and other memorabilia from her movie career, can be seen at the Santa Monica History Museum.

Bow (1934), *Fort Apache* (1948), *Mr. Belvedere Goes to College* (1949), and many more.

The curly-haired cutie was born in Santa Monica, California, which makes the Santa Monica History Museum the perfect location to see memorabilia from her incredible career. Due to preservation concerns, the Santa Monica History Museum's permanent display of Shirley Temple items rotates, but usually includes one film costume, one item of Shirley's personal clothing, and the antique carousel horse she personally restored to adorn the pool house at her home. The museum presents larger exhibits of Shirley Temple items periodically, but this varies year to year. Check the museum website prior to travel for possible upcoming Shirley Temple exhibits.

Statue Alert! Shirley Temple

"Come and Get Your Happiness" while you take a selfie with a statue of the little girl who made that song famous. The bronze Shirley Temple statue, created by Nijel Binns, is on permanent display on the 20th Century Fox Studios lot at the New Child Development Center which was named after Temple. At the unveiling of the statue, Rupert Murdoch said, "Shirley Temple Black is living proof of the magic of motion pictures, the power of children, and the importance of both."

FOREST LAWN CEMETERY

Last, but definitely not least, to visit in California are the Forest Lawn Cemetery and the Hollywood Forever Cemetery. If cemeteries do not give you the heebie-jeebies and you do not think that seeing where your favorite celebrities are buried is creepy, then you must visit Forest Lawn Cemetery. However, don't expect anyone at the cemetery to help you out

Website: http://forestlawn.com/visitors-guide

Contact: Forest Lawn Cemetery, 1712 S. Glendale Ave., Glendale, CA 91205; (888) 204-3131.

to find your Hollywood star's gravestone. You are really on your own, and since there are over one million people buried here, your search might take some time. Just enjoy those you do find as you walk through the property and, remember, it is a cemetery not a Hollywood set, so be on your best behavior, especially for others who are grieving.

HOLLYWOOD FOREVER CEMETERY

At Hollywood Forever, you can find the final resting places of Cecil B. DeMille, Johnny Ramone, Rudolph Valentino, Judy Garland, Eleanor Powell, Estelle Getty, and a marker for *The Wizard of Oz*'s Toto. Every summer, there are nighttime cemetery screenings

Website: http://cinespia.org

Info: Cost of admission for the nighttime cemetery screenings is $12 and up.

Contact: The Hollywood Forever Cemetery is located at 6000 Santa Monica Blvd., Los Angeles, CA 90038; (323) 469-1181.

where film fans come to the cemetery and sit under the stars to watch classic movies.

MOVIE STUDIO TOURS

Of course, a film and television lover's trip to California wouldn't be complete without taking one, or more, of the many studio tours. Go behind the scenes of the major motion picture studios and learn all about Hollywood's magic. Ride the rides that put you right in the "action" or at least make you feel like you are part of the movies.

Sony Pictures Studios

Here you'll see soundstages that were used for feature films such as *The Wizard of Oz*, *Men in Black*, and *Spider-Man* and sets that were used for such television shows as *Jeopardy* and *Wheel of Fortune*.

Website: www.sonypicturesstudiostours.com

Info: Cost of admission: $45 per person. Tours run Monday through Friday 9:30 a.m., 10:30 a.m., 1:30 p.m., and 2:30 p.m. Additional tour times are added during peak seasons.

Contact: Sony Pictures Studios, 10202 West Washington Blvd., Culver City, CA 90232; Studio Tours (310) 244-TOUR (8687).

Paramount Studio Tour

Depending on what you sign up for, you can experience up-close tours of studio lots, VIP studio access to Paramount's backlots, or a dark, evening tour of the lots where you can see hidden passageways and alleys.

Website: www.paramountstudiotour.com/studio-tours.html

Info: Prices range from $55 to $178 per person. Tours range from 2 to 4 hours.

Contact: Paramount Studio Tour, 5515 Melrose Ave., Hollywood, CA 90038; (323) 956-5000.

Warner Brothers Studio Tour

One of the many fun items you will see on the Warner Brothers' Stage 48 Studio Tour is the replica of the Central Perk coffee shop from the hit TV show *Friends*. Here you will also be able to buy a cup of Central Perk coffee at the Central Perk café. You will also see soundstages, props, cars, costumes, and more for *Fantastic Beasts and Where to Find Them*, the Harry Potter films, *Batman, Gilmore Girls, The Big Bang Theory, Argo,* and *Friends*. In the DC Universe exhibit, you can look at the No. 1 comic book issues of Superman, Batman, and Wonder Woman.

Website: www.wbstudiotour.com

Info: Cost of admission: In advance adult, $62; child, $52. On-site adult, $65; child, $55.

Contact: Warner Brothers Studio Tour, 3400 W Riverside Dr., Burbank, CA, 91505; (877) 492-8687.

Universal Studios Tour

The Studio Tour at Universal Studios is part of your Universal Studios theme park admission, but it's worth taking when you walk through those doors. You will see Wisteria Lane from ABC's *Desperate Housewives* and Norman Bates at the legendary Bates Motel from the television show *Psycho*. It's a fun day that makes you feel like you're in the productions.

Website: www.universalstudioshollywood.com

Info: Cost of admission: one day general admission ranges $105–$116, but other ticket packages are available.

Contact: 100 Universal City Plaza, Universal City, CA; (407) 363-8000.

OTHER THINGS TO SEE OR DO IN CALIFORNIA

If there hasn't already been enough in California, here's more to see and do:

POTTERCON: It doesn't matter if you're a Gryffindor or a Slytherin, if you even know what that means you're a Harry Potter fan. And if you're a fan of the Harry Potter books or movies, there are many filming locations that every fan could visit, but unfortunately they are all overseas. The closest you'll get in the United States is Universal Studios and Warner Brothers tours. However, if you want to enjoy a convention with other adults who enjoy Harry and the gang, don't miss PotterCon, a convention where PotterCons in New York City; Los Angeles; Washington, DC; and other locations get together for witchcraft, wizardry, and fun, including a Potter party. For more information, visit www.potterconusa.com.

NOHO ARTS DISTRICT: If you're visiting the Television Academy, make sure you spend some time in the NoHo Arts District, a one-square mile community where you can see professional theater, dance studios, art galleries, acting workshops, dining options, and more. For more information, visit http://nohoartsdistrict.com.

CINEFAMILY: If you're going to be in the Los Angeles area, check out the Cinefamily website and see what events they have going on. You can see premieres of movies and silent features at their

now-owned Silent Movie Theatre, as well as celebrity-attended panels and so much more.

Website: www.cinefamily.org

Info: Their box office opens one hour before the day's first showtime. Doors open 30 minutes before showtime.

Contact: Cinefamily, 611 N Fairfax Ave., Los Angeles, CA 90036; (323) 655-2510.

NEW BEVERLY CINEMA: Oscar-winning filmmaker Quentin Tarantino was once a benefactor of this cinema and is now its owner. When he took over, Tarantino, who is known for *Pulp Fiction* (1994), *Natural Born Killers* (1994), and other movies, decided that he wanted to have this theater solely project 35 mm film prints. For the film buff it's a great opportunity to step back in time and see movies like *The Untouchables* (1987) the way they were played in the good 'ol days.

Website: http://thenewbev.com

Info: Cost of admission for most movies is $8.

Contact: New Beverly Cinema, 7165 Beverly Blvd., Los Angeles, CA 90036; (323) 938-4038.

REDWOOD NATIONAL PARK: If you have the time, hop a short flight or take a long drive to Northern California and spend your travels exploring Redwood National Park, located between Crescent City and Orick, California. After the redwoods were chopped down, three state parks were formed to help protect them in the 1920s and, in 1968, Congress created the Redwood National Forest. Take time away from the hustle and bustle of Hollywood and look at some of the tallest trees in the world.

Website: www.nps.gov/redw/index.htm

Info: Redwood National and State Parks are always open. Visitor center hours vary, so check the website.

Contact: Redwood National Park, 1111 Second St., Crescent City, CA 95531; (707) 465-7335.

MUSEUM OF DEATH: Can't get enough of the detective work and murders on your favorite crime shows, such as *NCIS, Law & Order, Blue Bloods,* or *CSI*? Then you have to visit the Museum of Death, a strange art-gallery-turned-museum in Hollywood, which features gruesome exhibits, such as guillotined heads, crime scene photos, autopsy instruments, and serial killer artwork. If you can stomach it, you'll learn more about death than you've ever learned before.

Website: www.museumofdeath.net

Info: Cost of admission to the Hollywood museum is $15. There is another museum location in New Orleans, Louisiana. Museum hours are Sunday through Thursday 11 a.m. to 8 p.m.; Friday 11 a.m. to 9 p.m., and Saturday 11 a.m. to 10 p.m.

Contact: Museum of Death in Hollywood, 6031 Hollywood Blvd., Hollywood, CA 90028; (323) 466-8011.

THE LAST BOOKSTORE: I love books just about as much as I love television and movies, so I have to give a shoutout to this Los Angeles–based independent bookstore, The Last Bookstore, and urge you to visit it on your West Coast travels. The Last Bookstore is California's largest independent bookstore and houses over 250,000 new and used books, as well as graphic novels, vinyl records, a yarn shop, and art gallery. Don't worry, it won't bust your budget. You can check out the area which has books for only $1 each.

Website: http://lastbookstorela.com

Info: The bookstore's hours are Monday through Thursday 10 a.m. to 10 p.m., Friday and Saturday 10 a.m. to 11 p.m., and Sunday 10 a.m. to 9 p.m.

Contact: The Last Bookstore, 453 S Spring St., Los Angeles, CA 90013; (213) 488-0599.

COLORADO

With its deserts, canyons, and mountains, Colorado is a director's dream location to shoot their next movie. So many directors can already lay claim to having shot scenes here, starting with Charlie Chaplin's 1925 film *The Gold Rush*. Some of the other films that have used Colorado as a backdrop include Quentin Tarantino's *The Hateful Eight* (2015), which was filmed in Telluride; *Identity Thief* (2013); *Catch and Release* (2006); *Mr. & Mrs. Smith* (2005); *About Schmidt* (2002); *Independence Day* (1996); and *City Slickers* (1991).

DENNIS WEAVER MEMORIAL PARK

Television fans will remember actor Dennis Weaver as Chester Good in *Gunsmoke* and as Sam McCloud in *McCloud* and film lovers will know him from his 40 movie appearances, but Weaver hoped that he would also be remembered more for his love of the environment and his work as a humanitarian. That's easy to do when you stop and see the 60-acre Dennis Weaver Memorial

Foodie Fact! True Grit Café

True Grit was a 1969 American western film that starred John "The Duke" Wayne as US Marshal Rooster Cogburn. John Wayne won his only Academy Award for this role. Filming for the movie took place in Ouray County, Colorado, which is now the location of the True Grit Café, which has been open since 1985 and serves what they call the "Cowboy Cuisine." The True Grit Café was built to honor the movie and has a lot of photos of The Duke and his legacy.

WEBSITE: www.truegritcafe.com

INFO: Open every day except Thanksgiving and Christmas. Summer hours are 11 a.m. to 10 p.m.; fall hours are 11 a.m. to 9:30 p.m.; winter hours are 11 a.m. to 8:30 p.m.; spring hours are 11 a.m. to 9 p.m.

CONTACT: True Grit Café, 123 N Lena St., Ridgway, CO 81432; (970) 626-5739.

Park, located in Ridgway, Colorado. Here you can bike and hike on the trails and enjoy the mountain views. There is a poem written by Weaver on a plaque in the park.

THE SHINING'S STANLEY HOTEL

Located in Estes Park, Colorado, this is the actual hotel where horror author Stephen King stayed with his wife Tabitha while they were on vacation. It inspired him to write the novel *The Shining*. The story

Website: www.stanleyhotel.com

Info: Cost of tour admission: standard, $23; hotel guests, $20; seniors, $20; children 17 and under, $17.

Contact: The Stanley Hotel, 333 E Wonderview Ave., Estes Park, CO 80517; (970) 577-4000.

goes that King checked into room 217 back in 1973, so of course the fans of the author and the movie always request this room when they stay there. The book ultimately became a movie that was released in 1980, was directed by Stanley Kubrick and starred Jack Nicholson and Shelley Duvall. The Stanley Hotel offers 90-minute tours of the hotel, where you can see the "spirited hallways and former tunnels." There is also an illusion show with *America's Got Talent*'s Aiden Sinclair.

MOLLY BROWN HOUSE MUSEUM

Before there was James Cameron's blockbuster 1997 movie *Titanic*, which starred Leonardo DiCaprio and Kate Winslet, there was the actual sinking of the real-life ocean liner. On that ship was Molly Brown, who was concerned about the passengers left behind when she was put on a smaller ship and taken away from the sinking boat. Wanting to help those passengers, she was overruled by the boat captain but threatened to throw him overboard. She helped found the Titanic Survivor's Committee and ultimately ran for the Senate. She was a philanthropist and

someone who fought for the lives of others.

The story of *The Unsinkable Molly Brown* became a hit Broadway musical and ultimately a 1964 film of the same name, starring Debbie Reynolds. To learn more about this amazing woman, you can tour Molly Brown's 1889 Victorian house in Denver, Colorado, and learn more about her activism and impact on the world.

Website: www.colorado.com/museums/molly-brown-house-museum

Info: Cost of admission: $11 adult; $9 senior, military, college; $7 child. The museum is open Tuesday through Saturday 10 a.m. to 3:30 p.m. and Sunday noon to 3:30 p.m.

Contact: Molly Brown House Museum, 1340 Pennsylvania St., Denver, CO 80203; (303) 832-4092.

INDIANA JONES BED AND BREAKFAST

This bed and breakfast was featured in Steven Spielberg's movie *Indiana Jones and the Last Crusade* (1989) where young Indiana goes running into his home. Today, you can stay in these Antonito accommodations and enjoy one of the three rooms upstairs or the one downstairs. There is a living room, sitting area, and dining room. There is some movie memorabilia for you to see too.

Website: www.indianajonesbedandbreakfast.com

Info: Room rates begin at $109 per night.

Contact: Indiana Jones Bed and Breakfast, 502 Front St., Antonito, CO 81120; (800) 497-5650.

THE RIO GRANDE SCENIC RAILROAD

If you're an Indiana Jones fan, then you have to take a scenic ride on this steam engine train, located in Alamosa and running into New Mexico. It's the same one that Indiana rides in *Indiana Jones and the Last Crusade* (1989) and has also been featured in *A Million Ways to Die in the West* (2014) and *Wyatt Earp* (1995), among others.

Website: http://cumbrestoltec.com

Info: Cost of admission: adult, $95.75; child, $49.75. There are tourist rates and parlor rates as well.

Contact: Cumbres & Toltec Scenic Railroad; 500 Terrace Ave., Chama, NM 87520; (888) 286-2737.

COLORADO RAILROAD MUSEUM: This museum has nothing to do with Sheldon Cooper and *The Big Bang Theory,* but something tells me that he would really enjoy it (and the Cumbres & Toltec Scenic Railroad). That is because it is a 15-acre railyard that is home to more than 100 historic railcars, as well as exhibits, a library, restoration facility, and turntable. You might learn why Sheldon would do anything to get onto a train. Are your kids fans of the movie *The Polar Express?* Don't miss the Polar Express train ride here in November and December.

Website: http://coloradorailroadmuseum.org

Info: Cost of admission: members and children under 2, free; children 2 to 15, $5; adults (16–59), $10; seniors (60+), $8. Train ride tickets on Ride the Rails: children, $2; adults, $4. The museum is open 9 a.m. to 5 p.m., seven days a week.

Contact: Colorado Railroad Museum, 17155 W. 44th Ave., Golden, CO 80403; (303) 279-4591; (800) 365-6263.

TELLURIDE FILM FESTIVAL: Film buffs heading to Colorado should try and time their visit to the Telluride Film Festival, which has been held over Labor Day weekend for more than 40 years. It's one of the most celebrated film festivals in the movie industry. Here you'll see some of the most talented up-and-coming writers, producers, and directors as well as some of the biggest names in Hollywood; all converge on a weekend of movie-watching.

Website: http://telluridefilmfestival.org

Contact: Telluride Film Festival, 800 Jones St., Berkeley, CA 94710; (510) 665-9494.

WYOMING

Welcome to the big open fields of Wyoming! These mountains and fields make it perfect for Western films and there have been many that have been at least partially filmed here: *The Cowboy and the Lady* (1922), *The Big Trail* (1930) with John Wayne, and *Cheyenne Autumn* (1964). Of course, there was also *Dances with Wolves* (1990) with Kevin Costner.

DEVILS TOWER FROM *CLOSE ENCOUNTERS OF THE THIRD KIND*

Do you believe they are out there? In 1977, director Steven Spielberg made us believe that they are with his sci-fi movie *Close Encounters of the Third Kind*, which starred Richard Dreyfuss (remember him from *American Graffiti*?), François Truffaut, Melinda Dillon, and Teri Garr. Located in Wyoming, the Devils Tower was a major landmark in the movie and a spiritual connection to the American Indian community as it's considered sacred to the Northern Plains Indians and other tribes.

Website: www.nps.gov/deto/index.htm

Info: Cost of admission: vehicle pass, $15; individual permit, $5. Devils Tower National Monument is open 24 hours a day, 7 days a week. The visitor center is open daily, except December 25 and January 1. Operating hours vary seasonally.

Contact: Devils Tower National Monument is accessed by Wyoming Hwy 24; (307) 467-5283 x635.

The film was nominated for eight Oscars including Best Director and Supporting Actress (Melinda Dillon) and picked up the win for cinematography.

HAWAII

Hawaii, with six main islands, beautiful landscape and foliage, dormant volcanoes, beaches with multicolor sands, and its deep history, makes for an amazing filming location. The list of films that have been made here is long and includes *South Pacific* (1958), *50 First Dates* (2004), *Tropic Thunder* (2008), *The Descendants* (2011), *Forgetting Sarah Marshall* (2008), and *Jurassic Park* (1993). Television studios love the islands too and such filmed such shows as *Hawaii Five-O* and *Lost* here.

GILLIGAN'S ISLAND

Sit right back and you'll hear a tale of how Oahu, Hawaii, was the site of the television sitcom *Gilligan's Island,* a CBS show that ran from September 26, 1964, to April 17, 1967. The stars of the show—Bob Denver, Alan Hale Jr., Jim Backus, Natalie Schafer, Russell Johnson, Tina Louise, and Dawn Wells—portrayed seven castaways who were shipwrecked on a deserted island. Thanks to syndication, it seems like *Gilligan's Island* ran for much longer than its 98 episodes and three movies.

Coconut Island off the island of Oahu was used for the opening sequence of *Gilligan's Island* and today there are tour companies that can take you there for an adventure all your own. Don't worry, they'll be there to pick you up and bring you home and you won't suffer the same fate as the castaways. Also, don't expect much more than just seeing the island. There aren't any memorabilia or lingering sets on the island. This really is just an opportunity to say that you've been there, and made it back.

Website: www.shakatourshawaii.com/eco-tours/holokai-kayak-adventure and https://hokuhawaiitours.com/gilligans-island-filmed-oahu

Info: Costs for the kayak tours are $99 to $119 per person, and the tours operate Monday through Saturday.

Contact: Shaka Tours, 2463 Kuhio Ave., Honolulu, HI 96815; (808) 924-4474.

MAGNUM, P.I.

There are also tour companies that can take you on a helicopter ride so you can see the stunning views of Oahu, the same views that were shown on *Magnum, P.I.*, a CBS drama series that aired from 1980 to 1988 and starred the famously mustached Tom Selleck.

Statue Alert! Elvis Presley

The King of Rock and Roll, Elvis Presley, was a hunka hunka burnin' love! While staying in Waikiki on Oahu, "The King" made three movies: *Blue Hawaii* (1961), *Girls! Girls! Girls!* (1962), and *Paradise, Hawaiian Style* (1966). He also traveled to Hawaii frequently for concerts and performances. On January 14, 1973, Elvis performed *Elvis, Aloha from Hawaii*, so it's easy to understand why, on these beautiful islands, you will find a life-size statue of The King at the Neal S. Blaisdell Center & Waikiki Shell.

WEBSITE: www.blaisdellcenter.com

CONTACT: Neal S. Blaisdell Center & Waikiki Shell, 777 Ward Ave., Honolulu, HI; 96814; (808) 768-5400.

DID YOU KNOW?
If you are a big fan of Elvis Presley, then make sure you have his hometown of Graceland, located in Memphis, Tennessee, on your list of must-sees. Head over to the Tennessee section for more information on touring this lavish estate.

OTHER THINGS TO SEE OR DO IN HAWAII

Nobody really needs an excuse to stretch out a vacation in Hawaii, but just in case you'd like a list of more things to see and do, here you go:

VOLCANOES: Get up-close-and-personal with Hawaii's many dormant volcanoes, such as Mauna Kea that stands 4,205 m above sea level on the island of Hawaii, the highest point in the state. There's also the famous Diamond Head Volcano State Landmark in Honolulu as well as also other beautiful sights to behold, including Waimea Canyon, on Kauai's West Side, which

> ### Statue Alert! *Hawaii Five-O*
> "Book 'em, Danno!" If you know what that means, then you should definitely book some time into your Hawaiian vacation to take a selfie with the bust of Detective Steve McGarrett, played by Jack Lord in the CBS hit drama *Hawaii Five-O*. The show ran for a lengthy 12 years, from 1968 to 1980. The statue is in the parking lot outside a Macy's at the Kahala Mall, 4211 Waialae Ave., Honolulu, Oahu, HI.

has been described as "The Grand Canyon of the Pacific," that goes for 14 miles and is 3,600 feet deep.
Website: http://dlnr.hawaii.gov/dsp/parks/oahu/diamond-head-state-monument

PACIFIC AVIATION MUSEUM PEARL HARBOR: Hawaii is filled with a lot of rich history on the islands and, of course, much of it surrounds the attacks on December 7, 1941. The Pacific Aviation Museum is where you can see World War II–era planes, including an actual Japanese Zero and a Stearman N2S-3 once piloted by former American president George H. W. Bush, as well as exhibits and a 12-minute film that details the events. Pearl Harbor still remains an active military base and a National Historic Landmark.
Website: www.pacificaviationmuseum.org
Info: Cost of admission: adult $25; child (ages 4 to 12) $12. The museum is open daily from 8 a.m. to 5 p.m.
Contact: Historic Ford Island, 319 Lexington Blvd., Honolulu, HI 96818; (808) 441-1000.

USS *BOWFIN*: Dubbed the "Pearl Harbor Avenger," the USS *Bowfin*, which is over 10,000 square feet and includes 4,000 submarine-related artifacts, was launched one year to the day after the events of December 7, and it completed nine successful patrols before eventually arriving at Pearl Harbor. Today, the *Bowfin* is a National Historic Landmark and museum ship where visitors can get a firsthand experience on what it was like to work aboard a World War II–era sub.
Website: www.bowfin.org

Info: To tour the submarine and the museum: adults, $12; children (4–12 years), $5. To tour the museum only: adults, $6; children, $3.

Contact: USS *Bowfin,* 11 Arizona Memorial Dr., Honolulu, HI 96818; (808) 423-1341.

UTAH

Utah is home to some of the most breathtaking natural wonders in the United States. For example, Utah's Arches National Park is where you'll see more than 2,000 natural stone arches, including the beautiful red structure, the Delicate Arch. It is also where you can see hundreds of soaring pinnacles and massive fins. Then there's Moab, the "Holey Land," with their red cliffs and mountains, hilly lands, and areas to bike, hike, and raft. Talk about beautiful scenery for making movies and TV shows!

According the Utah Film Commission, more than 900 films have been shot in Utah in more than 70 years, including the westerns *Stagecoach* (1939) with John Wayne, *Billy the Kid* (1941) with Robert Taylor, and *Fort Apache* (1948) with John Wayne and Shirley Temple.

More recently, HBO has filmed its western-sci-fi thriller series *Westworld* in the area. Disney has also filmed many movies in Utah, including *Pirates of the Caribbean: At World's End, The Lone Ranger,* and all three *High School Musical* films.

Utah is also home to one of the most prestigious film festivals in the world—the Sundance Film Festival, which takes places in Park City every year since it was founded in 1978. The entire community is flooded with Hollywood A-listers and up-and-coming writers, directors, and producers for this event.

GUNSMOKE

James Arness played Marshall Matt Dillon on *Gunsmoke,* an extremely popular CBS-TV show that ran for a whopping 20 years, from 1955 to 1975. Many of the outdoor scenes for the television show were filmed in Kanab, Utah. Fans of *Gunsmoke* will enjoy visiting the Johnson Canyon, a replica of the set that is located three miles outside of Kanab. Although it's not something you can tour because it is said to be in a state of disrepair, you can still see it from the road. **Website:** www.visitsouthern utah.com/Gunsmoke-Movie-Set

MOAB MUSEUM OF FILM AND WESTERN HERITAGE

Another popular part of the beautiful state of Utah for filming is Moab, especially near Red Cliffs Ranch. This also makes it the perfect setting for the Moab Museum of Film and Western

Foodie Fact!

Ty Burrell, who plays Phil Dunphy on ABC's hit sitcom *Modern Family*, is owner of The Eating Establishment in Park City, Utah.

WEBSITE: www.theeatingestablishment.net

CONTACT: The Eating Establishment, 317 Main St., Park City, UT 84060; (435) 649-8284.

Heritage, a museum that honors the movies that were filmed here. Those movies include *Geronimo* (1962), *City Slickers* (1991), *Transformers* (2007), and *Thelma & Louise* (1991). Legendary actors John Wayne, Maureen O'Hara, Ben Johnson, Rock Hudson, Henry Fonda, Anthony Quinn, Lee Marvin, Richard Widmark, James Stewart, and Richard Boone have all worked on location here too. The museum is part of Red Cliffs Ranch. See the displays of early cowboy ranching as well as local movie memorabilia.

Website: https://redcliffslodge.com

Info: The museum is self-guided and a complete freebie so take advantage of it.

Contact: Moab Museum of Film and Western Heritage, Milepost 14, Highway 128, Moab, UT 84532; (866) 812-2002.

OTHER THINGS TO SEE OR DO IN UTAH

ARCHES NATIONAL PARK: You can't visit Utah without visiting Arches, home to more than 2,000 stone arches, including Delicate Arch, the most recognized landmark in the park. This beautiful red structure stands 65 feet tall and is freestanding as the sandstone below it has worn away, leaving behind this amazing natural wonder. Then there's Balanced Rock, located next to the park's main road, which stands at 128 feet.

There are more than 250 bird species to see and bird-watching walks and seminars to attend.

Website: www.nps.gov/arch/index.htm

Info: Cost of admission: $10 per person, $25 per vehicle. Youth 15 and under are admitted free. The park is generally open 24 hours a day, with occasional nighttime closures.
Contact: (435) 719-2299.

THE *UP* HOUSE: Do you love that adorable 2009 animated Pixar movie *Up* as much as I do? In Herriman, Utah, there is a replica of the house where Carl lived, right there on Herriman Rose Boulevard. Get your selfie, but don't worry, you won't float away. Please, however, know that it's a private residence now and, while they welcome fans, no trespassing!

EAST

NEW YORK

Before California became the pulse of the film and television industries, New York City was the capital of film production, especially up to 1910. While the Big Apple is typically known as the heart of Broadway musicals, there have been many, many films shot here and television shows created here. Again, we could create a book just on that. The television industry has found New York to be a great home for producing such amazing hits as *Sex and the City, 30 Rock, Saturday Night Live, Law & Order, Seinfeld, Orange Is the New Black,* and *Unbreakable Kimmy Schmidt.*

But keep in mind that New York isn't just Manhattan. There have been movies made throughout the five boroughs and the entire state, and there are many things that film and television buffs can see.

AMERICAN MUSEUM OF NATURAL HISTORY

You can only visit the American Museum of Natural History during the day, not overnight, so if you are a fan of the *Night at the Museum* movies, don't expect to see any dinosaur skeletons roaming about. The popular movie, which was released in 2006, stars Ben Stiller who plays a nighttime security guard at the museum, where he learns that there is an ancient curse that allows the animals and displays to come alive at night. It is worth a visit to the American Museum of Natural History though because there is a *Night at the Museum* self-guided tour where you can see the real exhibits behind the characters featured in the movie, including the capuchin monkey and the enormous mammoth. A highlight of the tour is seeing the Rapa

Website: www.amnh.org

Info: Cost of admission: adults, $22; children (2 to 12), $12.50; seniors/students with ID, $17. The museum is open daily 10 a.m. to 5:45 p.m. except on Thanksgiving and Christmas. The museum also hosts The Margaret Mead Film Festival each October, which screens documentaries that focus on the complexity and diversity of the peoples and cultures on the planet.

Contact: American Museum of Natural History, Central Park West at 79th St., New York, NY 10024; (212) 769-5100.

Nui (Easter Island). You will remember this carving because in the movie it's the one that said, "Hey dumb dumb, you give me gum, gum."

The American Museum of Natural History is home to one of the largest and most expansive museum collections in not only New York City, but the entire world. There are minerals, meteorites, and, yes, you will also get a chance to see the famous Tyrannosaurus rex from the movie. Don't miss the Theodore Roosevelt sculpture, which was made famous by Robin Williams' portrayal of the president in the movie as well.

SEINFELD

Seinfeld, "the show about nothing" ran for nine seasons on NBC, from 1989 to 1998, and there are several locations that fans of the show can visit throughout the Big Apple.

Website: www.tomsrestaurant.net

Info: The restaurant is open 24 hours a day.

Contact: Tom's Restaurant, 2880 Broadway, New York, NY 10025; (212) 864-6137.

Remember Monk's Diner, where the *Seinfeld* friends ate together? The outside of the restaurant is actually Tom's Restaurant and, yes, you can go inside and order a meal.

If you're looking for the famous Soup Nazi, look no further than The Original Soup Man, a chain of soup restaurants run by Ali "Al" Yeganeh, the man behind the character. Don't worry, you won't hear anyone say "No soup for you!" here.

Website: http://originalsoupman.com

Contact: The Original Soup Man, 1021 6th Ave., New York, NY 10018; (646) 852-6113.

If you prefer, you can take tours of the city with the "real" Kramer, Kenny Kramer, who will point out *Seinfeld* landmarks on a fun, three-hour tour. It is available on Saturdays only (some select Sundays are also available).

Website: www.kennykramer.com

Info: Tickets are $37.50, and reservations are a must.

Contact: For more information, call (212) 268-5525.

GHOSTBUSTERS

The original *Ghostbusters* movie starred Dan Aykroyd, Harold Ramis, Bill Murray, and Sigourney Weaver and has been a cult classic ever since its release in 1984. The Firehouse, Hook & Ladder Company 8 on Moore Street in New York City was chosen as the fictitious location of the Ghostbusters office.

In the 2016 reboot of *Ghostbusters*—which starred Melissa McCarthy, Kristin Wiig, and Kate McKinnon—you will see this same firehouse at the beginning of the movie when the team is looking for a place to run their business. It shows up then again at the end when (spoiler alert!) the mayor of New York gifts the firehouse to the crew as their permanent location.

Website: The Firehouse, Hook & Ladder Company 8 does not have its own website.

Info: Until early 2017, you could take a *Ghostbusters* selfie right in front of the firehouse, but then it seemed that the building had been under construction for several months, so check the status of the building before you make the trek. If the construction is done and you get a chance to peek inside the firehouse, check out the Ghostbusters logo from the second film hanging on the wall.

Contact: The Firehouse, Hook & Ladder Company 8, 14 N. Moore St., New York, NY 10013.

JIM HENSON AND THE MUPPETS AT THE MUSEUM OF THE MOVING IMAGE

Located in Astoria, the Museum of the Moving Image has to be on every film buff's list of sights to see. Here, you can make your own stop-motion animation, see movies and television shows from the past, and watch Q&As with famous filmmakers.

There are over 1,400 objects on display in the museum's exhibition entitled "Behind the Screen," and these include merchandise, still photographs, design materials, costumes, games, fan magazines, marketing materials, video and computer games, and movie theater furnishings.

One of the coolest parts of the museum is that it is home to a permanent exhibition for the wildly talented Jim Henson, who created the one and only Muppets. There will be a permanent gallery on Henson, and the museum will host education programs, live appearances, family workshops, and film screenings

based on Henson's career. There will be more than 50 puppets on display, including Kermit the Frog, Miss Piggy, Elmo, Gobo Fraggle, the Swedish Chef, and Statler and Waldorf. Bork, bork, bork! Fans will also get an up-close and personal look at Henson's sketches, storyboards, and scripts from The Jim Henson Company Archive and see rare behind-the-scenes footage of Henson and his collaborators.

Website: www.movingimage.us

Info: As of the writing of this book, the museum was still putting this amazing exhibit together. Please check their website for the most up-to-date information. Currently, the cost of museum admission is $15 adults (18+), $11 senior citizens (65+), $11 students with valid ID, $7 youth (3–17). Admission is free every Friday 4 to 8 p.m. Tickets are required for each individual screening and may be applied toward same-day museum admission: $15 adults, $11 seniors, $11 students, $7 youth.

Contact: Museum of the Moving Image, 36-01 35 Ave., Astoria, NY 11106; (718) 777-6888.

★ LISA'S PICK ★
ROXBURY MOTEL

Set in the Catskills, New York region, the Roxbury Motel is a film and TV lover's paradise. Here, you can book lodgings themed around your favorite show or movie. Have you ever dreamed of sleeping in a room that looks like the bottom of Jeannie's bottle

This coconut custard pie room at the Roxbury Hotel in Catskill, New York, is based on Mary Ann and Ginger from *Gilligan's Island*.

Website: www.theroxburymotel.com

Info: The motel is expanding to include Dracula's room, a fairy princess room, and more. Rates vary according to room and season.

Contact: 2258 County Highway 41, Roxbury, NY 12474; (607) 326-7200.

on *I Dream of Jeannie*, or have you wanted to live in Fred Flintstone's home? If you're a Trekkie, you'll love the *Star Trek* room and those who want to get happy will love the Mod Pod room that takes you back to the days of *The Partridge Family*. There's also rooms based on *Amadeus*, *The Wizard of Oz*, and *Bewitched*. You'll feel creepy and kooky in the two-story unit that makes you feel like you're a member of *The Addams Family*. (That's where I stayed. It was awesome.)

My absolute favorite part of this motel is The Digs, where the biggest Egyptian and Indiana Jones fans will absolutely love their, well, digs. Here, you will have your own cottage with three bedrooms. Inside there are hidden treasures and maps, secret passageways, fulfilled prophecies, Gods, libraries, idols, reptile skins, ancient curses, leather, hieroglyphics, bull whips, solid gold, fire features, babbling brooks, relics, and so much more. You'll spend a lot of time looking through the room and always find a new detail.

The hotel includes spa services and a yard with fire pits.

ELOISE AT THE PLAZA HOTEL

Do your children adore Eloise, the little girl who lives in New York City's Plaza Hotel? Eloise started out as the subject of a series of children's books in the 1960s by Kay Thompson. In

Website: www.theplazany.com/rooms-and-suites/the-eloise-suite

Info: Although Eloise never worried about money–she had people for that–you need to know that this hotel is for those travelers with bigger budgets. The rooms start at $1,900 per night and can go as high as $5,000 per night for a suite. The rate includes an Eloise tea for two at The Palm Court, Eloise gift bag with a special tote bag, welcome letter from Eloise, an Eloise robe, a copy of Eloise at The Plaza, a $100 gift card to the Eloise at The Plaza store, champagne and chocolate truffles (if you book the Edwardian Suite), and more.

Contact: The Plaza Hotel, Fifth Avenue at Central Park South, New York, NY 10019; (212) 759-3000.

2003, The Wonderful World of Disney premiered a film version, *Eloise at the Plaza*. If you were a fan of the books as a child or your children have a newfound love for her adventures thanks to the movie, then you'll be happy to know there's an actual room at The Plaza hotel where you can stay and live like Eloise.

Everything in the room is pink, from the door to the corridor to the bed, where there's an "Eloise" sign. You'll see Eloise's favorite toys, dolls and books and, of course, there's a zebra carpet.

MORE FOOD STOPS FOR FILM LOVERS

There are so many great movie and television-themed restaurants in New York that you can make it a fun trip just eating at these venues.

Sardis

This restaurant is smack in the middle of New York City's theater district, but just because you are Broadway bound, it doesn't mean that you won't find your favorite film/ TV stars on the walls. Well, not literally. On the walls of this restaurant are more than 250 caricatures of Hollywood and Broadway legends, including Alan Alda, Eddie Albert, Lucille Ball, Bea Arthur, Milton Berle, Sid Caesar, James Coco, Henry Fonda, and so many more. Get up and look around while you wait for your meal, it's okay! Sardis opened in 1927 and has also been featured in many movies and television shows, including *The Muppets Take Manhattan* (1984), *The Producers* (1968), *Shortcut to Happiness* (2003), *Mad Men*, and *Seinfeld*.

> **Website:** www.sardis.com/htmldocs/cms/restaurant.htm
>
> **Info:** The restaurant is open Tuesday through Saturday 11:30 a.m. to 11 p.m. and on Sunday noon to 7 p.m. The restaurant is closed on Mondays. (FYI, Broadway shows go dark on Mondays.)
>
> **Contact:** Sardis, 234 West 44th St., New York, NY 10036; (212) 221-8440.

Laughing Man Coffee

The story goes that, in 1999, Hugh Jackman traveled to Ethiopia with his wife Deb. While there, Jackman, an Academy Award–nominated, Golden Globe– and Tony Award–winning actor, who is probably most famous for his role as Wolverine in the *X-Men* film series, met a young coffee farmer. The farmer, named

Dukale, was working to get his family out of poverty. Inspired by Dukale's story, Jackman launched Laughing Man Coffee and opened two New York City coffee shops to help farmers in developing countries to sell their goods. Jackman then donates all of the profits from the coffee to his Laughing Man Foundation. The Laughing Man Foundation teaches students about social entrepreneurship, funds education and small business projects for farmers throughout the Kochore region of Ethiopia, and provides access to clean cookstoves and medical supplies. Stop by. You'll feel like you're helping Jackman, even though you're just getting a cup of java.

> **Website:** http://laughingman
> foundation.org
>
> **Contact:** There are two locations.
> The first is 184 Duane St., New York,
> NY, and the second is 1 North End
> Ave.; (212) 227-3240.

Beetle House

Okay, say it three times: "Beetlejuice! Beetlejuice! Beetlejuice!" He won't show up, but it's fun to say as you walk into the Beetle House, located in the city's East Village. The owners stress that they are in no way connected to the quirky and talented director of the 1988 feature film *Beetlejuice,* Tim Burton, except that they love all of his work. Not only is Burton known for this comedy-fantasy movie, but he's also the creative genius behind *The Nightmare Before Christmas* (1993), *Edward Scissorhands* (1990), *Sweeney Todd: The Demon Barber of Fleet Street* (2007), *Alice in Wonderland* (2010), and *Corpse Bride* (2005).

Meeting up at Beetle House a great way for fans to come together to honor Burton in this dark venue. Here you can order an "Alice's cup o' tea," a "Coco Skellington," or a "This is Halloween" drink. Try such tasty dishes as "Sweeny Beef" and "The Edward Burger Hands" burger.

> **Website:** www.beetlehousenyc.com
>
> **Info:** The bar is open Sunday to Thursday 4 p.m. to midnight. On Friday and Saturday, the bar is open 4 p.m. to 2 a.m.
>
> **Contact:** Beetle House, 308 E 6th St., New York, NY 10003; (646) 510-4786.

Katz's Delicatessen

Remember that famous scene in *When Harry Met Sally* (1989) when Meg Ryan faked an orgasm and the lady at the nearby table utters, "I'll have what she's having?" If you dare to recreate that scene, it was filmed here, at Katz's Delicatessen, a Jewish deli located on East Houston Street. The deli is also featured in *Donnie Brasco* (1997), *Across the Universe* (2007), and *Enchanted* (2007). If you are a fan of a corned beef sandwich, you must order Katz's version. You will not regret it.

Website: www.katzsdelicatessen.com

Info: The delicatessen is open Monday through Wednesday 8 a.m. to 10:45 p.m., Thursday 8 a.m. to 2:45 a.m., and Friday 8:00 a.m. through the night. On Saturday, they are open all night, and on Sunday the deli is open until 10:45 p.m.

Contact: Katz's Delicatessen, 205 East Houston St. (corner of Ludlow St.), New York, NY 10002; (212) 254-2246.

Neir's Tavern

PBS once called Neir's Tavern "The Most Famous Bar You've Never Heard Of," but if you've seen the 2011 film *Tower Heist*, you'll easily recognize this pub that is predominantly seen in the Ben Stiller and Eddie Murphy flick.

Located in Woodhaven, Queens, this quiet little bar is more than 185 years old and comes with a unique history. It is said that this is the same bar where then presidential candidate Abraham Lincoln threw back a few after his Cooper Union speech shortly before the Civil War.

Neir's Tavern has made appearances in other films and television shows as well, including *New York Originals*, an Emmy Award–winning show on PBS, as well as the incomparable flick *Goodfellas*.

The stars of the 1990 movie *Goodfellas*, including Robert De Niro, Ray Liotta, Joe Pesci, and Lorraine Bracco, actually walked into Neir's Tavern to film their scenes, which you can see in the movie. *Goodfellas* is based on the true story of New York City mobster Henry Hill Jr. From 1955 to 1980, he was associated with the Lucchese crime family.

It is also said that the legendary actress Mae West, who was born in Queens, made her first professional appearances at Neir's Tavern. She went on to star in vaudeville, and her scene in the 1932 movie *Night After Night* became famous. After seeing the

star's jewelry, a coat check girl says, "Goodness! What lovely diamonds." Mae replies, "Goodness had nothing to do with it." She also starred in *She Done Him Wrong* (1933) and *My Little Chickadee* (1940) with W. C. Fields.

To celebrate her legacy, the venue offers a hamburger in her honor. They also offer a "Goodfella" Burger, Ben Stiller Veggie Burger, and a "Sleepin' with Da Fishes" fish sandwich.

Website: http://neirstavern.com

Info: The pub is open Sunday noon to 1 a.m., Monday through Thursday 11 a.m. to 1 a.m., and Saturday and Sunday 11 a.m. to 2 a.m.

Contact: Neir's Tavern, 87-48 78th Street, Woodhaven, NY 11421; (718) 296-0600.

Bubba Gump Shrimp Company

In the 1994 movie *Forrest Gump,* starring Tom Hanks, the fictional Bubba Gump restaurant is a dream of Gump's friend, Benjamin Buford "Bubba" Blue. In the movie, Forrest opens the restaurant after Bubba dies in battle during the Vietnam War. After *Forrest Gump* was released, Viacom Consumer Products, which owns Paramount Pictures—the company that distributed the movie—opened the first Bubba Gump Shrimp Company restaurant in Monterey, California.

There are now locations all over the world, including in New York City's heart of Times Square. As Bubba said in the movie, there are all kinds of shrimp on the menu, "shrimp-kabobs, shrimp creole, shrimp gumbo. Pan fried, deep fried, stir-fried. There's pineapple shrimp, lemon shrimp, coconut shrimp, pepper shrimp, shrimp soup, shrimp stew, shrimp salad, shrimp and potatoes, shrimp burger, shrimp sandwich. That—that's about it."

Website: www .bubbagump.com

Info: The Bubba Gump Shrimp Company restaurant is open Sunday through Thursday 11 a.m. to midnight and Friday and Saturday 11 a.m. to 1 a.m.

Contact: Bubba Gump Shrimp Company, 1501 Broadway, New York, NY 10036; (212) 391-7100.

Nobu–Robert De Niro

Are you talking to me? Well, if you're talking about actor Robert De Niro, he is partners in Nobu, a Japanese restaurant located in New York City's financial district. There are more locations in the United States, including in Las Vegas, Miami, Newport Beach, and Honolulu. There are also other Nobu locations around the world, including in Beijing, the Bahamas, South Africa, and London. You probably won't run into *The Godfather* star at any one of his restaurants, but you can stop by and see why it's so popular.

Website: www.noburestaurants.com

Info: Nobu Fifty Seven is open on Sunday for lunch 11:45 a.m. to 2:15 p.m. and dinner 5:45 p.m. to 10:15 p.m. From Monday through Saturday, the restaurant is open for dinner 5:45 p.m. to 11:15 p.m. Nobu Downtown is open for lunch Monday through Friday 11:30 a.m. to 2:15 p.m. and for dinner Sunday to Wednesday 5:30 p.m. to 10:15 p.m. and Thursday to Saturday 5:30 p.m. to 11:15 p.m. The bar lounge is open Monday to Wednesday 11:30 a.m. to 11:00 p.m., Thursday and Friday 11:30 a.m. to midnight, Saturday 5 p.m. to midnight, and Sunday 5 p.m. to 11 p.m.

Contact: Nobu Fifty Seven, 40 West 57th St.; New York, NY 10019; (212) 757-3000. Nobu Downtown, 195 Broadway, New York, NY 10007; (212) 219-0500.

SERENDIPITY SKATING RINK

Pssst . . . if you're a romantic, like I am, you'll want to go to Wollman's Skating Rink, where they filmed a pivotal scene from *Serendipity* (2001), starring John Cusak (Jonathan) and Kate Beckinsale (Sara). It's one of those you-must-stand-here locations I decided to include because it's one of my favorite movies. It's about Jonathan and Sara, who meet one day while Christmas shopping and have a great night. Sara believes that if they are meant to be together again, they will be and they separate. They've never forgotten about each other and one day hope to get back

Website: www.wollmanskating rink.com

Info: It's open for public skating from November through March, so you can skate where this couple fell in love.

Contact: Wollman Skating Rink, Central Park, New York, NY 10065; (212) 439-6900.

together again, but the glitch is that they don't know how to reach each other.

ON LOCATION TOURS

In New York City, On Location Tours will take you to the New York City filming sites of *Sex and the City, The Sopranos, Gossip Girl, Real Housewives of New York, When Harry Met Sally*, and more. There's also a special tour called the TCM Classic Movie Tour which includes the filming locations of *Manhattan, North by Northwest,* and *King Kong,* just to name a few. Tickets range in price from $25 to $52 for adults, depending on the tour package that you purchase. For more information, visit https://onlocationtours.com or call (212) 683-2027.

THE TOUR AT NBC STUDIOS

Go behind the scenes of the hit NBC shows—like *Saturday Night Live, The Tonight Show Starring Jimmy Fallon,* and *Late Night with Seth Meyers*—that are filmed at NBC Studios. You will also produce your own show! Tickets range from $29 to $33. For more information, visit www.thetouratnbcstudios.com.

THE PALEY CENTER FOR MEDIA

You might remember The Paley Center for Media under its other names: the Museum of Television & Radio (MT&R) or the Museum of Broadcasting. Founded by William S. Paley, who built up CBS Television, The Paley Center for Media has locations in both New York and Los Angeles, so check out both event calendars before you travel to either location. Film and television lovers will enjoy the panels that the center hosts. The Paley Center for Media brings some of the leading experts in the entertainment industry to talk about the important issues surrounding the future of film, television, and radio.

Website: https://media.paleycenter.org

Info: Cost of admission: there is a suggested contribution of $10 for adults, $8 for students and senior citizens, $5 for children under 14. Paley Center members are free. The center's hours in New York are Wednesdays to Sundays noon to 6 p.m., noon to 8 p.m. on Thursdays.

Contact: The Paley Center is located at 25 West 52 St. (between Fifth & Sixth Avenues), New York, NY 10019; (212) 621-6600.

Statue Alert! *The Honeymooners*

And aawwwaaaay we go! Jackie Gleason's popular comedy show *The Honeymooners*, where the comedian portrayed Ralph Kramden, ran on CBS from 1951 to 1955. Kramden is a New York City bus driver who works for the Gotham Bus Company. He and his wife Alice (portrayed by Audrey Meadows) fight a lot but still love each other. Kramden and his neighbor and friend Ed Norton (played by Art Carney), a sewer worker, are constantly dreaming of get-rich-quick schemes, but typically just end up in trouble.

This popular comedy show was nominated for four Primetime Emmy awards and won one, for best supporting actor, which went to Art Carney.

Because of Kramden's job as a New York City bus driver, The Port Authority of New York & New Jersey, located on 8th Avenue in Manhattan, erected a statue outside the venue in the character's honor.

WEBSITE: www.panynj.gov/bus-terminals/port-authority-bus-terminal.html

CONTACT: Port Authority Bus Terminal, 625 8th Ave., New York, NY 10018; (212) 502-2200.

FILM FESTIVAL FUN

New York is home to many film festivals, so if you're touring the state, why not combine your visit to coincide with a film festival? That way, you can watch films by some of the best rising filmmakers in the country, and you may even have the chance to see quite a few of your favorite film and TV celebrities. Here are just a few festivals:

Hamptons International Film Festival: This festival takes place in the Hamptons in October, where you can see more than 100 features and shorts. There are also such events as "A Conversation With . . ." where Hollywood notables stop by to talk about their movies and their careers. Previous guests have included Golden Globe–nominated actor Aaron Eckhart, Academy Award–winning actress and producer Holly Hunter, and three-time Academy Award–nominated actor, director, producer

and activist Edward Norton. Visit http://hamptonsfilmfest.org for more information.

Chelsea Film Festival: Held in October in the neighborhood of Chelsea, this growing film festival consists of four days of screenings of independent shorts, feature-lengths, and documentaries from emerging directors. In between sessions, they host Q&A events, industry mixers, and more. Visit www.chelseafilm.org for more information.

★ LISA'S PICK ★

Woodstock Film Festival: The October festival is held in Woodstock, New York. Just so you know, Woodstock was not the home of the famous concert in the 1960s. That concert took place in Bethel, New York—which is only about 60 miles from Woodstock if you're interested in taking a side trip—but Woodstock has definitely made a name for itself in the film community. Their festival features, shorts, animated shorts, documentaries, and so much more. Past guests have included Alec Baldwin, Mary Stuart Masterson, Lori Singer, and Mark Ruffalo. For more information, visit www.woodstockfilmfestival.com.

Tribeca Film Festival: Held every April, the annual Tribeca Film Festival draws some of the biggest names in Hollywood. That could be because it was founded by one of the biggest names in Hollywood, legendary actor Robert De Niro, who is known for his performances in such films as *Goodfellas, The Godfather,* and *Raging Bull.* Other celebrities who have made an appearance at previous Tribeca Film Festivals include Barbra Streisand, Al Pacino, Diane Keaton, and director Alejandro González Iñárritu (*The Revenant*). Each year, there are more than 500 film screenings and hundreds of filmmakers, actors, and directors who attend. It is definitely a place where you can get close to the legends. For more information, visit https://tribecafilm.com.

ALL THINGS OZ

The Wizard of Oz is one of the most popular movies ever made, and it really needs no description. However, if you are one of the holdouts who have not seen the movie yet, here's a little background: It was released in 1939 and was based on the 1900 novel

The Wonderful Wizard of Oz written by L. Frank Baum. The movie starred Judy Garland (Dorothy), Ray Bolger (Scarecrow), Jack Haley (Tin Man), Bert Lahr (Cowardly Lion), Frank Morgan (Wizard of Oz), Billie Burke (Glinda), and Margaret Hamilton (Wicked Witch).

Baum was born in Chittenango, New York, in 1856, and it is here that The International L. Frank Baum & All Things Oz Historical Foundation works hard at keeping his memory alive. There is plenty to see and do here, and Oz fans should start with a tour of the All Things Oz Museum, located in an unassuming Chittenango storefront.

Only a half-hour drive away from the museum is The Baum-Neal House. This is the location where L. Frank Baum met Maud Gage, his future bride who ultimately encouraged Baum to write down his story, *The Wizard of Oz* (thanks Maud!).

The foundation also holds an annual three-day Ozstravanganza! weekend every June. In 2017, they celebrated their 40th year with a special appearance by Baum's great-grandson, Roger Staton Baum, who is a successful writer in his own right. There were other appearances by authors and artists, including Steve Metzger, the author of *Toto's Story: My Amazing Adventures with Dorothy in Oz.*

Website: www.allthingsoz .org. You can find out all the information you need to know on the foundation, the museum, the house, and the festival through this main website.

Info: Cost of admission to the museum is a $5 donation per person. Children 10 years old and under are free. The museum is open every Saturday 10 a.m. to 3 p.m. during the winter and other times by appointment.

Contact: All Things Oz Museum, 219 Genesee St., Chittenango, NY 13037; (315) 333-BAUM (2286).

Did you know?
Frank Baum's mother-in-law, Matilda Joslyn Gage, was a noted suffragist who led the National Woman Suffrage Association along with Elizabeth Cady Stanton and Susan B. Anthony. She was also a writer, and her home is open for tours too. The home is located in Fayetteville, New York, only seven miles away from the All Things Oz Museum. For more information, visit www .matildajoslyngage.org.

But wait, Oz fans, there's more!

Hey Oz fans! You're not done yet with places you can visit to honor your favorite movie, *The Wizard of Oz*! Turn to the Kansas section of the book for information on The Oz Museum in Wamego, and then flip the pages to North Carolina, where you can find information on a real-life Land of Oz park in Beech Mountain. There's also Egghead's, a *Wizard of Oz*-themed restaurant in California as well. You also won't want to miss The Judy Garland Museum in Grand Rapids, Minnesota, which also hosts an annual *Wizard of Oz* festival. Last, but not least, in Portland, Oregon, there's the OzCon International, an event that has celebrated Baum and everything Oz for the last 50 years.

 ### Foodie Fact! The Pandorica

A few hours north of The Way Station (see opposite page) is *Doctor Who*–themed restaurant The Pandorica. Located in the Hudson Valley city of Beacon, The Pandorica has episodes of *Doctor Who* on the telly, Trivia Thursdays, and such quirky Who-menu items as WHOmmus, Madame De Pompadour Cake, and the Bannakaffalatta Bread Pudding (yum!). They also serve a select variety of wines and beers and offer an extensive collection of teas.

WEBSITE: www.thepandoricarestaurant.com

INFO: The restaurant is closed on Tuesdays. It is open noon to 5:30 p.m. on Sundays and Mondays and noon to 8:30 p.m. on Wednesdays, Thursdays, Fridays, and Saturdays.

CONTACT: The Pandorica, 165 Main St., Beacon, NY 12508; (845) 831-6287.

DOCTOR WHO

The incredibly popular BBC television show *Doctor Who* follows The Doctor, a surprisingly human-looking alien, and his human companion as they travel through time and space in the TARDIS—a spaceship which happens to look exactly like a police phone box. The show, which debuted in 1986, has inspired a cult following with a fanbase called the Whovians.

Heads up Whovians, because there are not one, but two *Doctor Who*–themed venues in New York. The first, located in Brooklyn, is a bar and music venue called The Way Station, which is decorated in retro wallpaper and features a full-size TARDIS (psst, it's the bathroom). Check out the calendar of musical performances. The other is The Pandorica (see Foodie Fact, opposite page).

Website: www.thewaystationbk.com

Info: According to the website, fans of the show gather every Sunday at 4 p.m. for *Doctor Who* and other sci-fi-related screenings. The restaurant is open Monday to Thursday 4 p.m. to 2 a.m., Friday 4 p.m. to 4 a.m., Saturday 3 p.m. to 4 a.m., and Sunday 3 p.m. to 2 a.m. Happy hour will be held 4 p.m. to 8 p.m. daily.

Contact: 683 Washington Ave., Prospect Heights, Brooklyn, NY 11238; (347) 627-4949.

★ LISA'S PICK ★
LUCILLE BALL AND THE LUCY COMEDY FEST

"Luuuucccyyyy, I'm home!" And if you're in New York, take a trip to the west side of the state to Jamestown, where you can visit the hometown of our beloved redheaded comedian, Lucille Ball.

I've been an *I Love Lucy* fan since I was a little girl. As a kid, I wanted to stomp grapes and wrap chocolate. I would hold bottles of cough syrup and pretend to do a Vitameatavegamin commercial (of course the drunk version). I also wish I had a dollar for every time I said "Lucy, you got some 'splainin' to do" or "Luuucccy, I'm home."

I know practically every word of every episode of *I Love Lucy*, a show that ran on CBS from 1951 to 1957 and has since been on television somewhere in the world every single day. I always wanted to meet Lucille Ball. I wanted to *be* Lucille Ball. She was

The Lucille Ball–Desi Arnaz Center in Jamestown, New York, has a re-creation of Lucy and Ricky's apartment, including this set of the kitchen.

my idol and I admired all the work she did to pave the way for other female comedians, writers, producers, etc., after her.

Years ago, when I traveled to Atlantic City, New Jersey, there was an *I Love Lucy* exhibit that included memorabilia from the show, such as clothes, awards, and props. I remember turning a corner at the exhibit and seeing a re-creation of both the Manhattan apartment and the California hotel room. My eyes welled up and I couldn't control my tears. I felt that I had stepped back in history and right through my television set. The re-creations were THAT good. I felt like I was sitting in the Desilu Studios watching an actual taping of *I Love Lucy*. It was surreal.

Lucille Ball was born in Jamestown, New York, only a five-hour drive away from my own hometown. Since I wanted to see where my idol was born and raised, I added this small town onto my bucket list. Then, I found out about the Lucy Comedy Fest, an annual event in Jamestown where there are performances by professional comedians, as well as Lucy-style events such as grape stomping (yes!), candy wrapping contests (yes! yes!). Throughout the fest there are tributes to Lucy and tours of "Desilu Studios," which includes more of the re-creations and memorabilia.

I went to the Lucy Comedy Fest for the first time in 2016 and bought tickets to one of the dinners where we met the twins who

played Little Ricky, Joseph and Michael Mayer. Every year, the fest has different special guests who are somehow related to the show or to Lucille. Lucy and Desi's daughter, Lucie Arnaz, has even surprised guests and shown up to one of the fests.

At the festival, I finally geeked out and lived my dream of grape stomping and chocolate wrapping! The volunteers at the festival dressed us in similar garb to what Lucy wore (even my honey let them wrap a "skirt" and a bandana on him), and we stepped into a basket filled with grapes. Stepping into the bucket felt cold and goopy and yet absolutely wonderful. I couldn't wait to start. For two minutes, we stomped in circles and crushed the grapes. The lady next to me really got into it and actually threw the grapes at me, just like what happened to Lucy in the episode. Can I say "so much fun" too many times? Not in this case.

The chocolate wrapping contest was a hoot. My honey and I did it together (I'm Lucy, he's Ethel), and it was much more difficult than I thought it would be. "Speed it up a little!" they yelled! And they did! Before you knew it, there were chocolates flying everywhere and we just couldn't keep up, and we kept laughing. I resisted the urge to hide the "chocolates" down my shirt and in my hat, just like Lucy.

Next, I lived out another dream—I recorded a non-drunk version of a Vitameatavegamin commercial! I had some regrets about not doing the drunk one, but at least I gave it a shot.

Professional comedians from all over come to the festival and celebrate the life of Lucille Ball. In 2016, I went to a panel where Peter Farrelly (*There's Something About Mary* [1998], *Me, Myself & Irene* [2000], and *Dumb & Dumber* [1994]) shared funny stories about his career and then took a lucky winner for a ride in the Mutts Cuts van from the movie *Dumb & Dumber*. Other professional comedians who were there in 2016 also included Brian Regan, Trevor Noah, and Lewis Black.

There were Lucy and Ethel shows and tours of Jamestown where I saw the home where Lucille Ball was born and raised. Upon hearing that another buyer wanted to change the inside of Lucille's childhood home, the current owners purchased it just to make sure that nobody remodeled it. Nearby at the Lake View Cemetery (907 Lakeview Ave., Jamestown), Lucille is buried. I admit that I cried a little here. I also cried the day she died in 1989.

I was fortunate to be there for her 105th birthday celebration and witnessed the so-called "ugly" Lucille Ball statue. Then, I

was even more fortunate to be there during the unveiling of the beautiful "new" Lucille Ball statue. After the unveiling, along with about 200 people, we sang "Happy Birthday" to her (again, got choked up). This was one of those moments that I soaked in. Here I was paying homage to the woman who meant so much to me growing up—she made me laugh and, thanks to her hard work, inspired me to achieve whatever goals I set for myself. She reminded me to not let being a woman stop me. She didn't.

> **Website:** www.lucycomedyfest.com
>
> **Info:** The Comedy Fest is always held in August, while the museum is open year-round. The cemetery is also open year-round.
>
> **Contact:** National Comedy Center, 2 West Third St., Jamestown, NY 14701; (716) 484-0800.

If you're interested in going to the Lucy Comedy Fest in future years, go to the website and sign up for the newsletter so you know when they announce the dates. Travel tip: Book your hotel as soon as the dates are announced, but be forewarned that the rates of some of the hotels will double. We got a decent rate at the Red Roof Inn, which was only about 10 minutes from town so it was very convenient. There was plenty of parking around for every event, so I recommend staying here if you're going and, if you're a Lucy fan, GO!

In the next few years, Jamestown, New York, will also become home to the National Comedy Center, which was being built as of this writing. It is a $50 million project funded by a public-private partnership and has been awarded more than $3.5 million from New York State, Empire State Development, and I Love NY™. Many of the professional comedians who came to the festival went on a private hard-hat tour of the future site.

"Comedy is one of the most overlooked of all the arts—it's usually the dramatic stuff that gets all the attention & recognition," said Peter Farrelly in a release. "So to have a place that will celebrate comedy and the comics of the past is a great thing."

HAVANA CUBAN CAFE & PIZZERIA

For meals, I dined at Jamestown's Havana Cuban Cafe & Pizzeria, because, of course, there had to be a restaurant that honored Ricky, played by Desi Arnaz. Here is where I had my first Cuban

sandwich ever—YUM! Thanks, Ruben, who also happened to have the best flan around.

IT'S A WONDERFUL LIFE MUSEUM

It's a Wonderful Life, one of the most iconic holiday films of all time, starred Donna Reed and Jimmy Stewart and was released more than 70 years ago. It was nominated for five Academy Awards including Best Picture and was recognized by the American Film Institute as one of the 100 best American films ever made.

If you are a cinema lover who makes watching this classic film a tradition with your family, then you will be pleased to know that there is an entire museum in Seneca Falls, New York, that is dedicated to the movie.

For the few of you who might not have seen the movie yet, it focuses on George Bailey (James Stewart) who wishes he had never been born, so an angel comes to him and makes that wish come true. George then starts to see what the lives of others would be if he wasn't there.

It's a Wonderful Life was directed, produced, and written by Frank Capra. It was nominated for six Academy Awards, including Best Picture, Best Director, and Best Actor, but only took home one— the Technical Achievement

Website: www.wonderfullife museum.com

Info: Cost of admission: free. The It's a Wonderful Life Museum is open Tuesday to Saturday 11 a.m. to 4 p.m. The museum is closed on major holidays. The gift shop has a variety of movie souvenirs you can purchase too, including snow globes, calendars, and more.

Contact: It's a Wonderful Life Museum, 32 Fall St., Seneca Falls, NY; (315) 568-5838.

Award. It did win a Golden Globe for Best Director of a Motion Picture.

According to the museum's website, Capra visited Seneca Falls while writing the script. To celebrate the film's 70th anniversary, the museum hosted a three-day event and the "Bailey Kids" Carol "Janie" Coombs, Karolyn "Zuzu" Grimes, and Jimmy "Tommy" Hawkins appeared together for the first time. Each year, Seneca Falls hosts an *It's a Wonderful Life* Festival the second weekend in December.

OTHER THINGS TO SEE OR DO IN NEW YORK

POTTERCON: Remember, PotterCon is in New York too (I first mentioned it in the California chapter), so don't miss the convention where fans get together for witchcraft, wizardry, and fun, including a Potter party. For more information, visit www.potterconusa.com.

HUMPHREY BOGART'S FAMILY HOME: When legendary actor Humphrey Bogart, who starred in several 1940s films such as *The Maltese Falcon* (1941), *Casablanca* (1942), and *The Big Sleep* (1946), was young, he lived in and around New York City. There is a plaque outside the Bogart family home, a row of brownstones

Statue Alert! Hans Christian Andersen

Legendary actor and comedian Danny Kaye brought the storyteller to life in the 1952 movie *Hans Christian Andersen*. If you can't get to Denmark to tour Andersen's hometown, you can head to Central Park and take a selfie with the statue that honors Andersen. Every weekend in the summer, children also gather at the Hans Christian Andersen Storytelling Center to hear stories that have even been read by such celebrities as Victor Borge and Celeste Holm.

WEBSITE: www.centralparknyc.org/things-to-see-and -do/attractions/hans-christian-andersen.html

CONTACT: Hans Christian Andersen Storytelling Center, 74th Street near Fifth Avenue west of Conservatory Water.

Statue Alert! *Balto*

The animated movie *Balto*, which was released in 1995, was based on a true story about a dog who helped save children from the diphtheria epidemic. The live action shots of the film, which starred Kevin Bacon, Bridget Fonda, Phil Collins, Jim Cummings, and Bob Hoskins, were shot in Central Park. If you were a fan of this movie, then stay in Central Park after your selfie with the Hans Christian Andersen statue for another selfie with the statue that honors Balto.

WEBSITE: www.centralparknyc.org/things-to-see-and -do/attractions/balto.html.

on the north side of West 103rd Street that documents where the actor once lived.

EDGAR ALLAN POE COTTAGE: There are so many movies and television shows that have been centered around Poe's poems, including *The Raven* (1963), *The Pit and the Pendulum* (1964), and *Dark Shadows* (1966–1971), which used four of Poe's stories in its show. The writer spent the last years of his life in a cottage in the Bronx, now referred to as Poe Cottage. It is part of Poe Park, also located in the same area and opened in 1902. You can visit in a group tour or tour the cottage individually for only $5 per adult and $3 per child, student, and senior citizen.

Website: http://bronxhistoricalsociety.org/poe-cottage

Info: Cost of admission: $5 per adult, $3 for students, children, and seniors. The cottage is open Thursday and Friday 10 a.m. to 3 p.m., Saturday 10 a.m. to 4 p.m., Sunday 1 p.m. to 5 p.m.

Contact: Edgar Allan Poe Cottage, 2640 Grand Concourse at East Kingsbridge Road, The Bronx, NY 10458; (718) 881-8900.

NEW JERSEY

Thank you, Mr. Thomas Edison, because it was here, in West Orange, New Jersey, where you created *Black Maria*, the first motion picture to be copyrighted in the United States. According to motion picture history, it started in 1907 in Fort Lee and the first studio was constructed there in 1909.

Since then, New Jersey has had a thriving film and television industry, with such movies as *Goodfellas* (1990), *The Godfather Part III* (1990), *Ocean's Eleven* (2001), *The Wrestler* (2008), *Big* (1988), and *Friday the 13th* (1980) all filmed here. Of course, reality shows have been a big market in New Jersey too, including *The Jersey Shore* and, of course, *The Real Housewives*.

★LISA'S PICK★
LOU COSTELLO MEMORIAL PARK

It was on a road trip from New York to Atlantic City, New Jersey, when I made a pit stop at the Paterson Great Falls National Historical Park in Paterson, New Jersey. I own a National Parks Passport and this was a place to collect another stamp. It was halfway down to Paterson when I suddenly remembered, "Lou Costello was born in Paterson, New Jersey!" The little television and film trivia that stays in my brain comes in handy every now and then.

When I arrived at the Paterson Parks office, my plan was to ask if they had anything to see or visit that was in Lou Costello's honor, but I didn't even have to ask. Right in front of me was a huge map with "Lou Costello Memorial Park" on it. I became a ridiculously fangirly grown woman right there. Seeing photos and memorabilia from Costello's personal collection is like baseball fans seeing Babe Ruth memorabilia.

Along with his comedic partner Bud Abbott, he made 36 films between 1940 and 1956, including *Buck Privates, Hold That Ghost, Who Done It?, Pardon My Sarong, The Time of Their Lives, Buck Privates Come Home, Abbott and Costello Meet Frankenstein,* and *Abbott and Costello Meet the Invisible Man*. The comedy pair is also known for their hilarious "Who's On First" skit. When I was young, there were Saturday morning cartoons and Sunday morning Abbott & Costello movies. I'm a huge Abbott & Costello fan—I admit that I even have a life-size cutout of the

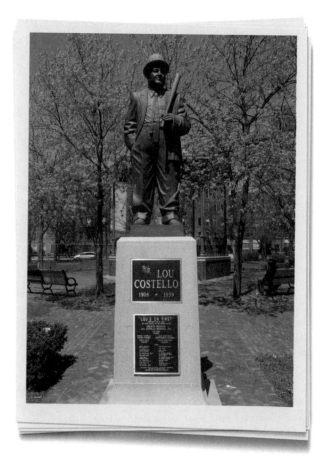

The Lou Costello Memorial Park is located in the comedian's hometown of Paterson, New Jersey.

duo in my family room. I own an Abbott & Costello coffee mug and a "Who's on First?" T-shirt.

I was fortunate that during my impromptu visit I just happened to catch an Abbott & Costello exhibit at the Paterson Museum (who knew there was a Paterson Museum?). I saw family photos of the funnyman as well as memorabilia from his career, such as awards, clothing, and even the backyard playhouse he built for his daughter. Right in front of me was even a script from the 1940s that belonged to Lou. As a screenwriter, I love looking at old scripts.

As soon as I was done with the exhibit, and I took my sweet time reading every photo they had, I bolted to find that park. It was only two minutes from the museum, but I have to admit, however, that it's not in the best part of Paterson. The park also has not been maintained well, and that made me quite sad, but there it was in big bold letters, "The Lou Costello Memorial Park."

Now, do you know how many times Cianci Street is mentioned in the Abbott & Costello shows? (The answer is: a lot.) There is a Cianci Street right near the Lou Costello Memorial Park!

Sadly, as much as I've tried, I couldn't find any kind of statue, park, or museum in Bud Abbott's honor. The Paterson Museum held a birthday celebration in honor of Abbott and has some of Lou's memorabilia which includes photos of Bud, but there is nothing specifically honoring Abbott, who was born in Asbury Park, New Jersey. In 2017, a petition was begun to change the South Monroe Street in Asbury Park to Bud Abbott Road, but no word on whether this change will take place.

Contact: Lou Costello Memorial Park, 50 Ellison St., Paterson, NJ 07505.

Foodie Fact!

About an hour away from the Lou Costello Memorial Park is the JBJ Soul Kitchen, which opened in October 2011 in Red Bank, New Jersey. It's a community-run restaurant founded by Jon Bon Jovi and the Jon Bon Jovi Soul Foundation. Jon Bon Jovi might be a famous rocker, but he has also honed his acting chops as well, portraying Victor Morrison on the popular series *Ally McBeal* in 2002. He's also appeared in *Sex and the City* and *30 Rock*, and in the feature film *New Year's Eve* (2011).

A second restaurant location was opened in Toms River, New Jersey. At both restaurants, the menu has no prices and that's not a typo. It's because that's how Bon Jovi wanted it to be. Come in and eat. If you're hungry and have no money to pay, you can volunteer for an hour to pay for your meal. If you can afford to pay for your meal, you are helping to feed the community. You are served a three-course meal based on American Regional cuisine, starting with salad or soup, a fish, meat or a vegetarian entrée, and a fresh dessert, all made with fresh, organic ingredients from their or the JBJ Soul Kitchen Farm.

WEBSITE: www.jbjsoulkitchen.org

INFO: The restaurant is open Wednesday, Thursday, Friday, and Saturday from 5 p.m. to 7 p.m. Sunday Brunch is available 11:30 a.m. to 2 p.m.

CONTACT: JBJ Soul Kitchen, 207 Monmouth St., Red Bank, NJ 07701; (732) 842-0900, and 1769 Hooper Ave., Toms River, NJ 08753; (732) 731-1414.

OTHER THINGS TO SEE OR DO IN NEW JERSEY

ABSECON LIGHTHOUSE: It's New Jersey's tallest lighthouse at 171 feet tall and it's the country's third tallest lighthouse. Climbing to the top of the 150-year-old lighthouse in Atlantic City, New Jersey, is a blast. Okay, it's a little bit of a workout, but you'll be proud you did it.

Website: www.abseconlighthouse.org

Info: Cost of admission: Free parking. Climbing fees: adults, $7; seniors (65+), $5; children (4 to 12), $4; active duty military, free; kids under 4, free. The lighthouse is open Thursday through Monday 11a.m. to 4 p.m. From July to August, the lighthouse is open 7 days a week 10 a.m. to 5 p.m. and Thursdays until 8 p.m. The last tower climb of the day is a half-hour before closing. The lighthouse is closed for two weeks around Christmas and New Year's.

Contact: Absecon Lighthouse, 31 S. Rhode Island Ave., Atlantic City, NJ 08401; (609) 449-1360.

PATERSON GREAT FALLS: Head down to Weehawken, New Jersey, and stand where Aaron Burr shot and killed Alexander Hamilton. In 1801, Hamilton's son Philip died here in a duel too. In Paterson, New Jersey, Hamilton cofounded the Society for Establishing Useful Manufactures (S.U.M.), which in 1792, purchased 700 acres of land above and below the Great Falls

and established the city of Paterson. There are many Alexander Hamilton souvenirs to buy, and there's a statue of Alexander Hamilton outside.

Website: www.nps.gov/pagr/index.htm

Info: The Paterson Museum, a partner of the National Park Service, doesn't charge an admission fee; however, there is a suggested donation of $2 per adult.

Contact: Paterson Great Falls, 72 McBride Ave., Paterson, NJ 07501; (973) 523-0370.

VERMONT

Vermont is such a pretty state in the New England region. It is home to mountains, wooden bridges, and, of course, maple syrup. It's also been the backdrop for many movies, including *The Trouble With Harry* (1955), *White Christmas* (1954), and *What Lies Beneath* (2000).

THE SOUND OF MUSIC'S TRAPP FAMILY LODGE

The hills are alive with the sound of music! Released in 1965, *The Sound of Music* won five Academy Awards, including Best Picture and Best Director. The film has since become a treasured classic, especially at holiday time. In 1998, the American Film Institute (AFI) listed *The Sound of Music* as the 55th greatest American movie of all time, and the fourth greatest movie musical.

The Sound of Music starred Julie Andrews and Christopher Plummer and was adapted from the 1959 musical of the same name. It is based on a true story, the memoir of *The Story of the Trapp Family Singers* by Maria von Trapp (although the von Trapp family has said that the film has changed portions of the story and does not reflect what happened). The film is about the von Trapp family singers and Maria (played by Andrews), who becomes a governess in the home of a widowed naval captain with seven children.

In Stowe, Vermont, fans of *The Sound of Music* can stay at the real-life Trapp Family Lodge, a 2,500-acre mountain resort which is actually inspired by Austrian architecture. The lodge opened in 1950 and was remodeled after a fire in 1980. You can take a tour while staying at the resort. While here, you can also enjoy horse-drawn carriage rides, sleigh rides in the winter, 35 miles of wooded hiking trails, the von Trapp gardens, and maple sugaring tours.

There is also a von Trapp Brewing center, which has been open since 2010 and produces

Website: www.trappfamily.com

Info: The lodge is a 96-room hotel with family suites, premier rooms, Salzburg suites, two-bedroom family rooms, and more.

Contact: Trapp Family Lodge, 700 Trapp Hill Rd., PO Box 1428, Stowe, VT 05672; (802) 253-8511; (800) 826-7000.

more than 2,000 barrels of lager per year. It is the brainchild of Johannes von Trapp, the youngest son of Maria and the baron.

OTHER THINGS TO SEE OR DO IN VERMONT

MERRILL'S ROXY CINEMAS: Located in downtown Burlington, Vermont, this all-digital cinema is a must-see for movie fans. Sit back in their luxury rocker chairs and enjoy a great flick.
Website: http://merrilltheatres.net
Info: Cost of admission: Matinee, $7.50; after 6 p.m. $9.75; 3D movies are available as well.
Contact: Roxy Cinemas, 222 College St., Burlington, VT 05401; (802) 864-FILM.

BEN & JERRY'S: I scream, you scream, we all scream for Ben & Jerry's! Visit the Ben & Jerry's Waterbury Factory and enjoy a 30-minute guided factory tour. Here you will see how their ice cream is made and make sure you sample some of that ice cream in the Scoop Shop. You can't miss Flavor Graveyard where old flavors are buried.
Website: www.benjerry.com
Info: Cost of admission: adults (ages 13–59), $4; seniors (ages 60 and up), $3; kids 12 and under, free.
Contact: Ben & Jerry's Homemade Inc., 30 Community Dr., South Burlington, VT 05403; (802) 882-2047.

VERMONT TEDDY BEAR FACTORY: Who doesn't love a teddy bear? A Vermont Teddy Bear is a must to add to your bear collection. You or your child (come on, it's you) can personalize your teddy bear to what you want and take a tour to see how these bears are born.
Website: www.vermontteddybear.com
Info: The factory is open seven days a week 9 a.m. to 6 p.m.
Contact: Vermont Teddy Bear Factory, 6655 Shelburne Rd., Shelburne, VT 05482; (800) 988-8277.

NEW HAMPSHIRE

New Hampshire is small-town beauty, noted for its cottages, beautiful fall foliage, pristine lakes, and mountainous landscapes. It has also been the backdrop for scenes in *The Thomas Crown Affair* (1968), *A Separate Peace* (1972), *On Golden Pond*, (1981), *Once Around* (1991), *Jumanji* (1995), and other films.

BOAT CRUISE *ON GOLDEN POND*

This 1981 film was nominated for an Academy Award for Best Motion Picture and its stars– Katharine Hepburn and Henry Fonda–won for Best Actress and Best Actor. The boating scenes were filmed in Squam Lake, New Hampshire, and you can take a 90-minute boat cruise on the lake too. You will learn about the lake's history, learn about the film, and look for some beautiful wildlife.

Website: www.nhnature.org

Info: Cost of admission: $19 to $27. Cruises are available May 20–June 30: daily at 1 p.m. July 1 to August 31: daily at 11 a.m., 1 p.m., 3 p.m. September 1 to October 9: Tuesday, Wednesday, Thursday at 11 a.m., 1 p.m., and Friday through Monday at 11 a.m., 1 p.m., 3 p.m. Advance reservations are strongly recommended. Each boat has a maximum passenger capacity set by NH Marine Patrol. Space on all cruises is limited. Seats are guaranteed for those making advance reservations and payment.

Contact: Squam Lakes Natural Science Center, 23 Science Center Rd., Holderness, NH 03245; (603) 968-7194.

RHODE ISLAND

Moviemaker magazine once named Providence, Rhode Island, one of the best places to live and work as a moviemaker, but the entire state is popular in the filming community. The reason is simple—it's home to beautiful architectural buildings and is a perfect balance of historical and modern development. It is also where such films as *Dan in Real Life* (2007), *Infinitely Polar Bear* (2014), *There's Something About Mary* (1998), and *Moonrise Kingdom* (2012) shot scenes.

ROSECLIFF MANSION

Film buffs might recognize this home from such films as *The Great Gatsby* (2013), *True Lies* (1994), *Amistad* (1997), and *27 Dresses* (2008). Rosecliff is a lavish mansion located in Newport, Rhode Island, that was built in 1899 for $2.5 million by Nevada silver heiress Theresa Fair Oelrichs. You can tour the inside of this posh place.

Website: www.newportmansions.org

Info: The Preservation Society of Newport County has a year-round operating schedule. However, some houses are open only seasonally. Check the calendar on the website for the most recent schedule.

Contact: The Preservation Society of Newport County, 424 Bellevue Ave., Newport, RI 02840; (401) 847-1000.

MAINE

Home to the tallest mountain on the Atlantic Coast, Maine is a hiker's paradise. It has picturesque landscapes, small towns, and beautiful areas on the water. All of this is a perfect recipe for directors to film. Throughout the years, Maine has been home to many filming locations, including *Carousel* (1956), *Peyton Place* (1957), *Pet Sematary* (1989), *The Man Without a Face* (1992), *Forrest Gump* (1994), *Jumanji* (1995), and *The Cider House Rules* (1998).

Statue Alert! John Ford

John Ford is one of the most famous directors in the history of Hollywood. Known for his westerns, he directed 130 films from 1914 to 1965 including *Iron Horse* (1924), *Stagecoach* (1939), *The Grapes of Wrath* (1940), *How Green Was My Valley* (1941), and *The Quiet Man* (1952). His hometown of Portland, Maine—where he moved to when he was a young child—honored the director with a ten-foot-tall bronze statue in 1998. According to Public Art Portland, the director's chair sits on a rock base that represents the rock formations of Monument Valley in Utah and Arizona, where Ford shot many of his westerns. There are also six four-foot high granite blocks with the names of the director's six Oscar-winning films.

WEBSITE: www.publicartportland.org/project/the-john-ford-statue

INFO: The statue is located at Gorham's Corner, intersection of Fore St., Pleasant St., York St., and Center St.

CONTACT: 389 Congress St., Portland, ME 04101; (207) 874-8901.

STEPHEN KING TOUR

Author Stephen King has kept readers on the edge of their seats for years with his many horror and suspense books, including *Carrie*, *It*, *The Shining*, and *Rita Hayworth and Shawshank*

Redemption. He also wrote the screenplays for *Pet Sematary* and *Cat's Eye*. If you want to see where King found his motivation and ideas, buy a ticket for a tour by SK Tours in Bangor, Maine, where the bestselling author has worked and lived for years.

Website: https://sk-tours.com

Info: Tours are $45.

Contact: SK Tours, 25 Thomas Hill Rd., Bangor, ME 04401; (207) 947-7193.

This tour will take you to approximately 30 places that have inspired King, as well as actual film locations from his movies, such as Mt. Hope Cemetery, where parts of *Pet Sematary* were filmed. You will even see King's current residence.

But wait, there's more!

If you're a fan of Stephen King's *Rita Hayworth and Shawshank Redemption,* which was then turned into the hit feature film *Shawshank Redemption*, check out the Ohio section of the book. You'll find an extremely popular *Shawshank Redemption* tour based in Ohio.

OTHER THINGS TO SEE OR DO IN MAINE

ACADIA NATIONAL PARK: Many hikers like the challenge that is Acadia National Park. Located in Maine, Acadia National Park has 47,000 acres and more than 120 miles to explore. Don't worry. You don't need to be an expert hiker in order to tackle these trails. There are some for the beginners and families who just want to take a stroll to the more advanced trekker.
Website: www.nps.gov/acad/index.htm
Contact: (207) 288-3338.

CONNECTICUT

This southern New England state is chock-full of larger cities and smaller towns. Parts of Connecticut are draped on the water, and all of these ingredients makes it an ideal location for filming. Filmed here throughout the years have been *Holiday Inn* (1942), *Far From Heaven* (2002), *And So It Goes* (2014), *The Stepford Wives* (2004), *Amistad* (1997), and *Revolutionary Road* (2008).

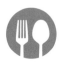

Foodie Fact! Mystic Pizza

One movie and one little pizzeria in Mystic, Connecticut, gets put on the map. The story goes that screenwriter Amy Jones was spending the summer in the area and found the Mystic Pizza store and then chose it as the setting of her movie. The movie of the same name, *Mystic Pizza*, which was released in 1988, didn't just put the restaurant on the map, it put Julia Roberts on Hollywood's radar. Roberts went on to star in such movies as *Pretty Woman*, *Erin Brockovich*, *Valentine's Day*, and *Ocean's Eleven*. There are now two locations where you can enjoy a "slice of heaven," with the second in North Stonington, Connecticut.

WEBSITE: www.mytogo.co/Mystic_Pizza_Main

INFO: The restaurant is open daily 10 a.m. to 11 p.m.

CONTACT: Mystic Pizza, 56 W Main St., Mystic, CT 06355; (860) 536-3700.

THE BARKER CHARACTER, COMIC & CARTOON MUSEUM

Where do you begin with this museum? It's best to start at the beginning. The beginning is when Gloria and Herbert Barker started collecting items when they were kids that had to do with their favorite television shows and films as well as other parts of their childhood. Almost 80,000 items later, some of which go back as far as 1873, they opened the Barker Character, Comic

If you think you have a big film/TV collection, check out the Barker Character, Comic & Cartoon Museum, which has 80,000 items.

& Cartoon Museum in September 1997. You can take a selfie with a life-size Homer Simpson from *The Simpsons*, the longest-running cartoon on television today. The collection is amazing. You'll see collectors' items from the early days of Walt Disney, Shirley Temple, Edgar Bergen's Charlie McCarthy character, Howdy Doody, Looney Tunes, and so much more.

Website: www.barkermuseum.com

Info: Cost of admission: $5 for adults and $3 for children 4–17; under 3 is free. The museum is open to the public Wednesday through Saturday, noon to 4 p.m.

Contact: The Barker Character, Comic & Cartoon Museum, 1188 Highland Ave., Cheshire, CT 06410; (203) 272-2357.

THE WITCH'S DUNGEON MUSEUM

This horror and sci-fi cinema museum, located in Bristol, Connecticut, started in 1966, and its life-size figures have been a tribute to the most-respected actors in the industry, including Lon Chaney (*The Phantom of the Opera*), Boris Karloff (*Frankenstein; Abbott & Costello Meet the Killer*), Bela Lugosi (*Dracula*), and

The Witch's Dungeon Museum pays homage to some of the creepiest characters in film.

Vincent Price (*Abbott and Costello Meet Dr. Jekyll and Mr. Hyde*). Through the years, visitors to The Witch's Dungeon Museum have met: Sara Karloff, the daughter of Boris Karloff; Bela G. Lugosi, the son of actor Bela Lugosi; Ron Chaney, the grandson of Lon Chaney Jr.; and others. If you are into these creepy characters, you'll love this museum.

Website: www.preservehollywood.org

Info: It's not open all year long, so check the website for the exact dates and times.

Contact: The Witch's Dungeon Museum, 98 Summer St., Bristol, CT 06010; (860) 583-8306.

THE KATE: KATHARINE HEPBURN THEATER AND MUSEUM

Katharine Hepburn's Hollywood career lasted a lengthy 60 years and included such movies as *Bringing Up Baby* and *The African Queen* as well as a list of movies with her most famous costar, Spencer Tracy. Together, the duo starred in *Woman of the Year, Guess Who's Coming to Dinner, Adam's Rib*, and *Keeper of the Game*.

Hepburn was born and raised in Connecticut by wealthy parents and often vacationed in Old Saybrook. She retired to this home in 1997, and the town hall in Old Saybrook named the renovated building after the legend and built a museum in her honor. The museum is part of the Katharine Hepburn Cultural Arts Center which hosts a variety of performances, including ballets, off-Broadway productions, and regular showings of Hepburn's movies. In the lobby of the theater, you can see photographs from Hepburn's life and career, her Emmy Award, and a self-portrait that Katharine painted.

Website: http://katharinehepburn theater.org

Info: The museum is open during box office hours and performances, so check the website to see when that is.

Contact: The Kate: Katharine Hepburn Theater and Museum, 300 Main St., Old Saybrook, CT 06475; (860) 510-0473.

OTHER THINGS TO SEE OR DO IN CONNECTICUT

MARK TWAIN MUSEUM: Samuel Langhorne Clemens wrote many novels under his pen name of Mark Twain, including *The Adventures of Tom Sawyer* (1876) and *Adventures of Huckleberry Finn* (1885). His novels have also become the basis of many movies, including *The Adventures of Mark Twain* (1944), *The League of Extraordinary Gentlemen*, and more. The Mark Twain House and Museum in Hartford, Connecticut, is the place to see if you're a fan of the novelist's work. It opened in 2003, and there are exhibits on Twain's life and work.

Website: www.marktwainhouse.org

Info: The house and museum is open daily (Sunday through Saturday) 9:30 a.m. to 5:30 p.m. They are closed on Tuesdays in January and February.

Contact: The Mark Twain House & Museum, 351 Farmington Ave., Hartford, CT, 06105; (860) 247-0998.

MYSTIC SEAPORT: Do you or your children love *Pirates of the Caribbean?* Then visit Mystic Seaport, where you'll get an up-close and personal view of historic vessels. Parts of the 1997 film *Amistad* were filmed here as well. There are exhibits, a planetarium, and gardens, and you have the ability to get out on the water.

Website: www.mysticseaport.org

Info: Cost of admission: adult, $28.95; senior (ages 65+), $26.95; youth (ages 4–14), $18.95; children (3 and younger), free.

Contact: Mystic Seaport, 75 Greenmanville Ave., Mystic, CT 06355; (860) 572-0711.

PENNSYLVANIA

Pennsylvania is filled with rich history of the United States, including Independence Hall and the Liberty Bell. There are mountains, farmland, small and big cities, all available to Hollywood, but when most people think of Pennsylvania and movies, most likely they are thinking of the iconic scene in the film *Rocky*. So many other films have been shot here as well, including *Dressed to Kill* (1980), *Trading Places* (1983), *Philadelphia* (1993), and *Twelve Monkeys* (1995).

Statue Alert! Rocky

Put your arms over your head, take a deep breath, and start running up the 72 stone steps that are located outside the entrance of the Philadelphia Museum of Art in Philadelphia, Pennsylvania. Can you hear "Gonna Fly Now" playing somewhere? Take those steps two at a time if you want because you're making the same climb that Rocky Balboa made in *Rocky*. Sylvester Stallone portrayed the small-time boxer who gets a rare chance to fight the heavyweight champ Apollo Creed in the 1976 movie that received 10 Oscar nominations in nine categories at the 49th Academy Awards, winning Best Picture. The film also starred Burgess Meredith (Mickey), Talia Shire (Adrian), and Carl Weathers (Apollo).

Once you're done recreating the iconic stairs scene, take out your camera and get a selfie with the man himself. There is a bronze statue of Rocky located at the bottom right of the steps.

WEBSITE: www.philamuseum.org

INFO: Cost of admission: adults, $20; seniors (65 & over), $18; students (with valid ID), $14; youth (13–18), $14; children (12 and under) and members, free. The museum is open Tuesday to Sunday 10 a.m. to 5 p.m.; Wednesday and Friday, the main building is open until 8:45 p.m. Closed Monday except for some holidays.

CONTACT: Philadelphia Museum of Art, 2600 Benjamin Franklin Pkwy., Philadelphia, PA 19130; (215) 763-8100.

THE PRINCESS GRACE MUSEUM (COMING SOON!)

The stunningly beautiful Grace Kelly, who started as an actress and then became Princess of Monaco, will be getting her own museum in Philadelphia. Her childhood home will be turned into a museum by 2018, according to her son, Prince Albert of Monaco, who purchased the home for $754,000 after the owner passed away. The home needs some work before it's opened for visitors.

Before retiring from acting in her early 20s, Kelly appeared in several movies, including *The Country Girl* (1954), *High Noon* (1952) with Gary Cooper, *Dial M for Murder* (1954) with Ray Milland, *Rear Window* (1954) with Jimmy Stewart, *To Catch a Thief* (1955) with Cary Grant, and *High Society* (1956) with Frank Sinatra and Bing Crosby.

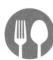

Foodie Fact! *It's Always Sunny in Philadelphia*

It's Always Sunny in Philadelphia is a black comedy sitcom that premiered on FX in 2005 and moved to FXX at the beginning of the ninth season. It stars Glenn Howerton, Charlie Day, Rob McElhenney, Kaitlin Olson, and Danny DeVito. The series follows The Gang, friends who run the Irish bar Paddy's Pub in South Philadelphia. The show's renewal of the 13th and 14th seasons ties it with *The Adventures of Ozzie and Harriet* as the longest running live-action sitcom in American TV history.

In real life, Paddy's Pub is not really Mac's Tavern, but it's the closest you can get for something for the show. Mac's Tavern is actually owned by two of the *It's Always Sunny in Philadelphia* stars, the real-life couple of Rob McElhenney and Kaitlin Olson.

The menu includes skillet mac and cheese, Mac's Gravy Fries, Grilled Chicken Wrap, Mac's Chili, The Bourbonic Steak Sandwich, and Buffalo Chicken Cheesesteak as well as a large selection of ales and cocktails.

WEBSITE: http://macstavern.com

INFO: The restaurant is open Monday 4 p.m. to 2 a.m., Tuesday through Sunday 11 a.m. to 2 a.m.

CONTACT: Mac's Tavern, 226 Market St., Philadelphia, PA 19106; (267) 324-5507.

Reports claim that in addition to its role as a museum, the Princess Grace museum will serve as a branch for the Princess Grace Foundation and Monaco's Princess Grace Irish Library, and there will be public programming, lectures, readings, concerts, and children's activities.

MACK TRUCK HISTORICAL MUSEUM

Calling all movie buffs! Get a glimpse of Megatron from the Transformers series at the Mack Truck Historical Museum in Lehigh Valley. Trucking fans can learn about how these powerful vehicles have changed over the years. And best of all? Admission to the Mack Truck Museum is free!

Website: www.macktruckshistoricalmuseum.org

Info: Cost of admission: free. The museum is open Monday, Wednesday, and Friday 10 a.m. to 4 p.m. (last tour starts at 3 p.m.).

Contact: Mack Truck Historical Museum, 2402 Lehigh Pkwy. South, Allentown, PA 18103; (610) 351-8999.

MISTER ROGERS

Fred Rogers was a soft-spoken man, known for his show *Mister Rogers' Neighborhood*, which ran on PBS from 1968–2001. There were a total of 895 episodes that all began with Mister Rogers asking the same question in song, "Won't You Be My Neighbor?" He then changed into sneakers and a zippered cardigan sweater.

There are several venues throughout Pennsylvania where fans of the show and of Mister Rogers can see items from the show and his career, including:

The Fred Rogers Memorial Statue

Located on the North Shore near Heinz Field in Pittsburgh, the statue measures 10 feet, 10 inches in height and weighs more than 7,000 pounds. Of course, Rogers is seated and tying his shoes.

Senator John Heinz History Center

Located in Pittsburgh, Pennsylvania, the Senator John Heinz History Center has an entire collection of original props from the *Mister Rogers' Neighborhood* television set on public view. This collection includes the entryway and living room set that Mister

Website: www.heinzhistorycenter.org/exhibits/mister-rogers-neighborhood

Info: Cost of admission: adults, $16; senior citizens (62+), $14; retired and active duty military, receive $2 off of admission; students with a valid school ID, $6.50; children ages 6–17, $6.50; children ages 5 and under, free; History Center Members, free. The center is open 10 a.m. to 5 p.m. daily.

Contact: Senator John Heinz History Center, 1212 Smallman St., Pittsburgh, PA 15222; (412) 454-6000.

Rogers walked through to begin each show; King Friday XIII's Castle; Great Oak Tree, the residence of Henrietta Pussycat and X The Owl; Picture Picture, the display that helped Mister Rogers teach children using interactive media; McFeely's "Speedy Delivery" tricycle; and a variety of additional items from the "Neighborhood of Make-Believe." The display also includes a lifelike figure of Mister Rogers with his sweater, necktie, khakis, and sneakers.

Fred M. Rogers Center

A Fred Rogers exhibit is located on the upper level of the Fred M. Rogers Center building at Saint Vincent College in Rogers' hometown of Latrobe, Pennsylvania. The exhibit covers the life and influence of

Website: www.fredrogerscenter.org

Info: The exhibit is open to the public during building hours, 8:30 a.m. to 4:30 p.m. Monday through Friday.

Contact: Fred M. Rogers Center, 300 Fraser Purchase Rd., Latrobe, PA 15650-2690; (724) 805-2750.

Rogers and includes narratives, photos, and artifacts from *Mister Rogers' Neighborhood*, video screens with clips of programs and interviews, and a "Speedy Delivery" letter-writing station for visitors.

Children's Museum of Pittsburgh

This exhibit has been in place at the Children's Museum since 1988. What can you see at the museum? You can see the original puppets from *Mister Rogers' Neighborhood* including King Friday XIII, Queen Sarah Saturday, Henrietta Pussycat, X the Owl, Lady Elaine Fairchilde, Daniel Striped Tiger, and Gran Pere. There's the iconic Mister Rogers' sweater located in the Makeshop, where kids can learn how to sew, build, and more.

There's also his iconic blue sneakers. Before you know it, you'll be singing, "It's a beautiful day in this neighborhood, a beautiful day for a neighbor, would you be mine? Could you be mine? Won't you be my neighbor?"

THE JIMMY STEWART MUSEUM

Hollywood has its legendary actors, and Jimmy Stewart is definitely one of them. Although he's widely known for his role as George Bailey in the 1946 holiday classic *It's a Wonderful Life*, Stewart had an incredible acting career starring with Cary Grant and Katharine Hepburn in George Cukor's *The Philadelphia Story* (1940), for which he also won his only Academy Award in a competitive category (Best Actor, 1941). He also had roles in *No Time for Comedy* (1940) with Rosalind Russell and *Come Live with Me* (1941) with Hedy Lamarr, with the Judy Garland musical *Ziegfeld Girl* and *Pot o' Gold*, featuring Paulette Goddard.

Website: www.jimmy.org

Info: Cost of admission: adults, $8; seniors (62+), military personnel, students, $7; children (7–17), $6; children under 6, free. The museum is open year-round, Monday through Saturday 10 a.m. to 4 p.m., Sunday noon to 4 p.m.

Contact: The Jimmy Stewart Museum, 835 Philadelphia St., Indiana, PA 15701; (724) 349-6112.

Fans of the legendary Jimmy Stewart will want to visit The Jimmy Stewart Museum in Indiana, Pennsylvania, the actor's hometown. The museum hosts film presentations and gallery talks, and displays photos from his career, family life, and military days. You can watch movies in the 1930s vintage movie theater. There is also a statue of Jimmy Stewart outside the courthouse.

THE STOOGEUM

Nyuck! Nyuck! Nyuck! Fans of the crazy Three Stooges *soitenly* have to visit The Stoogeum in Ambler, Pennsylvania, which has more than 100,000 pieces of Stooge memorabilia.

Did you know that there were actually six stooges throughout the lifetime of the act, but Moe Howard, Larry Fine, and Jerome "Curly" Howard were the most well-known for their whoop, whoop, whoop! From 1934 to 1946, Moe, Larry, and Curly produced over 90 short films for Columbia. The Three Stooges, who were known for their vaudevillian slapstick comedy routines, appeared in a total of 220 films through their career.

The Stoogeum includes movie posters, artwork, movie props and costumes, games, bowling balls and other novelties, personal effects, and hundreds of rare photos.

Website: http://stoogeum.com

Info: Cost of admission: adults, $10; seniors (65+), $8; students (13+, with ID), $8; military, $8; children 12 and under, free. The Stoogeum is open every Thursday (except holidays) 10 a.m. to 3 p.m. Keep in mind that no photography is allowed inside the museum.

Contact: The Stoogeum, 904 Sheble Ln., Ambler, PA 19002; (267) 468-0810.

JAMES A. MICHENER ART MUSEUM

Why is there an art museum in a film and television travel book? It's for James A. Michener, known for his work on *South Pacific* (1958), *Sayonara* (1957), and *The Bridges at Toko-Ri* (1954).

Website: www.michenerartmuseum.org

Info: Cost of admission: adult, $18.00; senior, $17.00; college student with valid ID, $16.00; youth (ages 6–18), $8.00; children under 6, free. Members: free. The museum is open Tuesday through Friday 10 a.m. to 4:30 p.m., Saturday 10 a.m. to 5 p.m., Sunday noon to 5 p.m.

Contact: James A. Michener Art Museum, 138 S. Pine St., Doylestown, PA 18901; (215) 340-9800.

THE ANDY WARHOL MUSEUM: The Andy Warhol Museum is located in Pittsburgh, Pennsylvania, and has extensive collections of Warhol's art, with more than 250 restored Warhol films and more than 4,000 paintings, prints, drawings, photos, sculptures, and installation.

Website: www.warhol.org

Info: Cost of admission: adults, $15; senior citizens (55+), $9; students with valid ID, $8; children (3–18), $8; group rates and discounts available. The museum is open Sunday, Tuesday through Thursday, and Saturday 10 a.m. to 5 p.m., Friday 10 a.m. to 10 p.m.

Contact: The Andy Warhol Museum, 117 Sandusky St., Pittsburgh, PA 15212.

MASSACHUSETTS

Another state known for its rich colonial history, Massachusetts is home to the Freedom Trail, Bunker Hill, and other important sites related to the American Revolution. Of course it's also home to the Boston Red Sox and Fenway Park. When it comes to its film and television history, that's pretty rich too. The movies that have been filmed here include *Who's Afraid of Virginia Woolf?* (1965), *Jaws* (1975), *The Thomas Crown Affair* (1968), *The Judge* (2014), and of course *Good Will Hunting* (1997).

CHEERS

If you want to go where everybody knows your name, or at least knows the name of every character on the megahit NBC sitcom *Cheers*, this is the place to visit. There are two Boston

Foodie Fact!

Good Will Hunting is the award-winning 1997 film that starred Robin Williams, Matt Damon, Ben Affleck, Minnie Driver, and Stellan Skarsgård. The movie is about Will Hunting (Damon), a genius who assaults a police officer and becomes a client of a therapist (Williams). At the 70th Academy Awards, *Good Will Hunting* earned Robin Williams an Academy Award for Best Supporting Actor and Affleck and Damon won the Academy Award for Best Original Screenplay.

The L Street Tavern in Boston was used for several scenes in the movie and has become a popular spot for those who are fans of the flick. This Irish bar doesn't serve food, just munchies. The bar has undergone remodeling, but still looks like the famous scene in the movie. How do you like them apples!?

WEBSITE: www.facebook.com/L-Street-Tavern-148636346441

INFO: The Tavern is open noon to 1 a.m. daily.

CONTACT: L Street Tavern, 658 E 8th St., Boston, MA 02127; (617) 268-4335.

Foodie Fact! Wahlburgers

Mark Wahlburg was once known as Marky Mark and his brother, Donnie, was known for starting the famous band New Kids on the Block. Mark went on to have an acting career, including an Academy Award nomination for his role in *The Departed* as Dignam.

Mark and Donnie, together with their brother Paul, own the Wahlburgers chain of restaurants, with locations in Massachusetts, Florida, Michigan, Nevada, New York, Pennsylvania, and South Carolina. There's no guarantee that you'll see any of the brothers at any of these locations when you stop by for a meal, but it's great to just stop by if you're fans of either of them. You can say you enjoyed the burgers, sandwiches, salads, and other items on the menu. While you wait for your meal, you can debate whether Marky Mark was cuter now or then and if NKOTB is better than 'N Sync.

WEBSITE: www.wahlburgersrestaurant.com

LOCATION: The Hingham Shipyard, 19 Shipyard Dr., Hingham, MA 02043.

locations—Beacon Hill and Faneuil Hall—of the bar that was the inspiration for *Cheers*.

Cheers premiered on September 30, 1982, and stayed on the air until May 1993. It starred Ted Danson, Shelley Long, Kirstie Alley, Rhea Perlman, Kelsey Grammer, John Ratzenberger, Woody Harrelson, George Wendt and Bebe Neuwirth. The sitcom was nominated for Outstanding Comedy Series for all 11 of its seasons on the air, it earned 28 Primetime Emmy Awards from a record of 117 nominations. Kelsey Grammer's character, Frasier Crane, received his own spin-off show, which stayed on the air for an incredible 11 years and won its own list of awards.

Make sure during your visit to the *Cheers* bar you try the Norm Challenge–nope, it's not about

Website: http://cheers boston.com

Info: Opens daily at 11 a.m., and children are allowed until 10 p.m., then 21 and over only.

Contact: Cheers! Beacon Hill, 84 Beacon St., Boston, MA 02108; (617) 227-9605; and Faneuil Hall Marketplace, Quincy Market South, Boston, MA 02109; (617) 227-0150.

drinking the most beer–it's a burger challenge. If you finish the burger, the bar will add your name to the wall. Not in the mood to down a burger? Then you could also choose menu items such as Ma Clavin's Soup, Woody's Garden Greens, Norm's Sandwiches, or Diane's entrées. Sit back and enjoy some live music too.

DR. SEUSS GARDENS AND MUSEUM

Oh the places you'll go! And one of those places needs to be to Springfield, Massachusetts, where you can visit the brand-new Dr. Seuss Gardens and Museum. The gardens opened in 2002 in honor of Ted "Dr. Seuss" Geisel, the author of 60 of the most famous children's books ever written, many of which have been turned into cartoons and movies including *The Cat in the Hat* starring Mike Myers; *Horton Hears a Who!*, an animated movie; and *How the Grinch Stole Christmas* starring Jim Carrey.

Ted's stepdaughter, who is noted sculptor Lark Grey Dimond-Cates, was selected to make over 30 bronze statues for the museum's grounds.

In 2017, The Amazing World of Dr. Seuss also opened in Springfield. This

Website: www.seussinspring field.org

Info: Cost of admission: adults, $25; seniors, $16.50; college students with ID, $16.50; children 3-17, $13; children 2 and under, free. History Library & Archives only $9. Springfield Museums & Museum Store is open Monday through Saturday 10 a.m. to 5 p.m. and Sunday 11 a.m. to 5 p.m.

Contact: Dr. Seuss Gardens and Museum, 21 Edwards St., Springfield, MA 01103; (800) 625-7738.

highly anticipated center features the interactive exhibition *The Amazing World of Dr. Seuss*, as well as a re-creation of Geisel's studio, an exhibition about the making of the Dr. Seuss National Memorial Sculpture Garden and other related displays. The 3,200 square foot museum is being built to promote reading and is located on the first floor of the William Pynchon Memorial Building. The museum also includes Geisel's memorabilia, including original oil paintings, zany hats and bow ties, and actual furniture from his home, including his drawing board.

ON LOCATION TOURS

On Location Tours will take you to the filming locations from TV shows and movies filmed in the Boston area such as *American Hustle, The Heat, The Departed, Good Will Hunting, Cheers, The Town, Legally Blonde, Ally McBeal, Mystic River, Boston Legal, Knight & Day, 21, Fever Pitch, Gone Baby Gone,* and more! They also offer a 1½-hour Boston Movie Mile Walking Tour, where you can stroll Boston and explore the locations made famous by over 30 TV shows and movies. This tour leaves from the Boston Common Convention Visitors Bureau, 139 Tremont St.

Website: https://onlocationtours.com/tour/boston-tv-movie

Info: The cost of the walking tour ranges from $17 to $23. These tours are private tours and need to be arranged, and the cost depends on the tour package that you purchase. The walking tour is not offered from November through March (it's Boston after all!).

Contact: On Location Tours, (212) 683-2027.

OTHER THINGS TO SEE OR DO IN MASSACHUSETTS

WOMEN AT WORK MUSEUM: In Attleboro, Massachusetts, the Women at Work Museum has exhibits and events that chronicle and honor the role of women in the workplace. They have such exhibits as the publication of Mary Wollstonecraft's *A Vindication of the Rights of Woman* in 1792 and the speeches of Elizabeth Cady Stanton in 1840. Past exhibits include an exhibit on Diane Crump, the one woman competitor in the Kentucky Derby.

Website: www.womenatworkmuseum.org

Info: The museum is open Saturday 11 a.m. to 4 p.m.

Contact: Women at Work Museum; 35 County St.; Attleboro, MA 02703; (508) 222-4430.

ERIC CARLE MUSEUM: Another one of the most popular and beloved children's authors today, Eric Carle brought our children 70 wonderful books, including *The Very Hungry Caterpillar* and *Brown Bear, Brown Bear, What do you see?* The museum was founded by Carle himself, and is located in Amherst, Massachusetts. There are interactive exhibits, art studios, storytimes, and films. You and your children will love being immersed in the world of Eric Carle.

Website: www.carlemuseum.org

Info: The museum is open Tuesday to Friday 10 a.m. to 4 p.m., Saturday 10 a.m. to 5 p.m., and Sunday noon to 5 p.m.

Contact: The Eric Carle Museum of Picture Book Art, 125 West Bay Rd., Amherst, MA 01002.

SOUTH

ARKANSAS

Arkansas is known for its parks, wilderness, mountains, caves, rivers, and hot springs. There's so much to see and do and, over the years, many movies have been filmed here, including *Sling Blade* (1996), *End of the Line* (1987), and *Thelma & Louise* (1991).

THE OLD MILL FROM *GONE WITH THE WIND*

Georgia isn't the only place that fans of the classic 1939 movie *Gone With the Wind* should travel to. There's a building in Arkansas called The Old Mill that appears in the opening scenes and it is believed to be the only building remaining from the film. Constructed in 1933, the building was designed to look as if it were right out of the 1800s, and it is listed on the National Register

Statue Alert! Popeye

Blow me down! Alma, Arkansas, calls itself the Spinach Capital of the World, so it's only appropriate that they have a bronze 8-foot statue of everyone's favorite sailor man, Popeye and, of course, it's located in Popeye Park. Popeye started out as a comic strip and then became a television show, and Robin Williams portrayed the muscular sailor in the 1980 film *Popeye*. Popeye, his gal pal Olive Oyl, and his friends have appeared in other movies as well.

WEBSITE: www.arkansas.com/attractions/detail/popeye -statue/92001

INFO: Popeye Park, 801 Fayetteville Ave., Alma, AR 72921; (479) 632-4127.

DID YOU KNOW?
If you're a fan of Robin Williams' *Popeye* (1980), you should plan a trip to the actual set that was built for the movie, located on the island of Malta. Popeye Village Malta was constructed in Anchor Bay during the last 7 months of 1979 and has become one of Malta's major tourist attractions. For more information, visit https:// popeyemalta.com.

Website: www.northlittlerock.org/attractions_detail/285

Info: Cost of admission: free. The mill is open 6 a.m. to 30 minutes after sunset. Guided tours of 30 minutes are available for groups of 10 or more.

Contact: The Old Mill, 3800 Lakeshore Dr., Lakeshore Dr. and Fairway Ave., North Little Rock, AR 72116; (501) 758-1424.

of Historic Places. Rand Brooks (Charles Hamilton) and Ann Rutherford (Carreen O'Hara) have visited the mill.

CHAFFEE BARBERSHOP MUSEUM

In 1958, singer Elvis Presley famously received a haircut from a US Army barber at the Chaffee Barbershop in Fort Smith, Arkansas. The Chaffee Barbershop Museum honors that fateful day when The King was seen getting his hair clipped. The museum also has memorabilia from the movies *Biloxi Blues* (1988), *The Tuskegee Airmen* (1995), and *A Soldier's Story* (1984) all which were all filmed at Fort Chaffee.

Website: http://chaffee crossing.com

Info: Cost of admission: free. The museum is open Monday through Saturday 9 a.m. to 4 p.m. except on national holidays.

Contact: The Chaffee Barbershop Museum, 7313 Terry St., Fort Smith, AR; (479) 434-6774.

MISSISSIPPI

Down south, Mississippi is a beautifully wooded area with peaceful waters, white sandy beaches along the Gulf of Mexico, and glorious historic homes. Hollywood has called numerous times and films such as *The Help* (2011), *O, Brother Where Art Thou?* (2000), *Big Bad Love* (2001), and *Cookie's Fortune* (1999) have all been shot here.

ELVIS PRESLEY'S BIRTHPLACE

The King of Rock and Roll might have lived in Tennessee's Graceland once he was a superstar, but he was born and raised in Tupelo, Mississippi. If you're a fan of the singer and of his famous movies such as *Viva Las Vegas, Blue Hawaii,* and *Girls! Girls! Girls!,* then a trip to this city is a must because there is so much of Elvis' life to experience. Start your visit by taking a tour of the two-room house built by Elvis' father, grandfather, and uncle.

Then, get that camera ready because there is a bronze statue of 13-year-old Elvis displayed at the Elvis Presley Birthplace Park and it's your opportunity for a photo op.

Then head over to the actual church where Elvis attended services, heard rich Southern gospel music, and learned how to play guitar. Make sure you take a few moments at the meditative place that Elvis dreamed of having, located in the Elvis Presley Birthplace Park.

Website: https://elvispresleybirth place.com

Info: The museum is open Monday through Saturday 9 a.m. to 5 p.m. and Sunday 1 p.m. to 5 p.m.

Contact: Elvis Presley Museum, 306 Elvis Presley Dr., Tupelo, MS 38801; (662) 841-1245.

There's also the Fountain of Life, with 13 waterspouts that represent the years when Elvis lived in Tupelo. Finally, stop at the Elvis Presley Museum and pick up a souvenir, while you peek at the memorabilia from Elvis' childhood and his music. Tupelo also holds a fan day every year, so you might want to time your visit to enjoy the festivities.

But wait, there's more!

Once again, all Elvis Presley fans should have Graceland, located in Memphis, Tennessee, on your list of must-sees. You'll be saying "Thank you, thank you very much," when you read about all the things you can see and do if you are a fan.

FLORIDA

It's called the Sunshine State for a reason, and filmmakers love it. From the beaches to the theme parks and the small towns, Florida makes a perfect filming location. Remember *The Adventures of Superboy* (1988–1990), *Burn Notice* (2007–2013), *Cougar Town* (2009–2015), *CSI: Miami* (2004–2012), *Dexter* (2006–2013), and of course *Miami Vice* (1984–1988)? Those are just a few of the television shows that have been filmed here. When it comes to feature films, the list is extensive. It's no wonder Florida was nicknamed "Hollywood East."

PIPPI LONGSTOCKING

Swedish author Astrid Lindgren wrote a series of books about the redheaded nine-year-old little girl, Pippi Longstocking. Her adventures were made into movies, including the 1969 *Pippi Longstocking* and the 1988 version, *The New Adventures of Pippi Longstocking,* which was partly filmed in Amelia Island, Florida. In Old Town, the Captain's House, which is also known as the "Downes House," was used for filming. The Amelia Island Transportation and Trolley Tours will take you and your guests by this gorgeous house on a tour.

Website: www.ameliaisland trolleys.com

Info: There is no tour inside the home. It is currently privately owned, but if you or your child is a fan of the movie, you will appreciate seeing the home.

Contact: Amelia Island Transportation and Trolley Tours, 1014 Beech St., Fernandina Beach, FL 32034; (904) 753-4486.

STAR WARS CELEBRATION

The Star Wars Celebration, which takes place every other year, is perfect for the fan who wants to see movie memorabilia, meet cast members, meet other superfans, and get autographs from those associated with the *Star Wars* movies. Celebration is the official, definitive *Star Wars* event, with entertainment, interactive experiences, and exclusives that can only be found at this Lucasfilm production. In 2017, the event took place in

Website: www.starwars celebration.com

Orlando, Florida. Visit the website for details on the upcoming 2019 celebration.

But wait, there's more!

In case you missed it, *Star Wars* fans should flip back to the California section where you'll find information on Rancho Obi-Wan in Petaluma, California, and the George Lucas' Museum of Narrative Art that will open soon in Los Angeles, California. There's also a Yoda statue alert!

CRUISE *THE AFRICAN QUEEN*

The African Queen, released in 1951, was the only movie that actor Humphrey Bogart won an Academy Award for and this one was for Best Actor for his portrayal of Charlie Allnut. *The African Queen* also stars the legendary Katharine Hepburn as Rose Sayer.

At one time, the actual steamboat that was used in the film sat in a dock in Key Largo, Florida, largely ignored. The boat was restored by a lifelong Bogart fan, Jim Hendricks Sr., and it is said that Hendricks had rescued it from a cow pasture in Ocala, Florida, and then purchased it for $65,000. Approximately $70,000 was then invested to get the boat back to operational status. Today, it is used to take guests on 90-minute cruises in and around Key Largo. Imagine sitting exactly where Humphrey Bogart and Katharine Hepburn once sat!

A little history on the boat: It wasn't created for the movie. In fact, it was built in 1912 at Lytham shipbuilding in England. According to the African Queen Canal Cruises, the boat was once called the S/L Livingstone and was shipped to the British East Africa Railways company on the Victoria Nile and Lake Albert. It was here that she carried mercenaries, missionaries, cargo, and hunting parties on their voyages.

Website: http://africanqueen flkeys.com

Info: The 90-minute canal cruise is $49 and leaves at 10 a.m., noon, 2 p.m., 4 p.m., and 6 p.m. On Friday and Saturday nights, there is a two-hour canal cruise that includes a three-course dinner at the Pilot House Restaurant and Marina. That dinner cruise is $89.

Contact: (305) 451-8080.

African Queen Canal Cruises offer 1½-hour cruises that depart from the Marina Del Mar and travel down the Port Largo Canals to the Atlantic Ocean before turning around to return.

There are also two-hour cruises that depart from the Marina Del Mar and travels down the Port Largo Canals to the Pilot House Marina and Restaurant. Here, guests disembark the *African Queen* and enjoy a meal before returning to the vessel and heading back to Marina Del Mar.

The *African Queen* boat is now on the National Register of Historic Places.

But wait, there's more!

If you're a fan of Katharine Hepburn and her movies, check out the Performing Arts Center named after her in Connecticut. There is a lobby filled with memorabilia on her life. In New York City, you can see the building where Bogart lived as a child.

HUMPHREY BOGART FILM FESTIVAL

The famous boat from *The African Queen* movie found its permanent home in Key Largo, Florida, which is the perfect destination for it since its star, Humphrey Bogart, also starred in the 1948 hit film, *Key Largo*. *Key Largo*, a classic John Huston film, also starred Lauren Bacall, Lionel Barrymore, Claire Trevor, and Edward G. Robinson. The film focuses on a man who visits his old friend's hotel and finds a gangster is running things.

Every October, Key Largo, Florida, is also home to the four-day Humphrey Bogart Film Festival, which honors Bogie, as well as his films and his life. The festival also pays homage to the golden era of cinema. The festival hosts cocktail receptions featuring none other than Bogart's Gin, as well as roundtable discussions, family-owned memorabilia, dancing, dining, and more. The event is hosted by Stephen Bogart, the son of Bogie and Lauren Bacall.

Website: http://bogartfilm festival.com

THE TRUMAN SHOW

"Good morning, and in case I don't see ya–good afternoon, good evening, and good night!"

In *The Truman Show,* Jim Carrey plays an insurance salesman/adjuster who discovers that his entire life is actually a television show and the people in his life are merely actors. Much of this 1998 movie was filmed throughout locations in Seaside, Florida, and the home that was used as the outside of Truman's home is now a tourist attraction for many fans to stop and snap that

> **Contact:** The address for the house is 31 Natchez St. in Seaside, Florida. You will see a #36 on the outside of the home, which is the number of Truman's house in the movie.
>
> **Info:** This is a private home which is not open for tours, but the owners are very nice about the fans who want to take photos, so be sure to wave and say hi when you do.

selfie. According to a local real estate website, the owners of the home, Don and Vicky Gaetz, officially dubbed their home "The Truman House," and display the moniker on the sign outside the gate. They even left the house number from the movie—36—fixed above the front door.

TALLAHASSEE AUTOMOBILE MUSEUM

Holy cool ride, Batman! The Tallahassee Automobile Museum is home to a large collection of authentic Batmobiles, including the actual Batmobiles used in the movies *Batman Forever* and *Batman Returns*. You can also see a replica of the Batmobile from the original *Batman* television series, as well as the Penguin's Duck Vehicle from *Batman Returns*, a Bat-Boat, and an array of other Batman movie props.

Holy automobile, Batman! This Batmobile can be found at the Tallahassee Automobile Museum.

I DREAM OF JEANNIE

I Dream of Jeannie was a hit comedy show on NBC that ran from 1965 to 1970. It starred the beautiful Barbara Eden as a genie and Larry Hagman as Tony Nelson, an astronaut who finds her bottle and becomes her master. They eventually fall in love and marry, but their daily lives are filled with mayhem.

Because of Tony Nelson's astronaut connection, Cape Canaveral was often mentioned on the show. Today, The Air Force Space & Missile Museum in Cape Canaveral Air Force Station, Cape Canaveral, Florida, has a permanent exhibit on *I Dream of Jeannie* at their primary facility—Launch Complex 26 at the Cape Canaveral Air Force Station. Keep in mind that none of the show was filmed at this location, but it's the fact that they mentioned Cape Canaveral and the city of Cocoa Beach so often that this area feels a connection to the television show.

It's interesting to note that Barbara Eden has actually visited this exhibit and the Air Force Station in the past and has also visited Launch Complex 43 where she pushed the button to launch a small weather rocket.

The Cape Canaveral area also hosts a Cocoa Beach Half Marathon where all finishers of both the half marathon

Fold your arms and blink and you just might find yourself at Cape Canaveral Air Force Station in Florida, where you can see her bottle.

Website: http://afspacemuseum.org

Info: The museum at Launch Complex 26 is accessible from the "Cape Canaveral: Then and Now" tour that originates from the "Cape Canaveral Early Space Tour" Kennedy Space Center Visitor Complex. The two and one-half hour tour includes a tour of the museum and stops at several historic sites on Cape Canaveral Air Force Station. The tour runs 4 days a week (Thursday, Friday, Saturday, and Sunday), launch schedule permitting.

Address: Cape Canaveral Air Force Station, Cape Canaveral, FL; (321) 853-9171.

and half relay receive the green "Evil Twin Sister" Jeannie bottle medal. They also host an *I Dream of Jeannie* genie costume and look-alike contest.

BOB HOPE TRIBUTE AT THE NAVAL AVIATION MUSEUM

You can't talk about television and film comedy without talking about Bob Hope, who became one of the most legendary entertainers in Hollywood. He was known for movies that he costarred in with Bing Crosby and Dorothy Lamour, including *Road to Singapore* (1940*), Road to Zanzibar* (1941), *Road to Morocco* (1942), *Road to Utopia* (1946), *Road to Rio* (1947), *Road to Bali* (1952), and *The Road to Hong Kong* (1962).

Hope also hosted the Academy Awards a whopping 14 times and has been honored for all the work he did with the United Service Organization (USO) shows and entertaining the troops. The Naval Aviation Museum in Pensacola, Florida—the world's largest naval aviation museum—honors Bob Hope with a display of his items donated by the late entertainer's estate, including a life-size mannequin of him complete with his signature golf club. When you tour the exhibit, you can enjoy sound and video presentations where you can hear the actual jokes that he used to keep everyone laughing.

Website: www.navalaviation museum.org

Info: Free admission. The museum is open daily 9 a.m. to 5 p.m.

Contact: National Naval Aviation Museum NAS DRMO, 1750 Radford Blvd., Pensacola, FL 32508; (850) 452-3604.

But wait, there's more!
Flip back to the California chapter because it's there that you will find a Bob Hope statue in San Diego, California.

THE NORMAN STUDIOS SILENT FILM MUSEUM

If you're a fan of the silent film era, then The Norman Studios Silent Film Museum in Jacksonville, Florida, is a must-see on your list. This unassuming five-building studio complex became the home and workplace of filmmaker and inventor Richard E. Norman. According to his bio, Norman was among the first to produce "race films," starring black actors in positive, non-stereotypical roles. Only one building is open to the public at this time though. The studios hold Silent Sundays and events based on Jacksonville's Hollywood history.

Website: http:// normanstudios.org

Contact: The Norman Studios Silent Film Museum, Inc., 6337 Arlington Rd., Jacksonville, FL 32211; (904) 742-7011.

AMUSEMENT PARKS

When you think of traveling to Florida, amusement parks naturally come to mind. Even if you're not a roller coaster fan, visiting Disney World and Universal Studios is a fun way to celebrate the film and TV fan in you, no matter what your age.

Disney World

This Orlando-based amusement park is a magical getaway for family vacations, thrilling rides, and long-lasting memories. Since Disney is known for its movies and TV shows, the various amusement parks that make up Disney World are filled with rides based on those classic tales.

First, there are the classic movies such as *Cinderella* and *Snow White* which were the films that cemented Disney's legacy and are synonymous with Disney's early success. Many other Disney movies have been made into rides at the amusement park. There's Dumbo the Flying Elephant, a tame spinning ride; Under the Sea: Journey of the Little Mermaid, a calm animatronics ride; and Prince Charming Regal Carrousel. Their parks also have rides inspired by the newer movies, such as *Finding Nemo* and *Toy Story*.

Disney has many other projects and companies within it that stray from their traditional princess and animated movies. One example is *Pirates of the Caribbean*, the exciting and swash-buckling ride that inspired the films is one of the most popular Disney attractions, with realistic animatronics.

Disney also owns Lucasfilm, the production company responsible for the cult favorite movie series *Star Wars*. In the Hollywood Studios park, *Star Wars* fans will enjoy the Launch Bay, which has replica props and games to play. There's also a motion-stimulated ride and a live-show featuring classic characters like Darth Vader.

The Great Movie Ride is a slow, but visually stunning 22-minute ride that takes you through some of your cult movie favorites and classic movies with realistic animatronics and immersive sets. Some of the movies featured include *The Public Enemy* and *Raiders of the Lost Ark*. The guide of this tour will share secrets and fun facts about some of these classic films, and you might find that your ride lands you in a little bit of trouble (it's harmless fun).

The most anticipated ride to open at Disney World in Florida over the last few years has been Pandora: The World of Avatar, which opened in 2017 at Disney's Animal Kingdom. It is based on the 2009 *Avatar* movie and features the film's blue-skinned Na'vi inhabitants of Pandora, floating mountains, bioluminescent plants, and flying banshees. Here fans can enjoy the 3-D flight simulator "Avatar Flight of Passage" that takes you through the skies of Pandora, and the family-friendly "Na'vi River Journey"–an indoor boat ride that sends you down a sacred river hidden within a bioluminescent rainforest of Pandora.

Website: https://disneyparks.disney.go.com

Universal Orlando

The other iconic and classic amusement park in Florida is Universal Orlando. Universal bases itself on bringing iconic television and movie characters to life, so naturally it is filled with attractions and rides featuring all of your fan favorites. If you're a superhero fan, make sure to check out some of the exciting roller coasters like The Incredible Hulk Coaster and Doctor Doom's Fearfall, as well as the motion-based 3D ride, The Amazing Adventures of Spider-Man. Then you can stop and eat at Café 4, the *Fantastic Four*-based-eatery, when you're done.

If you're not a superhero fan, don't worry—there are still plenty of other movie- and TV-based rides and shows for you to enjoy, such as E.T.'s Adventure, Despicable Me's Minion Mayhem, Revenge of the Mummy, and Shrek 4-D. There are also sections of the park devoted to the cult favorite series *Jurassic Park*, as well as a world devoted to the work of Dr. Seuss, whose

classic children's books such as *Cat in the Hat* and *The Lorax* have been made into movies and TV shows as well. Wherever you go at Universal, whether you're looking for somewhere to eat, a show to watch, or a ride to enjoy, you and your children will be surrounded by some of your favorite film and TV characters.

It would be hard to put Universal Orlando on this list without mentioning The Wizarding World of Harry Potter. For fans of the *Harry Potter* books and movie series, this park is a must-see and a dream destination. Universal has crafted the town of Hogsmeade and the famous Diagon Alley from the books and movies and brought them to life. There are fun rides like Flight of the Hippogriff and Dragon Challenge. There's also Harry Potter and the Forbidden Journey, which literally takes guests through the castle of Hogwarts before heading into an exciting ride that has you flying with Harry Potter himself. Fans can visit Ollivanders and have their wand choose them, stop by the Three Broomsticks for a classic Butterbeer, or even ride the Hogwarts Express.
Website: www.universalorlando.com.

Admission prices for both Disney World and Universal Orlando vary depending on the amount of days you want to visit and package deals available with hotel, dining packages, and airfare.

TENNESSEE

The beautiful Tennessee mountains, the vast farmland, and the amazing rich history of country and jazz music make Tennessee a director's dream. Movies, such as *Coal Miner's Daughter* (1980), *Hannah Montana* (2009), *Identity Thief* (2013), *Silence of the Lambs* (1991), *The Firm* (1993), and *The Green Mile* (1999) have been filmed here.

ROOTS' ALEX HALEY MUSEUM AND INTERPRETIVE CENTER

In 1977, one groundbreaking television mini-series had millions of Americans glued to their seat. The show was *Roots,* and it was based off of the book of the same name written by author Alex Haley. The book, *Roots: The Saga of an American Family*, pro-filed Haley's family line from ancestor Kunta Kinte's enslavement to their liberation. *Roots* starred LeVar Burton, Todd Bridges, and Robert Reed and received an incredible 37 Primetime Emmy Award nominations and won nine. It set other records as well including the third highest rated episode for any type of television series, and the second most watched overall series finale in US television history. Two years later its sequel, *Roots: The Next Generations*, aired.

Website: www.alex-haley.com/alex_haley_museum.htm

Info: Cost of admission: adults, $6; seniors, $5; students, $4; group rates: adults, $5; seniors, $4; students, $3. The museum is open Tuesday to Saturday 10 a.m. to 5 p.m.; Sunday is reserved for groups of 15 or more.

Contact: The Alex Haley House Museum, 200 Church St., Henning, TN 38041; (731) 738-2240.

In Henning, Tennessee, The Alex Haley Museum and Inter-pretive Center is dedicated to the Pulitzer Prize–winning author and features his work and memorabilia. The Alex Haley House is listed in the National Register of Historic Places and also includes his final resting place.

GRACELAND

Elvis Presley was the "King of Rock and Roll," and was also just known as "The King." He was a music icon, responsible for such hit songs as "Love Me Tender," "Any Way You Want Me," "Don't Be Cruel," and "Hound Dog." He was also in 33 films, including *Love Me Tender, Jailhouse Rock, Blue Hawaii, Girls! Girls! Girls!, The Trouble With Girls, Viva Las Vegas,* and more. With his gyrating hips, twitchy lips, and smooth sounds, Elvis Presley became one of the most popular entertainers ever.

A fan of Presley's music or films must visit Graceland, located in Memphis, Tennessee, where the rock and roller lived after he became the legend. Graceland is a mansion on a 13.8-acre estate, and you can take an interactive iPad tour of Graceland Mansion, hosted by John Stamos and featuring commentary and stories by Elvis and his daughter, Lisa Marie. The tour includes the living room, his parents' bedroom, the kitchen, TV room, pool room, the Jungle Room, his father's office, the newly enhanced Trophy Building, the Racquetball Building, and Meditation Garden. You will also tour the Elvis: The Entertainer Career Museum where you will see the artifacts and photos from Elvis' life, including gold and platinum records and memorabilia from his movies. Elvis was all about the music and Sun Studio Recording was where he recorded some of his most popular songs. Tour the studio where other legends like Jerry Lee Lewis also recorded some of his songs as well.

Website: www.graceland.com

Info: The ultimate VIP tour is $159 per person and includes a private tour guide, Elvis' planes, private dining, meal voucher, and private lounge. You will have your own personal tour guide with your tour to Graceland Mansion, a self-guided tour of Elvis' Custom Jets, access to Elvis Presley's Memphis Entertainment Complex, including Presley Motors Automobile Museum, the Elvis: The Entertainer Career Museum, and more. There is also an Elvis Entourage VIP Tour for $93.75 and $98.75 with airplane tour. A mansion-only tour price is adult, $38.75; seniors 62 and older, $34.90; youth/students 13–18, $34.90; children 7–12, $17.00; children 6 and under, free.

Contact: Graceland, 3734 Elvis Presley Blvd., Memphis, TN 38116; (901) 332-3322.

Hotel Tip: Memphis has plenty of hotels, but if you want the entire experience, then choose the Guest House at Graceland, with its 450 rooms, two restaurants, and a 464-seat theater for live performances and movies. For more information, including reservations and rates, visit http://guesthousegraceland.com. The hotel is located at 3600 Elvis Presley Blvd., Memphis, TN 38116; (901) 443-3000.

RUSTY'S TV AND MOVIE CAR MUSEUM

At Rusty's TV & Movie Car Museum, you can see cars from the owner Rusty's collection that includes *The Fast and the Furious, The Dukes of Hazzard, Monster Garage, Wayne's World, The Munsters, Batman, Scooby Doo,* and so much more. There are more than 20 cars that were actually used in the shows and movies

Website: www .rustystvandmoviecars.com

Info: Cost of admission: $5.00 for everyone. The museum is open Friday, Saturday, and Sunday 9 a.m. to 5 p.m. Monday to Thursday by appointment.

Contact: Rusty's TV & Movie Car Museum, 323 Hollywood Dr., Jackson, TN; (731) 267-5881.

mentioned. Located in Jackson Tennessee, Rusty's TV & Movie Car Museum is a great place for car and movie lovers to combine their loves.

TITANIC MUSEUM

If you're fascinated with the *Titanic*—the ship and the movie— then the *Titanic* Museum attraction in Pigeon Forge, Tennessee, is a must-see. You can walk through a replica of the ship and see the 400 artifacts. You can learn what it was like on the RMS *Titanic*, get a boarding pass, and take a self-guided tour.

Website: www.titanicpigeonforge.com

Info: Cost of admission: adult, $19.66; child (ages 5–12), $11.59; family pass (2 adults and up to 4 children, ages 5–18 occupying same residence as parent), $71.38; children (ages 0–4), free.

Contact: Titanic Pigeon Forge; 2134 Parkway, Pigeon Forge, TN 37863; (800) 381-7670; (417) 334-9500.

CROCKETT TAVERN MUSEUM

Also known as "King of the Wild Frontier," Davy Crockett was a real American folk hero, frontiersman, and soldier. Once the television show debuted in the 1950s, every little boy and girl was wearing a coonskin cap, pretending to be just like the soldier. Fess Parker played Crockett in the series which aired on ABC from 1954 to 1955. Buddy Ebsen, who played on *The Beverly Hillbillies*, portrayed Crockett's friend, George.

The Crockett Tavern Museum in Morristown, Tennessee, stands on the site of the tavern owned by Davy's father, John Crockett. According to the museum's history, "After the Crockett family abandoned it, the original tavern was used as a field hospital during the Civil War and a 'pest house' during a smallpox epidemic before finally burning to the ground."

Website: http://crocketttavern museum.org

Info: Cost of admission: adults, $5; students (ages 5–18), $1; children (under age 5), free; seniors (65 and over), 10 percent discount on admissions. Crockett Tavern Museum is open 11 a.m. to 5 p.m., Tuesday to Saturday, May to October.

Contact: Crockett Tavern Museum, 2002 Morningside Dr., Morristown, TN 37814; (423) 587-9900.

Once Disney's show *The Adventures of Davy Crockett* premiered, the town decided to build a museum on the site. The museum was opened in 1958 and dedicated by none other than *Davy Crockett* actor Fess Parker, who played the adventurer in the Disney film. The Tavern Museum is a re-creation of John Crockett's 1790 tavern and includes authentic household items from Davy's era and Davy Crockett memorabilia.

OTHER THINGS TO SEE AND DO IN TENNESSEE

GRAND OLE OPRY: Grand Ole Opry is where you can hear country legends perform right in front of you. It's been called the "home of American music" and "country's most famous stage" and is a must-see if you're going to be in the area. There are backstage tours and VIP tours as well.

Website: www.opry.com
Contact: Grand Ole Opry, 2804 Opryland Dr., Nashville, TN, 37214; (800) SEE-OPRY.

JOHNNY CASH MUSEUM: The 2005 Reese Witherspoon movie *Walk the Line* is a biographical movie about the Man in Black, Johnny Cash. If that movie has piqued your interest on the musician, then check out the Johnny Cash Museum, located in Nashville.

Website: www.johnnycashmuseum.com

Info: Cost of admission: adults, $18.95; military and senior, $17.95; youth (6–15), $14.95 with adult admission; children (5 and under), free with adult admission. The museum is open 9 a.m. to 7 pm., 7 days a week.

Contact: Johnny Cash Museum, 119 Third Ave. South, Nashville, TN 37201; (615) 256-1777.

PATSY CLINE MUSEUM: Patsy Cline is a country music singer who tragically died young just when she was at the height of her career. Known for such songs as "Crazy," "Walking After Midnight," and "I Fall to Pieces," Cline was only 30 years old when she passed away in 1963. In the 1985 movie *Sweet Dreams,* Jessica Lange portrays Cline and won an Academy Award for Best Actress.

Website: www.patsymuseum.com

Info: Cost of admission: adult, $18.95 plus convenience fee; children (ages 6–15), $14.95 plus convenience fee; children (ages 5 and under), free. Museum and store hours: Monday to Sunday 9 a.m. to 7 p.m. Closed on Thanksgiving and Christmas.

Contact: The Patsy Cline Museum, 119 3rd Ave. South, Nashville, TN 37201; (615) 454-4722.

GEORGIA

Ray Charles got it right in his song "Georgia on My Mind." It's not easy to get Georgia off of your mind, with its beaches, architecture, farmland, and mountains. It's rich in the heritage of the South and home to such monuments as the Martin Luther King Jr. National Historic Site. Movies and television shows such as *42* (2013), *The Hunger Games* (2012), *The Walking Dead* (2010–present), *Remember the Titans* (2000), and *The Last Song* (2010) have all been filmed here.

JIM HENSON COLLECTION

The mission of the Center for Puppetry Arts in Atlanta, Georgia, is "to inspire imagination, education and community through the global art of puppetry." When you think of puppets, Jim Henson definitely comes to mind. Henson, known for creating the Muppets, and his iconic characters, Kermit the Frog, Miss Piggy, and Elmo, is honored with a special showcase at the Center for Puppetry Arts. The Jim Henson exhibit is available to view and includes the life and legacy of this puppet master.

Website: www.puppet.org

Info: Cost of admission for all-inclusive family ticket includes show, Create-A-Puppet Workshop, and Museum. Non-members, $19.50; members, $9.75. The museum is not open on Monday, but is open Tuesday through Friday 9 a.m. to 5 p.m., Saturday 10 a.m. to 5 p.m., Sunday noon to 5 p.m.

Contact: Center for Puppetry Arts, 1404 Spring St. NW at 18th, Atlanta, GA 30309-2820; (404) 873-3391.

FORREST GUMP PROPS AT THE SAVANNAH HISTORY MUSEUM

If you're in Savannah, don't head to Chippewa Square expecting to see the famous bench that Forrest Gump sat on at the bus stop. Instead, head over to the Savannah History Museum, where fans of Tom Hanks' 1994 movie can see that authentic movie prop. This authentic prop created by the props department

Website: www.chsgeorgia.org

Info: Cost of admission: $7 per adult; $4 per child (ages 2–12). Hours of operation: daily 9 a.m. to 5:30 p.m. Closed Thanksgiving, Christmas, and New Year's Day.

Contact: Savannah History Museum, 303 Martin Luther King Jr. Blvd., Savannah, GA 31401; (912) 651-6825.

of Paramount Studios was one of four fiberglass benches constructed for the filming of *Forrest Gump* in 1994.

LAUREL & HARDY MUSEUM

It was always another fine mess that Oliver Hardy and Stan Laurel got into, but it won't be a mess to check out this museum.

Website: www.laureland hardymuseum.com

Info: Admission is free. The museum is open Tuesday through Saturday 10 a.m. to 4 p.m.

Contact: 250 N Louisville St., Harlem, GA 30814; (706) 556-0401.

Did you know?
The Oz Museum in Wamego, Kansas, includes earlier silent films, one of which starred Oliver Hardy as the Tin Man.

Laurel and Hardy was one of the most popular slapstick comedy duos from the 1920s to the 1940s. Laurel and Hardy appeared together in more than 100 movies, including such hits as *Sons of the Desert* and *March of the Wooden Soldiers*.

Oliver Hardy was born on January 18, 1892, in Harlem, Georgia and that's where this Laurel & Hardy Museum is located. It does a nice job of paying homage to both of the comedians. The museum has a modest collection of memorabilia as well as a movie screening room.

Every October, Hardy's hometown of Harlem presents an Annual Oliver Hardy Festival. There are food and craft vendors, inflatables, live entertainment, and Laurel and Hardy impersonators.

But wait, there's more!

In case you were wondering, Stan Laurel was born in Ulverston, in the United Kingdom, where there is another Laurel and Hardy Museum. For more information, visit www.laurel-and-hardy.co.uk. There is also an annual Laurel & Hardy Convention. Visit www.laurelandhardy.org/convention.html.

Fans of Laurel & Hardy unite! There is also a *Sons of the Desert* fan group with chapters all over the world. The idea is to keep the comedy of the pair alive. Each chapter across the country is individually run and hosts social events and movie screenings. For more information, visit www.sonsofthedesertinfo.com

MARGARET MITCHELL HOUSE AND MUSEUM

Frankly, my dear, you *are* going to give a damn about visiting the Margaret Mitchell House and Museum in Atlanta, Georgia.

This is the home of the author who wrote the best-selling book, *Gone with the Wind*, which then became one of the most iconic movies of all time. The story is about young Scarlett O'Hara, the daughter of a well-to-do plantation owner, who does what she can to get to get out of poverty after losing everything. The movie starred Vivien Leigh and Clark Gable as Scarlett O'Hara and Rhett Butler.

Website: www.atlantahistorycenter .com/explore/destinations/margaret -mitchell-house

Info: Cost of admission: adults, $13; seniors (65+), $10; students (13+), $10; youth (4–12), $8.50; under 4, free. The history center is open every day: Monday through Saturday 10 a.m. to 5:30 p.m. and Sunday noon to 5:30 p.m.

Contact: Margaret Mitchell House & Museum, 979 Crescent Ave. NE, Atlanta, GA 30309; (404) 249-7015.

At the Margaret Mitchell House and Museum, you can take a guided tour of the Mitchell's home where she wrote the Pulitzer Prize–winning book. The home is listed on the National Register of Historic Places. There are guided tours of Apartment No. 1, which Margaret nicknamed "The Dump."

The museum also has exhibitions on Mitchell's life, including one on her life as a reporter for the *Atlanta Journal* and another on The Making of a Film Legend and how the book went from story to film.

GONE WITH THE WIND MUSEUM

Only a half hour away (about 20 miles) from the Margaret Mitchell House in Atlanta, is another museum for *Gone with the Wind* fans. This Marietta-based museum is located at none other than Scarlett on the Square, where it has been since it opened in 2003. Some of the memorabilia at the house includes

It's one of Scarlett O'Hara's iconic dresses, and you can see it at the *Gone with the Wind* Museum in Marietta, Georgia.

the original Bengaline honeymoon gown worn by Vivien Leigh during her portrayal of Scarlett O'Hara. It also includes several

Website: www.gwtwmarietta.com

Info: Cost of admission: adults, $7; seniors and students, $6; groups of 15 or more, $5. The museum is open Monday through Saturday 10 a.m. to 5 p.m.

Contact: Gone with the Wind Museum, 18 Whitlock Ave., Marietta, GA 30064; (770) 794-5576.

of Mitchell's personal volumes of the novel; an exhibit dedicated to the African American cast members; as well as film posters, artwork, costumes, and other mementos.

But wait, there's more!

If these two museums aren't enough for the die-hard *Gone with the Wind* fan, there is yet another museum to check out on your visit to Georgia. The Road to Tara Museum, which has items from the movie as well as artifacts from the Civil War, is located at the 1867 Historic Train Depot in Jonesboro. Here you will see exhibits that feature Margaret Mitchell's china, as well as reproductions of Scarlett's most famous dresses.

Website: www.atlantastruesouth.com/gone-with-wind/road-to-tara-museum

Info: Cost of admission: adults, $7; seniors, $6; children (6–12), $6. The museum is open Monday through Friday 8:30 a.m. to 5:30 p.m. and Saturday 10 a.m. to 4 p.m.

Contact: The Road to Tara Museum, 104 N Main St., Jonesboro, GA 30236; (770) 478-4800.

MY COUSIN VINNY

My Cousin Vinny is a hysterical 1992 comedy film that starred Joe Pesci, Ralph Macchio, Marisa Tomei, Mitchell Whitfield, Lane Smith, Bruce McGill, and Fred Gwynne. The film was about two New Yorkers—portrayed by Ralph Macchio and Mitchell Whitfield—who are arrested for a murder they didn't commit. They turn to their cousin, Vincent Gambini (Pesci), to help defend them. The movie earned Marisa Tomei an Academy Award for Best Supporting Actress for her portrayal as Vinny's girlfriend, Mona Lisa Vito.

Website: Sac-O-Suds does not seem to have a website, but you can find them on Facebook, www.facebook.com/sacosuds.

Info: There is no admission to go into this store, but remember that it is a working business. It is open daily 7 a.m. to 9 p.m.

Contact: Sac-O-Suds, Hwy. 16, Monticello, GA 31064; (770) 504-9272.

The movie opens in Monticello, Georgia, at the Sac-O-Suds Store where the boys steal a can of tuna. Fans of *My Cousin Vinny* will love to know that this store exists today. The new owners remodeled it from its original look, but it still showcases some film mementos and sells T-shirts and, of course, souvenir tuna cans.

THE WALKING DEAD

The Walking Dead premiered in 2010 and has been going strong ever since. This AMC American horror show is a narrative-driven show about the zombie apocalypse based on the comic series and has built quite a large cult following. A companion series and prequel, *Fear the Walking Dead*, debuted five years later, in 2015.

Much of *The Walking Dead* series takes place in and around Atlanta, Georgia, and Alexandria, Virginia. There are many fun tours and museums for Deadheads to see in Georgia, where most of the filming is done.

Let's start with The Touring Dead Walking Tour by the Georgia Mercantile:

The Touring Dead Walking Tour

According to the Georgia Mercantile website, The Touring Dead Walking Tour is specifically geared for fans of *The Walking Dead.* The 2.5-mile walking tour from Woodbury to Alexandria takes you through four seasons of filming locations. In addition, you might see scenes currently being filmed on your tour. Along the way, you will also see filming locations for other movies and television shows, including *Pet Sematary II* (1992), *Drop Dead Diva* (2009–2014), and *Fried Green Tomatoes* (1991).

The Georgia Mercantile also offers The Touring Dead II: Survive the Ride, described as an interactive, live-action theatrical production.

Website: www.georgiamercantile.com

Info: Cost of the tour is $25 for The Touring Dead Walking Tour and $125 for The Touring Dead II: Survive the Ride tour.

Contact: The Georgia Mercantile, 60 Georgia State Bicycle Route 45, Senoia, GA 30276; (770) 599-0091.

Shopping Alert!

Stop in at The Official Walking Dead Store at the Woodbury Shoppe, located on 48 Main St., in Senoia, Georgia. It is dedicated to all things *The Walking Dead*. Visit www.woodburyshoppe.com for more information.

Walking Dead Tour

Here's another tour that Dead-heads can take in Georgia. You will visit film sites from *The Walking Dead* on a 3-hour zombie tour from Senoia that Viator.com says includes insider stories and trivia with guides who have worked

Website: www.viator .com/tours/Atlanta/ Walking-Dead-Big -Zombie-Tour-Part-2/d784 -5709P6?pub=vcps

as extras on the show. Fans will "explore the fictional town of Woodbury, visit the Zombie Arena and Oaks Motor Inn, then see Beth's hospital and Morgan's apartment with a group of 'The Walking Dead' fans." There's another tour in Haralson, Georgia,

Foodie Fact! Nic & Norman's

Don't expect to see any zombies at Nic & Norman's, the restaurant of Greg Nicotero and Norman Reedus from *The Walking Dead*. Located in Senoia, Georgia, where the series is filmed, the eatery offers a menu of options such as Norman's burger (a bison patty with beetroot, spinach, onions, fried egg, and mustard—without a bun), home-style meat loaf, potpie, flatbread, and so much more.

WEBSITE: http://nicandnormans.com

INFO: Nic & Norman's is open Monday through Thursday 11 a.m. to 10 p.m., Friday and Saturday 11 a.m. to 11 p.m., and Sunday 11 a.m. to 9 p.m.

CONTACT: Nic & Norman's, 20 Main St., Senoia, GA 30276; (770) 727-9432.

where you can choose from a morning or afternoon departure time, then visit places like Cherokee Rose Retail, the Esco Feed Mill Complex, Merles Death Barn, the Meeting Barn, and more.

HUNGER GAMES HOUSE

The Swan House at the Atlanta History Center was one of many locations in and around Georgia that were used during the filming of the movie *The Hunger Games: Catching Fire,* a 2013 American dystopian science fiction adventure film starring Jennifer Lawrence as Katniss. *The Hunger Games: Catching Fire* was based on Suzanne Collins' dystopian novel, *Catching Fire* (2009), and was the second installment in *The Hunger Games* trilogy. *Hunger Games* fans can take The Capitol Tour experience which includes a guided tour through Swan House. Here you can see rooms that were used during filming and enjoy a behind-the-scenes exhibit displaying photos and select props from the film.

Website: www.atlantahistory center.com/visit-us

Info: Cost of admission for the Capitol Tours is $10 per person in addition to the cost of general admission. Tours are offered Monday through Saturday, 4 p.m.

Contact: The Swan House at the Atlanta History Center, 130 W Paces Ferry Rd. NW, Atlanta, GA 30305-1380; (404) 814-4000.

OTHER THINGS TO SEE OR DO IN GEORGIA

Don't think that California and New York are the only places you can take film and television tours. Atlanta is a popular filming destination and has been used as a backdrop to many iconic movies and television programs. As a matter of fact, more than 700 movies and 20 television shows have been shot here since 1972.

BEST OF ATLANTA TOUR: Visitors can enjoy the Best of Atlanta Tour, a 3-hour coach tour of Atlanta's film sites including *Driving Miss Daisy, The Walking Dead, The Hunger Games, Spider-Man: Homecoming, The Blind Side*, and, of course, *Gone with the Wind*. It's a fun tour with movie and television clips, trivia, prizes, and more.

Website: www.viator.com

Foodie Fact! Ted's Montana Grill

In the entertainment world, Ted Turner is widely known as the founder of Cable News Network, otherwise known as CNN, the first 24-hour news channel. He is also the name behind the Turner Broadcasting Network (TBN) and Turner Classic Movies. In sports entertainment, Turner purchased World Championship Wrestling (WCW) to create the famous Monday Night Wars, which pit his show against Vince McMahon's *Monday Night Raw*. Today, Turner owns Ted's Montana Grill, a franchise of restaurants with 13 locations in Georgia, as well as in many locations in Montana, Colorado, and throughout the East Coast. The menu includes Bison Chili, beef or bison burgers, bison meat loaf, and more. Noticing a trend? Don't worry, there's more than just bison on the menu, but it is a featured staple in Turner's restaurants.

WEBSITE: www.tedsmontanagrill.com

INFO: Each restaurant is individually owned, so check the website for the exact hours and menu of the restaurant you want to visit.

CONTACT: Ted's Montana Grill, 133 Luckie St. Northwest, Atlanta, GA 30303; (404) 521-9796.

WORLD OF COCA-COLA: What is a movie without popcorn and an ice-cold Coca-Cola? If you're in Atlanta, the World of Coca-Cola is a fun, interactive stop on your film/TV travel tour. Located in Pemberton Place, adjacent to the Georgia Aquarium in downtown Atlanta, the World of Coca-Cola includes a 4-D theater and a behind-the-scenes look at the Coca-Cola bottling process. It's a fun connection to the movie industry and a great pit stop on your travels.

Website: www.worldofcoca-cola.com

Info: General admission prices are $17 for ages 13–64, $15 for seniors 65+, $13 for ages 3–12, and toddlers 2 and under are free with an adult. There are also guided group tours available for $32 per person.

Contact: World of Coca-Cola, 121 Baker St. NW, Atlanta, GA 30313.

CNN STUDIO TOUR: Here is Ted Turner's masterpiece television station and on this tour you can go behind the scenes and experience access to the CNN world headquarters with a tour. You can take a 50-minute walking tour and see how a broadcast is produced and learn about the history of the station or you can take a VIP tour where you can enhance your experience and get expanded access into live newsrooms, the HLN control room, and a state-of-the-art studio that CNN uses daily. CNN also offers an HLN Morning Express Tour with Robin Meade, where you'll get to meet Robin during the visit.

Website: http://tours.cnn.com

Info: The Behind-the-Scenes Tour lasts approximately 50 minutes while the VIP and Morning Express Tours last approximately 75 minutes each. Last tour departs at 5 p.m.

Contact: CNN Studios are located inside the CNN Center at the corner of Marietta Street and Centennial Olympic Park Drive in downtown Atlanta. One CNN Center, Atlanta, GA 30303; (877) 4CNNTOUR or (404) 827-2300.

MIDWEST

MICHIGAN

If a director needs to film near a lake, they might want to check out Michigan, a Midwestern state that borders four of the Great Lakes. On top of that, it has more than 11,000 inland lakes. Michigan takes its filming industry seriously. They have created multiple film tours where you can download a map of various areas—Ann Arbor, West Michigan, for example—and visit the spots that were used as filming locations. For example, Planet Rock in Ann Arbor, an indoor rock climbing site, was featured as the "Climbing Wall Adventure Zone" in the movie *Cedar Rapids* (2011).

Other movies, such as *Beverly Hills Cop* (1984), *Midnight Run* (1987), *Action Jackson* (1988), *Whip It* (2009), *You Don't Know Jack* (2010), *Scream 4* (2011), *Transformers: Dark of the Moon* (2011), and *A Very Harold and Kumar Christmas* (2011) have been filmed here.

There's an app for that!

The Michigan Film & Digital Media Office commissioned the *Batman v Superman: Dawn of Justice* mobile tour app, which allows you to create a self-guided navigation of locations from the film's scenes shot in Detroit. It features an interactive map with 12 shooting locations, gives background information about the scene shot at the site, and a library of *Batman v Superman: Dawn of Justice* characters and clips.

In addition, film fans can also download specific filming tours. For example, the film version of John D. Voelker's best-selling novel, *Anatomy of a Murder* (1959) was filmed here, and you can take a tour of the courthouse, lighthouse, and other venues used in the movie. There are other tours for *Gran Torino* (2008), *Real Steel* (2011), *The End of the Tour* (2015), and *Somewhere in Time*.

SOMEWHERE IN TIME WEEKEND

This 1980 time-traveling fantasy film became one of Christopher Reeve's and Jane Seymour's best roles, and it has become a romantic favorite with fans over the years as well (***Note:*** Lisa even gave her firstborn the middle name of Elise, named after Jane's character).

The movie was filmed at The Grand Hotel on Michigan's Mackinac Island, and in 2015, Jane Seymour visited for the 35th anniversary of the film and the 25th anniversary of the *Somewhere in Time* Weekend that is held here. Fans will love the weekend festival that is held typically on a weekend in October. The weekend includes a screening of the film, discussions of the movie's production process, and appearances by some returning cast. Guests come dressed in costume.

Website: www.grandhotel.com/packages/somewhere-in-time-weekend

Info: The rooms can be a little pricey, coming in at $1,099 per couple for a standard room and $1,449 for a Lakeview room in 2017.

Contact: The Grand Hotel, 286 Grand Ave., Mackinac Island, MI 49757; (800) 33GRAND.

NEBRASKA

Terms of Endearment (1983), *About Schmidt* (2002), *Nebraska* (2013), *Children of the Corn* (1984), and *Heaven Is for Real* (2014) are just some of the movies that have been filmed in Nebraska, a Midwestern state known for its prairies and dunes.

BOYS TOWN HALL OF HISTORY

Spencer Tracy portrayed Boys Town founder Father Flanagan in the 1938 movie, *Boys Town*, which went on to become nominated for Best Picture and won two Oscars, including Tracy's for Best Actor. Tracy's Oscar can be found at the Boys Town Hall of History, where you'll also find exhibits on the movie and the organization.

Website: www.boystown.org

Info: The Hall of History is open to the public Monday through Saturday 10 a.m. to 4:30 p.m. and Sunday 11 a.m. to 4 p.m.

Contact: Boys Town, 14100 Crawford St., Boys Town, NE 68010; (402) 498-1300.

BESS STREETER ALDRICH HOUSE AND MUSEUM

Bess Streeter Aldrich was a writer from Nebraska whose stories of hardships and struggles of those who lived in a small town during pioneer life were made into television movies. *Cheers for Miss Bishop* and *The Gift of Love: A Christmas Story* were just two examples of movies that fans of this writer can watch. You can also tour the Bess Streeter Aldrich House and Museum, where you'll first learn about where Bess loved

Website: www.bessstreeteraldrich.org

Info: Cost of admission: adults, $5; children 6–12, $3. The house and museum are open May to October, Wednesday through Sunday, 1 p.m. to 4 p.m. November to April, the house and museum are open Saturday and Sunday only 1 p.m. to 4 p.m.

Contact: Bess Streeter Aldrich House and Museum, 204 East "F" St., Elmwood, NE 68349; (402) 994-3855.

to write and see original memorabilia. Then, at The Aldrich Museum, you can see Bess' letters, souvenirs from her movie *Cheers for Miss Bishop*, family history pieces, and more.

HENRY FONDA'S CHILDHOOD HOME

Henry Fonda made some great movies during his 50-year movie career, starting with his Academy Award–nominated performance as Tom Joad in *The Grapes of Wrath* (1940). He also appeared in *The Ox-Bow Incident* (1943), *Mister Roberts* (1955), *12 Angry Men* (1957), *Yours, Mine and Ours* (1968), and, of course, *On Golden Pond*, his final movie and one that he won the Academy Award for Best Actor that year.

Website: www.stuhrmuseum.org

Info: The museum is open 7 days a week except for Mondays in January, February, and March. Hours are Monday through Saturday 9 a.m. to 5 p.m. and Sundays noon to 5 p.m.

Contact: Stuhr Museum of the Prairie Pioneer, 3133 W US Hwy. 34, Grand Island, NE 68801; (308) 385-5316.

Fonda's childhood home is located on the grounds of the Stuhr Museum of the Prairie Pioneer in Grand Island, Nebraska. He actually paid to have the house moved to the museum, and fans who visit the area can even sit on a bench in the Henry Fonda Memorial Rose Garden and reflect on his career.

OTHER THINGS TO SEE OR DO IN NEBRASKA

CARHENGE: Heard of Stonehenge? Here near Alliance, Nebraska, you can see Carhenge, a re-creation of the original that Jim Reinders saw in England, but he decided to "modernize" it. It's worth a peek.
Website: http://carhenge.com
Info: It's open 24/7.
Contact: Carhenge, City of Alliance, 305 Box Butte Ave., Alliance, NE 69301; (308) 762-3569.

THE NATIONAL MUSEUM OF ROLLER SKATING: I don't know about you, but I loved *Whip It*, Drew Barrymore's 2009 movie about a young girl (played by Ellen Page), who joins a roller derby league. So, this museum about roller skating definitely piqued my interest.
Website: www.rollerskatingmuseum.com

Info: Cost of admission is free. The museum is open Monday through Friday 9 a.m. to 5 p.m.
Contact: The Museum of Roller Skating, 4730 South St., Lincoln, NE 68506; (402) 483-7551.

MISSOURI

When you think about Missouri, you think about grassy plains and the Ozark Mountains and Kansas City jazz. This state also has a film history that dates back to 1910 with the movie *The Range Riders*, starring legendary actor Tom Mix. (Check out Oklahoma for a museum all about Mix.) Over the years, moviemakers and television producers have flocked to Missouri to film *Jesse James* (1939), *In Cold Blood* (1967), *The Beverly Hillbillies* (1969), *Paper Moon* (1973), *Fever Pitch* (2005), and so many more.

LAURA INGALLS WILDER HISTORIC HOME & MUSEUM

If you're a fan of Laura Ingalls Wilder's books and the popular television show *Little House on the Prairie* that was created from these books, you need to visit the Laura Ingalls Wilder Historic Home & Museum in Mansfield, Missouri. Visitors can see the study where Laura wrote her books, as well as Pa's fiddle and Almanzo's tools.

Website: www.lauraingallswilderhome.com

Info: The home is open for visits March 1 to November 15, Monday through Saturday 9 a.m. to 5 p.m. and Sunday 12:30 p.m. to 5 p.m. Closed Easter Sunday, but open one weekend in December for "Christmas with Laura." Admission: adults (18 and over), $14; children (6–17), $7; children (under 6), free.

Contact: Laura Ingalls Wilder Historic Home & Museum, 3060 State Hwy. A, Mansfield, MO 65704; (877) 924-7126

The *Land of Laura* Travel Series

Sandra Hume watched *Little House on the Prairie* when she was a kid, which led her to the book series when she was about nine years old. "The book series was a constant in my life until I left for college," said the author of the *Land of Laura* travel series. "I read the entire *Little House* series at least once a year. And what most people who aren't familiar with the books don't realize is that the TV show deviated from the 'real' story after, oh, the second episode."

Hume explained that although severe plot liberties were taken during the course of the show—the Ingalls family never adopted

any kids and Mary never got married—the very basic storyline of the Ingalls, and Laura in particular, was present.

"What was absolutely the same between the books and the TV show was the unquestionable sense of family. The love and loyalty between Pa, Ma, and the Ingalls girls is just as strong in the books as it was depicted in the TV show," she said.

Hume said she believes that everyone likes *Little House* for different reasons. "For some, the history is the draw, or the simplicity of the pioneering life, which was actually super-difficult and not simple at all," said Hume. "But she wrote about it simply. What made me love it was the sense of family. They were my 'comfort books.'"

The internet connected her with like-minded fans in her adulthood, and that coincided with a move from the coast to the middle of the country.

"I now realized I could actually visit all of the places she lived throughout her pioneering childhood—places that were all lovingly depicted in her books," she said. "So I did. Multiple times. For ten years, I published a newsletter about these 'homesites' of hers, as they're called. I also directed my interest into the Laura Ingalls Wilder Legacy and Research Association, of which I was a founding board member in 2009. I was on the board until 2015." The association also plans the every-two-years Laura-Palooza conference, for academic researchers of Laura Ingalls Wilder and fans of the *Little House* books.

Hume said there are several museums throughout the country for Ingalls Wilder fans and fans of *Little House* to visit. "There's one in De Smet, South Dakota, for example, where Laura spent

Statue Alert! Marlin Perkins

He was a pioneering zoologist, bringing audiences worldwide wildlife documentaries and hosting the TV series *Mutual of Omaha's Wild Kingdom*, which premiered on January 6, 1963. Perkins was host of the show from 1963 to 1985. Perkins was also director of the New York Zoo in Buffalo, New York, the Lincoln Park Zoo in Chicago, and the St. Louis Zoo. He founded the Endangered Wolf Center in St. Louis in 1971. He died in 1986 at age 81. This bronze sculpture of him is located on South Garrison Avenue in Carthage, Missouri, where Perkins was born.

her teen and young adult years and where she met and married her husband, Almanzo Wilder," said Hume. "There's also one in Mansfield, Missouri, her home for over 50 years and where she wrote the *Little House* books. But the one with the most connection to the TV show is in Walnut Grove, Minnesota. Yes, it actually exists!

"What's ironic is that this town, which has become iconic through television, was never mentioned by name in the books. The Walnut Grove museum houses a lot of memorabilia from the TV show, including the CICI mantelpiece with Charles' and Caroline's initials from the Ingalls home. (Not authentic from her real parents, by the way.) As far as I've heard, it's the only museum Melissa Gilbert herself has actually visited."

However, there really weren't any complete travel guides about Laura's homesites. "If you wanted to go to any of them, you either bought a twenty-year-old book that lightly covered all of them or you dug deep into the internet to extract your own info. These places are geographically diverse—from South Dakota all the way to upstate New York—and they all have their own separate events each year."

So Hume created the *Land of Laura* travel series. "The first guide I wrote was for what is probably the most popular of her homesites: De Smet, South Dakota. Next up is Pepin, Wisconsin."

To buy any of Hume's books, visit Amazon: www.amazon.com/Land-Laura-Insider-Ingalls-Wilders-ebook/dp/B01EX KAORQ, or Hume's website, www.littlehousetravel.com. You can also visit her Facebook page: www.facebook.com/Landof LauraTravelSeries.

CELEBRITY CAR MUSEUM

Car enthusiasts who are also film buffs will love this museum, which is filled with some of your automotive favorites. There's the Scooby Doo Mystery Machine, as well as cars from *Jurassic Park, Men in Black, Back to the Future, Transformers, Death Race, The Terminator,* and more.

Website: www.celebritycar museum.com

Info: Cost of admission: adults, $17.95; children (5–13), $7.95; children under 5, free. The museum is open 9 a.m. to 8 p.m. Monday through Saturday and 9 a.m. to 6 p.m. Sunday.

Contact: Celebrity Car Museum, 1600 W Hwy. 76, Suite A, Branson, MO 65616; (417) 239-1644.

INDIANA

Think Indiana and you're bound to yell out "Hoosiers!" or perhaps your first thought is the speed of the Indianapolis 500. Maybe you think about downtown and the theaters and galleries. There's something for everyone in Indiana, and that means there's something for everyone in Hollywood too. Throughout the years, many films have been made here, including *The Judge* (2014), *Phantom of the Woods* (2013), *A Nightmare on Elm Street* (2013), *Transformers: Dark of the Moon* (2011), *Road to Perdition* (2002), *Pearl Harbor* (2001), and *Rudy* (1993).

HOOSIERS MEMORABILIA

The 1986 sports film *Hoosiers* has been called one of the most inspirational films ever made and was ranked #13 on the list of best inspirational films by the American Film Institute. The film is loosely based on the story of the Milan High School basketball team in Milan, Indiana, that wins the state championship. Gene Hackman stars as Milan's high school coach Norman Dale and the film costars Barbara Hershey (Myra Fleener) and Dennis Hopper (who earned an Oscar nod for his performance as Shooter Flatch).

Website: http://milan54.org; http://thehoosiergym.com

Info: The Milan 54 Museum is open Wednesday through Saturday 10 a.m. to 4 p.m. and Sunday noon to 4 p.m. The Hoosier Gym hours are 9 a.m. to 5 p.m.

Contact: Milan '54 Hoosiers Museum, 201 W. Carr St., Milan, IN 4703; Hoosier Gym, 355 N Washington St.; Knightstown, IN 46148; (800) 668-1895.

There are a few things that *Hoosiers* fans can do in Indiana. First, head on over to the Milan 54 Museum, a museum that opened in 2013 that honors the boys behind the story and is home to many of the *Hoosiers* memorabilia. Their collection includes uniforms of the team and the opposing team, as well as Myra Fleener's (Barbara Hershey) "Betty Rose" vintage coat, shorts, Chuck Taylor shoes, warm-ups, pullovers, cheerleader outfits, and much more.

Once you're done with the museum, take a one-hour drive over to Knightstown, Indiana, where you can walk on the floor of the historic Hoosier Gym and buy memorabilia and feel the connection to the historic movie.

HALL OF (SUPER)HEROES

If you've ever wanted to visit one place that honors your favorite superheroes, the Hall of Heroes is it. This venue in Elkhart, Indiana, has a whopping 60,000 comic books, 10,000+ toys, figures and props, and over 100+ pieces of original art, comic pages, and animation cels from your favorite cartoons and comic books.

What does that mean? Hall of Heroes covers 75 years of superheroes who are in comics, toys, film, and animation. If it looks familiar when you get there, that's because the building is a replica of The Hall of Justice from the *Super Friends* cartoon. Step inside and you'll see a replica of the Bat Cave set from the 1960s *Batman* television show as well as Batman's costume. They also have the original shield used in *Captain America: The First Avenger* as well as Captain America comics, a Green Lantern ring worn by Ryan Reynolds, *The Greatest American Hero* costume, a '65 Shelby Cobra used in *Iron Man*, the Hell Cycle used by Nicolas Cage in *Ghost Rider,* and so much more.

Website: www.hallofheroesmuseum.com

Info: The museum's hours are noon to 4 p.m.

Contact: Hall of Heroes, 58005 17th St., Elkhart, IN 46517; (574) 522-1187.

The Hall of Heroes also hosts a Super Heroes Villain Haunt House, Spider Man Day, Wonder Woman Day, and other fun events. This is one of those don't-miss museums for fans of superheroes.

THE JAMES DEAN GALLERY

James Dean became a cultural icon, most noted for his portrayal of the troubled teenager Jim Stark in the 1955 film *Rebel Without a Cause*. Dean also starred as Cal Trask in *East of Eden* (1955) and Jett Rink in *Giant* (1956), both roles for which he was (posthumously) nominated for an Academy Award for Best Actor.

Born in Marion, Indiana, Dean graduated from Fairmount High School but quit college to pursue acting. After his success on the big screen, Dean was headed toward a legendary career on

the same scale as Marlon Brando and Rock Hudson. However, on September 30, 1955, James Dean crashed his car and died as a result of his injuries, stunning Hollywood and the legions of fans that he had made along the way.

Located in Fairmount, Indiana, The James Dean Gallery is the private collection of James Dean archivist David Loehr, who began collecting in 1974. The exhibit consists of thousands of pieces of memorabilia, including childhood photos, high school yearbooks, dozen original movie posters, books, and magazines dedicated to Dean, and so much more. There's a Kenneth Kendall Room, which features paintings, drawings, and sculptures of Dean that were completed by Kendall, a host of novelty items that have been produced about Dean since the 1950s, and an archive and library where you can see photographs, hundreds of books and magazines, and clippings on this Hollywood legend. There's also a room where you can actually see Dean's artwork that he created.

Website: www.jamesdeangallery.com

Info: The cost of admission is free. The gallery's hours of operation are 9 a.m. to 6 p.m., but it's closed Thanksgiving, Christmas, and New Year's Day.

Contact: James Dean Gallery, 425 N. Main St., Fairmount, IN; (765) 948-3326.

But wait, there's more!

Your James Dean tour in Fairmount isn't over. Make sure you visit the Fairmount Historical Museum (203 E Washington St.; www.jamesdeanartifacts.com), which has a large collection of the actor's memorabilia including newspaper clippings, photos and letters, clothing, and more.

Also, each year the annual James Dean Festival and Run occurs typically in September, so check out the dates on the museum's website for the next event.

Next, head on over to the James Dean Memorial Park, located at 200 N. Main St., in Fairmount, where you can see the six-foot-high column with the Kenneth Kendall bust of Dean and a special tribute plaque. Kendall created a second bust of Dean that is at the Griffith Observatory in Los Angeles (see California's section for a write-up on the observatory under La La Land).

Lastly, James Dean's final resting place is at the Park Cemetery in Fairmount (Park Cemetery, 8008 S. 150 E.; 765-948-4040),

Foodie Fact! Mayberry Café

Have you ever wanted to be served a home-cooked meal by *The Andy Griffith Show*'s Aunt Bee? Well you can feel just like Andy and Opie did at The Mayberry Café, the closet experience you'll get to feeling like you're right in the show. The Mayberry Café was opened in 1989 by Brad and Christine Born. Here you can enjoy such daily specials as Aunt Bee's Famous Fried Chicken Dinner and other comfort foods such as Floyd's Fish Sandwich and Sheriff Taylor's Grilled Prime Rib. You can also participate in such fun events as Goober Hat Night.

WEBSITE: www.mayberrycafe.com

INFO: The café is open Sunday through Thursday 11 a.m. to 9:30 p.m. On Friday and Saturday, the café is open 11 a.m. to 10 p.m.

CONTACT: Mayberry Café, 78 West Main St., Danville, IN 46122; (317) 745-4067.

just about one mile from the James Dean Gallery. He is buried next to his mother and father, Mildred and Winton Dean.

A LEAGUE OF THEIR OWN STADIUM

So if you haven't heard of *A League of Their Own* and you call yourself a fan of sports or movies, then you have a job to do. Buy the anniversary edition of the movie (they celebrated their 25th anniversary in 2017) and watch it. And remember, "There's no crying in baseball!"

But go ahead and laugh. The film starred the legendary Tom Hanks, Geena Davis, and Madonna. Hanks plays Jimmy Dugan, a washed-up ballplayer whose big league days have ended. After the men go to war, Dugan decides to coach in the All-American Girls Baseball League of 1943. It's a fantastic movie and one that you can watch as a family.

League Stadium is a baseball stadium in Hunting-burg, Indiana, that opened

Website: http://dcbombers.com

Info: Free admission, unless you're seeing a DC Bombers game (which you really should check out).

Contact: Huntingburg League Stadium, 203 S. Cherry St., Huntingburg, IN; (812) 683-2211.

in 1894 and was renovated in 1991 just for the filming of *A League of Their Own*. Take a walk around and you will feel transported back to the film (which you have watched at this point, right?).

RED SKELTON MUSEUM OF AMERICAN COMEDY

Who was your favorite Red Skelton character? Was it Clem Kadiddlehopper, the dim-witted country bumpkin? Freddie the Freeloader, who was a hobo who lived in a dump? Gertrude and Heathcliffe, the two seagulls that Red brought to life? Cauliflower McPugg, the punch-drunk fighter? George Appleby, the henpecked husband? Willie Lump Lump? Whoever it was, there's no doubt that Skelton was an amazing entertainer who could make us laugh and brought audiences so many memorable characters throughout his career.

Born in 1913 in Vincennes, Indiana, Red was raised by a single mother after his father died two months before he was born. His childhood was hard and filled with poverty, but

Website: http://redskeltonmuseum .org

Info: Cost of admission: adults, $8; seniors 60+, $7; students kindergarten through college, $5; children under 5, free. The museum's hours are Tuesday through Saturday 10 a.m. to 5 p.m. and Sunday noon to 5 p.m. The First Sunday of every month is Summers Sunday in honor of Dr. Phillip Summers, with free admission for all guests.

Contact: Red Skelton Museum of American Comedy, 20 Red Skelton Blvd., Vincennes, IN 47591; (812) 888-4184.

Statue Alert! Red Skelton

You can find a bronze sculpture of comedic legend Red Skelton in the lobby of Vincennes University's Red Skelton Performing Arts Center. If you can't get enough of Red Skelton's comedy and want to be around others who feel the same way, then make plans to attend the annual Red Skelton Festival, typically held in July every year. The festival is held on the grounds of the Red Skelton Museum of American Comedy in Vincennes, Indiana. For more information, visit http://redskelton museum.org.

he enjoyed making others laugh, so he left home at 15 years old to perform in shows.

In the 1940s, he had his own radio show, *The Red Skelton Show,* which he then moved to television. *The Red Skelton Show* stayed on NBC and then on CBS for a total of 20 years, from 1951 to 1971. In 1986, Red Skelton received the Governor's Award for lifetime achievement from The Academy of Television Arts and Sciences.

The Red Skelton Museum of American Comedy, located in Skelton's hometown of Vincennes, Indiana, is a tribute to the entertainer and features a huge 3,500-square-foot interactive exhibit entitled "Red Skelton: A Legacy of Laughter" which allows visitors to engage in activities of physical comedy, learn more about Red's life, and see scrapbooks of photos and memorabilia of his career. The best part of the entire exhibit is the costumes that Red used to become Freddie the Freeloader, Clem Kadiddlehopper, San Fernando Red, Sheriff Dead-Eye, Cauliflower McPugg, and others. You can almost see Red performing when you see the costumes.

WISCONSIN

Say cheese! Wisconsin is the cheese state, but that's not all it's known for. Can you say beer? I thought you could because Wisconsin is also home to many breweries. I also need to throw in a "Go Pack Go" because it's home to the Green Bay Packers. For directors, however, they love filming here. Over the years, the following shows and movies have been filmed here: *Public Enemies* (2009), *Mr 3000* (2004), *Amityville Horror* (2005), and more.

Statue Alert! The Bronze Fonz

Aaaayyyyy! Two thumbs up to Milwaukee for dedicating a statue to the leather jacket–wearing biker from the hit show *Happy Days*. Arthur Fonzarelli, who was known as "Fonzie" or "The Fonz" was a character on the sitcom that ran on ABC from 1974 to 1984. Portrayed by Henry Winkler, he became the most popular character on the show. In downtown Milwaukee where *Happy Days* takes place, the statue of Fonzie in his two thumbs up pose can be found near the Riverwalk.

INFO: The statue can be found at 117 E. Wells St., Milwaukee, WI 53202.

OTHER THINGS TO SEE OR DO IN WISCONSIN

TEN CHIMNEYS: Many film and television buffs also enjoy a good theater performance and many of those performances have been created by Broadway legends Alfred Lunt and Lynn Fontanne. Lunt and Fontanne were Broadway actors who performed in more than two dozen productions together including *Sweet Nell of Old Drury* (1923) and *The Visit* (1958). Noël Coward's play *Design for Living* (1933) was written for them. Ten Chimneys is the couple's National Historic Landmark home that you can tour that includes memorabilia of their theatrical history. *Website:* http://tenchimneys.org

Info: Cost of admission: Main House Only Tours are 90 minutes and $28 per person. Two-hour Full Estate Tours are $35 per person. The estate tour season lasts May to December. Tours are available Tuesday to Saturday 10 a.m. to 2:45 p.m. and Sunday noon to 2:45 p.m. The Lunt-Fontanne Program Center is open (free of charge) to the public during the tour season.

Contact: S43 W31575 Depot Rd., Genesee Depot, WI 53127; (262) 968-4110.

LAMBEAU FIELD: The rich sports history of the Green Bay Packers is worth exploring at their home grounds of Lambeau Field. Learn about Vince Lombardi (the man behind the Lombardi trophy) and how one team, owned by a town, became one of the most beloved, and toughest, teams in the country. Take a tour of the stadium and walk on Lambeau Field and tour their Hall of Fame. If you can snag tickets to a game, do so. It's an experience you'll never forget.

Website: www.packers.com

Info: The cost of admission to the Lambeau classic tours is adults (18–61), $15; seniors (62+), $12; military (with valid military ID), $12; youth (12–17), $12; student (with college student ID), $12; children (6–11), $9, and children (5 and under), free. Tours run throughout the day.

Contact: Lambeau Field, 1265 Lombardi Ave., Green Bay, WI 54304; (920) 569-7500.

OKLAHOMA

Oklahoma, where the wind comes sweeping down the plain and the directors come to film their next ventures. It's here they will find the Great Plains, hills, lakes and forests, and, of course, a rich history of cowboys and western and pioneer life. Great movies have been filmed here, including *The Grapes of Wrath* (1940), *Tumbleweeds* (1925), *True Grit* (1969), *Rumble Fish* (1983), *Rain Man* (1988), and *Elizabethtown* (2005).

WILL ROGERS DOG IRON RANCH & BIRTHPLACE HOME

Will Rogers, known as "Oklahoma's Favorite Son," was born on the Dog Iron Ranch in Indian Territory, near present-day Oologah, Oklahoma. Will Rogers contributed so much to Hollywood. Not only was he a stage and motion picture actor, performing with the Ziegfeld Follies, but he was also an American cowboy, humorist, newspaper columnist (4,000 columns!), and social commentator. America loved Will Rogers.

Rogers made 71 movies and 50 of them were silent movies. His film credits include *Laughing Bill Hyde* (1918) and *The Ropin' Fool* (1921), both silent films, and such talkies as *They Had to See Paris* (1929) and *State Fair* (1933).

Website: www.willrogers.com/memorial-museum

Info: Cost of admission: adults, $7; seniors 62+, $5; military with ID, $5; children 6-17, $3; children 5 and under, free. Admission is free to the Birthplace Ranch in Oologah, Oklahoma. The museum is open daily 10 a.m. to 5 p.m.

Contact: Memorial Museum, 1720 W. Will Rogers Blvd., Claremore, OK 74017. Birthplace Ranch, 9501 E. 380 Rd., Oologah, OK 74053; (918) 341-0719.

He accomplished so much, but sadly his life was cut short on August 15, 1935, when a plane he was flying, with aviator Wiley Post, crashed near Point Barrow, Alaska, killing them both.

Fans can take a free tour of the Will Rogers Dog Iron Ranch & Birthplace Home in Oologah, a Greek Revival–style home that was built in 1875. In his honor, there was also a Will Rogers memorial built in Claremore, Oklahoma, which was dedicated in 1938 by President Franklin

Roosevelt. The site also holds family days, lectures, frontier camps, Halloween nights, and Will Rogers Days.

To find out more about the actor and cowboy, fans can also visit the Will Rogers Memorial Museum in Claremore, Oklahoma, where you'll see the world's largest collection of Will Rogers' memorabilia and his entire collection of writings.

But wait, there's more!

In Utqiaġvik, Alaska, there is a free permanent memorial to Will Rogers at the Wiley Post/Will Rogers Airport welcome center.

Contact: Wiley Post/Will Rogers Airport, 1747 Akavak St., Utqiaġvik, AK 99723.

TOM MIX MUSEUM

Tom Mix was a cowboy/silent film actor who averaged about five or so films a year for a total of 370 full-length westerns. His first role was in *Ranch Life in the Great Southwest* (1910), and it is said that at the peak of his fame he was the highest-paid actor in Hollywood, earning as much as $17,500 a week. If you're wondering, that's about $218,000 in today's dollars. His last movie was *The Miracle Rider* in 1935. Unfortunately, five years later, Mix was killed after he lost control of his car near Florence, Arizona.

There's a story that goes along with that having to do with the "Suitcase of Death." Mix was driving so fast on the day that he died that he didn't notice a sign warning him that a bridge was out ahead of him. Unfortunately the car fell into the gully and he was smacked in the back of his head by an aluminum suitcase in the backseat. You can see the dented "Suitcase of Death" at the Tom Mix Museum in Dewey, Oklahoma.

Website: www.tommix museum.com

Info: The museum is open February through December 23. The hours are Tuesday through Saturday 10 a.m. to 4:30 p.m.

Contact: Tom Mix Museum, 721 North Delaware, Dewey, OK 74029; (918) 534-1555.

The city also hosts an annual Tom Mix Festival and Western Heritage Weekend, which includes a parade, costume contests, a stick horse rodeo, street vendors, gunfights, music, prestidigitation, and much more.

But wait, there's more!

At the crash site where cowboy/actor Tom Mix lost his life, you can find a 2-foot-tall iron statue of a riderless horse and a plaque that reads: "In memory of Tom Mix whose spirit left his body on this spot and whose characterization and portrayals in life served to better fix memories of the Old West in the minds of living men."

GENE AUTRY OKLAHOMA MUSEUM

Gene Autry was one of the most popular singing cowboys of his time. (Remember the song "Back in the Saddle Again"?) He was an entertainer on his own show on CBS, *The Gene Autry Show*, which aired for 91 episodes from 1950 until 1956. He is honored in the Autry Museum of the American West located in Los Angeles. (Find out more about this museum in the California section.)

The Gene Autry Oklahoma Museum in (where else?) Gene Autry, Oklahoma, opened in 1990 and is home for Autry's memorabilia and dedicated to the careers of other singing cowboys too. The museum also hosts a series of concerts every year that culminate in a three-day festival called the Cowboy Way.

Website: https://geneautryok museum.org

Info: The museum is open Thursday through Saturday 10 a.m. to 5 p.m. and Sunday noon to 5 p.m.

Contact: The Gene Autry Oklahoma Museum, 47 Prairie St., Gene Autry, OK 73436; (580) 294-3335.

Statue Alert! James Garner

Actor James Garner was known for his costarring role as Bret Maverick in the western series *Maverick* (1957), which ran on ABC from 1957 to 1962. He also portrayed private eye Jim Rockford in the NBC weekly hit show *The Rockford Files*, which ran from 1974 to 1980 (1974). He also appeared in *The Great Escape* (1963), *Grand Prix* (1966), *Victor/Victoria* (1982), *Murphy's Romance* (1985), *Space Cowboys* (2000), and *The Notebook* (2004). Born in Norman, Oklahoma, the popular actor was honored by the town with a 10-foot-tall bronze statue of his portrayal as Maverick, which is located in James Garner Plaza on, of course, James Garner Avenue.

TWISTER MUSEUM

Bill Paxton and Helen Hunt portrayed storm chasers in the 1996 film *Twister*. The film made almost $500 million at the box office and was nominated for an Academy Award for Best Visual effects. If you're a fan, then stop at the Twister Museum in Wakita, Oklahoma. This isn't a big studio museum with lots of interactive exhibits and hundreds of square footage of memorabilia, but it's worth a visit if you're in the area. It showcases the original Dorothy I machine used in the film, as well as photos, signed shirts, and pieces of items destroyed by the twister in the film.

Website: http://twistercountry.com

Info: The museum is open 1 p.m. to 5 p.m. daily, April through October, and other times by appointment.

Contact: Twister Museum, 101 W. Main, Wakita, OK 73771; (580) 594-2312.

OTHER THINGS TO SEE OR DO IN OKLAHOMA

FRONTIER PARK: This western-themed amusement park in Oklahoma City really takes you back to the days of Rogers, Mix, and Autry. Well, if they had roller coasters and mile-long waterslides back then. Either way, it's still a great way to cool off after a hard day of touring.
Website: www.frontiercity.com
Info: Cost of admission: $31.99 + tax for guests 48" and taller and $29.99 + tax for guests under 48"; children 2 and under, free. Hours are 10:30 a.m. to 9:30 p.m.
Contact: Frontier Park, 11501 N I-35 Service Rd., Oklahoma City, OK 73131; (405) 478-2140.

AMERICAN BANJO MUSEUM: The first time I ever heard a banjo was on *Hee Haw*, a variety show on CBS that started airing in 1969. Roy Clark was fiddling and I think I saw smoke coming up from the strings. This museum is a banjo lover's dream.
Website: www.americanbanjomuseum.com
Info: Cost of admission: adults, $8; seniors (55+), $7; students, $7; youth (5–17), $6. The museum is open Tuesday through Saturday 11 a.m. to 6 p.m. and Sunday noon to 5 p.m.
Contact: American Banjo Museum, 9 E Sheridan Ave., Oklahoma City, OK 73014; (405) 604-2793.

NORTH DAKOTA

North Dakota is in the heart of the Breadbasket of America. When you drive through the state, you'll see yellow fields of sunflowers and amber waves of grain and other crops. There are also many North Dakota Indian reservations that have been used for filming. Such movies as John Wayne's *Three Faces West* (1940) and *Dakota* (1945), as well as *Fargo* (1996), have been filmed here.

LAWRENCE WELK BIRTHPLACE
(LUDWIG AND CHRISTINA WELK HOMESTEAD)

The Ludwig and Christina Welk Homestead built in 1893 is a historic farm house located at 845 88th St. Southeast in Strasburg, North Dakota, and was the birthplace of one of the most beloved entertainers of his generation.

Website: http://history.nd.gov/historicsites/welk

Info: The homestead is open May 26 to September 4 Thursday through Sunday 10 a.m. to 5 p.m.

Contact: Lawrence Welk Birthplace, 845 88th St. SE, Strasburg, ND 58573; (701) 336-7103.

SOUTH DAKOTA

Known for its mountains, desert, rolling plains, small towns and historical buildings, South Dakota has been used in such movies as *Badlands* (1973), *Thunderheart* (1992), *Mercury Rising* (1998), and, of course, *Dances with Wolves* (1990).

DANCES WITH WOLVES FILM SET

In 1990, the Kevin Costner movie *Dances with Wolves* won the Academy Award for Best Picture and with good reason. The drama centers on a Civil War soldier who develops a relationship with a band of Lakota Indians and received the name Dances with Wolves. The soldier then falls in love with a white woman in the tribe and Union soldiers soon come for a battle over land.

The *Dances with Wolves* film set is located only 15 miles from the Mount Rushmore National Memorial in Fort Hays, South Dakota. You can see the sets that were used in the movie, including the Supply House and Sawmill, as well as memorabilia from more than 50 other movies that were filmed in South Dakota.

Website: http://mountrushmoretours.com/fort-hays-old-town-square

Info: The film set is open mid-May to mid-October 7 days a week, 7:30 a.m. to 7:30 p.m.

Contact: Mount Rushmore Tours, 2255 Fort Hayes Dr., Rapid City, SD, 57702; (888) 343-3113.

The movie went on to earn a whopping $424.2 million. In 2007, *Dances with Wolves* was selected for preservation in the United States by the National Film Registry and the Library of Congress for being culturally significant.

MINNESOTA

From its beautiful mountains to its tremendous snowfalls, Minnesota has been a popular location for many films, such as *Slaughterhouse-Five* (1972), *The Wrestler* (1974), *Catch Me if You Can* (1989), *The Mighty Ducks* (1992), *A Prairie Home Companion* (2006), and more. Television shows such as *Bizarre Foods*, *Old Home Love*, *Stonehouse Revival*, *American Rehab*, *My Big Family Renovation*, *Design on a Dime*, *Rehab Attic*, and *Call of the Wild* have found a reason to come to Minnesota.

PURPLE RAIN TOUR

Minneapolis, Minnesota, was the backdrop for much of the filming of *Purple Rain,* a 1984 rock musical drama film that starred the legendary Prince in his acting debut playing "The Kid," a quasi-biographical character. The film had a $7 million budget and ultimately grossed more than $148 million worldwide.

Principal photography took place almost entirely in Minneapolis. Now Prince's fans can visit Paisley Park, the estate and sanctuary in the area where the musician lived and created music.

Regarding the film *Purple Rain,* the city of Minneapolis offers a self-guided tour of Prince's hometown, which includes various landmarks seen in the movie. Visit www.minneapolis.org/princes-minneapolis/visit-princes-hometown-of-minneapolis for a brochure.

Website: https://officialpaisleypark.com

Info: Admission is $38.50 and includes 70-minute guided tours of the recording and mixing studios where Prince recorded, produced, and mixed some of his biggest hits; his video editing suites and rehearsal rooms; and the soundstage and concert hall where Prince rehearsed for concert tours and held exclusive, private events and concerts. You can also take a Paisley Park After Dark tour for $60.00 or a $100, 100-minute VIP tour. The park is open 9 a.m. to 11 p.m. every day.

Contact: Paisley Park, 801 Audubon Rd., Chanhassen, MN 55317.

Did you know?
Purple Rain featured the iconic Minneapolis rock club First Avenue & 7th Street Entry as its setting. It's still open and tourists can still enjoy concerts. For more info, visit http://first-avenue.com.

Statue Alert! Mary Tyler Moore

The Mary Tyler Moore Show aired on CBS from 1970 to 1977 and starred Mary Tyler Moore, who was also known as Laura Petrie on *The Dick Van Dyke Show*. *The Mary Tyler Moore Show* featured American television's first single career woman in a leading role, Mary Richards. Over the course of its seven-year run, *The Mary Tyler Moore Show* won the Emmy for Outstanding Comedy Series three years in a row (1975–77).

The premise of the show was simple—Mary Richards moves to Minneapolis after leaving her fiancé and works at WJM's six o'clock news. Her boss, Lou Grant, is played by Ed Asner. The sitcom also stars Gavin MacLeod, Ted Knight, Cloris Leachman, Betty White, and Valerie Harper.

The Mary Tyler Moore Show was based in Minneapolis, but the only thing that fans of the show can do here to honor their fave sitcom is to take a selfie with the Mary Richards statue. The statue freezes Richards tossing her hat in the air, a replica of the iconic scene in the opening credits of the show.

WEBSITE: www.minneapolis.org/things-to-do/visitor-information

INFO: The statue is located in the glass-enclosed Minneapolis Visitor Center inside the CenterPoint Energy Building. It is open 10 a.m. to 6 p.m. weekdays and noon to 5 p.m. on weekends. Admission to the center is free.

CONTACT: Minneapolis Visitor Center, 505 Nicollet Mall #100, Minneapolis, MN 55402; (612) 397-9275.

DID YOU KNOW?

In case you're wondering, the house featured in the exterior shots of Mary's apartment in *The Mary Tyler Moore Show* is a private residence now, so no tours are allowed. Outside photo ops are fine; just please respect any current resident who may live there. The address of the home is 2104 Kenwood Pkwy. in Minneapolis, between Cedar Lake and Lake of the Isles.

JUDY GARLAND MUSEUM

It's undeniable that no matter how you know the actress Judy Garland, you still know her as one of America's favorite entertainers. Most famously known for her role as Dorothy in the 1939 movie *The Wizard of Oz,* Garland actually made more than two dozen films with MGM, including nine with actor Mickey Rooney.

She also had roles in the films *Meet Me in St. Louis* (1944), *The Harvey Girls* (1946), and *Easter Parade* (1948) and had two Academy Award–nominated performances for *A Star Is Born* (1954) and *Judgment at Nuremberg* (1961). Garland was also the youngest and first female recipient of the Cecil B. DeMille Award for lifetime achievement in the film industry.

Website: www.judygarland museum.com

Info: Cost of admission to the museum is $9 and covers the entire campus of attractions; children under 2 years old admitted for free; $8 for American Automobile Association members. Museum hours are October to May, Friday and Saturday 10 a.m. to 5 p.m.; May 1 to Memorial Weekend, Monday to Saturday 10 a.m. to 5 p.m.; Memorial Weekend to September 30, Monday to Sunday 10 a.m. to 5 p.m.

Contact: Judy Garland Museum, 2727 Pokegama Ave. South, Grand Rapids, MN 55744. (218) 327-9276; (800) 664-5839.

The Judy Garland Museum, located where the actress was born in Grand Rapids, Minnesota, is a huge 15,000 square feet dedication to Garland. Opened in 1975, it honors the life and work of this legendary performer and includes the world's largest collection of Garland memorabilia and *The Wizard of Oz* collectibles. Fans can tour the 1892 house where Judy grew up and then head to the museum where they'll see her test dress from *The Wizard of Oz,* her birth certificate and work permit, and a memorial garden. The museum also features educational exhibits, lectures, performances, seminars, and film screenings.

Interestingly, the museum includes the Barouche Carriage, a Civil War–era Brewster used in *The Wizard of Oz*. You see it in the movie when the doors to the Emerald City open for Dorothy and Toto, The Scarecrow, The Tin Man, and the Cowardly Lion. Did you know that it was also owned by Abraham Lincoln? There's so much to learn!

WIZARD OF OZ FESTIVAL

The Judy Garland Museum hosts an annual festival that honors Garland and the fun of *The Wizard of Oz*. It includes a 5K Dash for the Ruby Slippers, trivia nights, Dorothy's farm animals, Judy Garland's movies, talent contests, and special guests. In 2017, documentarian John Fricke shared behind-the-scenes stories and video about the making of *The Wizard of Oz*. The festival includes watching *The Wizard of Oz* outdoors with other fans on a jumbo screen.

Website: www.judygarland museum.com/wizard-of-oz-festival

Contact: Judy Garland Museum, 2727 Pokegama Ave. South, Grand Rapids, MN 55744; (218) 327-9276; (800) 664-5839.

LAURA INGALLS WILDER MUSEUM

Little House on the Prairie was an extremely popular drama series that starred Michael Landon, Melissa Gilbert, and Karen Grassle. It that ran on NBC from September 11, 1974, to March 21, 1983. Set in Walnut Grove, Minnesota, *Little House on the Prairie* was loosely based on Laura Ingalls Wilder's best-selling series of *Little House* books that were released between 1932 and 1943. The books were based on Wilder's pioneering life.

In case you didn't realize it, Walnut Grove, Minnesota, actually does exist and the Laura Ingalls Wilder Museum and Gift Store located here is a must-see for fans of both the books and the television show. On the property, there is an 1898 depot, a chapel, an onion-domed house, dugout display, little red schoolhouse, early settler home, and covered wagon display.

You'll also see memorabilia from the *Little House on the Prairie* actors who brought it with them on a visit, including Karen Grassle (Ma), Melissa Sue Anderson (Mary), Katherine McGregor (Mrs. Oleson), Alison Arngrim (Nellie), Kevin Hagen (Doc Baker), Dean Butler (Almanzo Wilder), and Lindsay & Sidney Greenbush (Carrie). There is also a Kelton Doll Collection, scale models of the Ingalls TV series homes, historic documents, and more.

Website: http://walnut grove.org

Info: Cost of admission: ages 4 and under, free; ages 5–12, $4; ages 13 & over, $7.

Contact: Laura Ingalls Wilder Museum, 330 8th St., Walnut Grove, MN 56180; (800) 528-7280.

> ### Statue Alert! Peanuts
>
> Charles Schulz, the man behind Charlie Brown, Snoopy, and the gang, was born in Minneapolis, Minnesota, and his childhood life was spent in Saint Paul's Mac-Groveland neighborhood. There are permanent bronze Peanuts sculptures dedicated to the popular animated characters in Landmark Plaza and Rice Park. For more information, visit www.visitsaintpaul.com/blog/charles-m-schulz-saint-paul.
>
> If you can't get enough of Snoopy, Woodstock, and the gang, head on over to the California section, where you can learn more about the Charles Schulz at the Charles M. Schulz Museum in Santa Rosa.

But wait, there's more!

If you're a Laura Ingalls and *Little House on the Prairie* fan, there are more things to see throughout the United States, including the Laura Wilder Park and Museum in Burr Oak, Iowa; the Little House on the Prairie Museum near Independence, Kansas; and the Laura Ingalls Wilder Historic Home & Museum in Mansfield, Missouri. Learn more about the series and also read about Sandra Hume, her love of Little House travel, and her Little House Travel Series.

OTHER THINGS TO SEE OR DO IN MINNESOTA

MALL OF AMERICA: There's so much to do here, it's impossible to mention it all, but some of the highlights include 520 stores and restaurants; Nickelodeon Universe, an indoor theme park featuring 27 rides; SEA LIFE Minnesota Aquarium, FlyOver America a 4D immersive flight adventure; Crayola Experience; and an 18-hole golf course. There are also concerts, book signings, celebrity meet-and-greets, a 500-room Radisson Blu hotel, a 342-room JW Marriott hotel, and so much more. The mall was prominently featured in the holiday movie, *Jingle All the Way* (1996).
Website: www.mallofamerica.com
Info: The mall hours are different for each venue, so check their website for the hours of what you want to see.
Contact: Mall of America, 60 East Broadway, Bloomington, MN 55425; (952) 883-8800.

IOWA

Iowa is filled with rolling plains and cornfields and has a huge history in the filmmaking and television business. Such films as *State Fair* (1945), *Field of Dreams* (1989), *The Bridges of Madison County* (1995), *Michael* (1996), and the classic *The Music Man* (1962) were filmed here.

JOHNNY CARSON'S CHILDHOOD HOME

Heeeeeere's Johhny! Jack Nicholson might have also made that line famous in his 1980 movie *The Shining,* but for 30 years, viewers who tuned into NBC's *The Tonight Show* heard Ed McMahon announce Johnny Carson with this phrase five nights a week.

Johnny Carson created some of the most memorable moments in *The Tonight Show* history. Remember Carnac the Magnificent, Floyd R. Turbo, The Mighty Carson Art Players, and his interactions with such guests as Betty White, David Brenner, and Robin Williams?

Carson was born in Corning, Iowa, and fans of this comedian can visit the house where he was born and raised. Here you can sit back and watch episodes of *The Tonight Show with Johnny Carson*. This diminutive white home brings you back to Carson's childhood.

> **Website:** www.johnnycarsonbirth place.org
>
> **Info:** Cost of admission: $7 per person. Tours are available during the summer, on weekends Memorial Day through Labor Day. The museum is open on Saturdays 10 a.m. till 2 p.m. Other times during the year appointment tours are welcome.
>
> **Contact:** Johnny Carson Birthplace, 500 13th St., Corning, IA 50841; (641) 322-3212.

DONNA REED MUSEUM

Do you know Donna Reed from her role as Mary Hatch Bailey in Frank Capra's 1946 film *It's a Wonderful Life*, as Lorene Burke in the 1953 film *From Here to Eternity*, or as a middle-class mom and housewife in the sitcom *The Donna Reed Show* (which ran from 1958–66)? Maybe you've watched all of the performances of this Academy and Emmy Award-winning versatile actress. If

so, you'll want to check out the Donna Reed Museum, located in Denison, Iowa, where Reed was born and raised. It opened its doors in 2004 and is home to the annual Donna Reed Performing Arts Festival and Workshops.

But wait, there's more!

If you are a fan of the classic holiday movie, *It's a Wonderful Life*, which starred Donna Reed and Jimmy Stewart, don't miss the It's a Wonderful Life Museum, that is dedicated to the film, located in Seneca Falls, New York. (See page "It's a Wonderful Life Museum" on page 85.) Jimmy Stewart also has his own museum, The Jimmy Stewart Museum, located in the actor's hometown of Indiana, Pennsylvania.

THE MUSIC MAN SQUARE

"You got trouble with a capital T, and that rhymes with P and that stands for Pool."

The good news is that in this River City streetscape, there is no trouble. Instead, it's just a lot of fun to see the re-creation of the street that was first made famous in the 1957 play by Meredith Willson and then in the 1962 musical movie of the same name. The movie starred Robert Preston (who was also in the theater performance), Shirley Jones, and Buddy Hackett and was nominated for six Academy Awards. It won one of those awards, for Best Musical Score.

The *Music Man* Square is located where Meredith Willson was born in Mason City, Iowa, but here you will feel like you are right in River City with Mrs. Paroo's front porch and the Pleez-All pool hall.

Take a tour of the Meredith Willson home where he was born and learn about him and his mother, Rosalie, who loved to sing together. There's also a Meredith Willson Museum where you can learn more about Willson's life and see a replica of his California home studio and the actual piano he used. The house is open for tours.

> ### Statue Alert! Meredith Willson
>
> It almost seems as if Meredith Willson is leading the *Music Man* parade, as the life-size statue of the author greets visitors who stroll up the walkway. The statue can be found outside and to the east of The *Music Man* Square complex in Mason City, Iowa.

FIELD OF DREAMS FARM

The Lansing Family Farm in Dyersville, Iowa, was the site of the famous 1989 baseball movie that starred Kevin Costner, Ray Liotta, and James Earl Jones and responsible for one of the most well-known phrases in movies: "If you build it, they will come."

Field of Dreams is the adaptation of W. P. Kinsella's novel *Shoeless Joe.* Ray Kinsella (Costner) is an Iowa farmer who, while walking through his cornfields, hears a voice whispering to him, "If you build it, they will come." He continues hearing

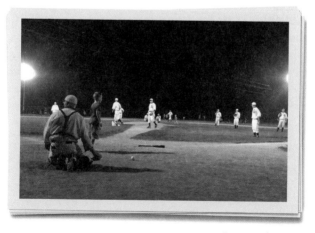

Every year, the Lansing Family Farm in Dyersville, Iowa, hosts a Field of Dreams baseball game.

Website: www.fodmoviesite.com

Info: The farm is open daily through October. In November, the site is open on weekends only. Several events are held each year. For example, the Ghost Sunday Comedy Show lets visitors watch the Ghost Players emerge from the magical corn to entertain the crowd with comedy.

Contact: 28995 Lansing Rd., Dyersville, IA 52040; (888) 875-8404.

this before finally seeing a vision of a baseball diamond in his field.

It was a cold day in late December, 1987, when a volunteer with the Dubuque Chamber of Commerce (working in conjunction with the Iowa Film Board), Sue Reidel, knocked on the door of the Lansing Family Farm bringing Don Lansing to his feet. A stranger at his door would explain, "We're thinking of making a movie in the area on a farm. It possibly could be your farm. Would you allow us to take video of the environs?" And the rest is history.

STAR TREK'S CAPTAIN JAMES T. KIRK'S FUTURE BIRTHPLACE

If you're a Trekkie, this may not be news to you. Just in case you need to know, Star Trek's Captain James Tiberius "Jim" Kirk (portrayed by William Shatner) will be born on March 22, 2228, in Riverside, Iowa. That is, according to what has been said on the show. There's a commemorative plaque and bench that marks Kirk's future birth. The plaque is located behind the New Image Salon at 51 W. First Street.

THE BRIDGES OF MADISON COUNTY TOUR

Clint Eastwood and Meryl Streep portray Robert and Francesca in this romantic adaptation of the novel. Robert, a photographer, steps into the life of a housewife, changing it forever. Madison County honors the legacy of this movie with a Bridges of Madison County tour. You will visit the Holliwell Covered

Website: www.madisoncounty.com

Info: The Madison County Visitors Center is open May through October, 9 a.m. to 4 p.m. Monday through Saturday, and noon to 3 p.m. on Sunday. From November through April, the center is open 10 a.m. to 3 p.m. Monday through Friday.

Contact: Madison County, Iowa Chamber & Welcome Center, 73 Jefferson St., Winterset, IA 50273; (515) 462-1185.

Bridge, featured in the movie, as well as the Roseman Covered Bridge (where Robert first asked Francesca for directions. Later, it's where Francesca wants her ashes to be scattered).

JOHN WAYNE BIRTHPLACE & MUSEUM

Howdy Pilgrim! John Wayne was one of the most popular western actors of our time. (Lisa's note: One of my favorite episodes of *I Love Lucy* brings John Wayne and Lucy together when she tries to steal his footprints out of Grauman's Chinese Theatre.) The tough man was born Marion Mitchell Morrison in Winterset, Iowa, but he changed his name to a more Hollywood-friendly John Wayne later on and, of course, nicknamed "The Duke." Wayne hit it big in Hollywood when he performed in John Ford's 1939 film *Stagecoach*. He went on to act in an impressive 142 movies, including *The Quiet Man, The Alamo, Sands of Iwo Jima, Rio Bravo,* and *The Shootist*. Wayne was nominated for three Academy Awards and won once for Best Actor in a Leading Role in 1970 for his role as Rooster Cogburn in the 1969 film *True Grit*.

In his hometown of Winterset, the John Wayne Birthplace & Museum honors the actor with 6,100 square feet of original posters from his movies, clothes that he wore, movie scripts, contracts that he signed, letters that he wrote, artwork and sculptures.

The museum also includes one of Wayne's customized automobiles. It also includes a movie theater where you can watch a documentary on Wayne's career and shop in the gift shop. There is also an annual birthday celebration.

Website: www.johnwaynebirthplace.museum

Info: Cost of admission: adults, $15; seniors (60 and over), $14; children (8–12), $8; children (7 and under), free. The John Wayne Birthplace & Museum is open daily for visitors 10 a.m. to 5 p.m. (until 4 p.m. December through February). Handicap accessible.

Contact: The John Wayne Birthplace & Museum, 205 S. John Wayne Dr., Winterset, IA 50273; (515) 462-1044; toll-free: (877) 462-1044.

Did you know?
John "The Duke" Wayne beat lung cancer in 1964, but died 15 years later after a struggle with cancer of the stomach. His family created the John Wayne Cancer Foundation to bring The Duke's courage and grit to the fight against cancer. The main offices are located in Newport Beach, California. You can find out more information at https://johnwayne.org.

OTHER THINGS TO SEE OR DO IN IOWA

LAURA WILDER PARK AND MUSEUM: There is so much in this
country for Laura Ingalls Wilder fans to see. The author of the
Little House on the Prairie series lived in this home starting when
she was nine years old when her family traveled to Burr Oak,
Iowa, to manage the Masters Hotel. Today it's the only child-
hood home that remains on its original site and it is registered on
the National Register of Historical Places. Wilder's books went
on to become the popular *Little House on the Prairie* television
series.

Website: www.lauraingallswilder.us

Info: Cost of admission: adults/seniors, $8; children (ages 6 to
17), $6; children 5 and under, free. Season opens May 1. Hours
are Monday to Saturday 10 a.m. to 4 p.m., Sunday noon to
4 p.m. From Memorial Day through Labor Day, Monday to
Saturday hours are 9 a.m. to 5 p.m. Other parts of the year, call
for hours.

Contact: Laura Ingalls Wilder Park & Museum, 3603 236th
Ave., Burr Oak, IA 52101; (563) 735-5916.

IOWA 80 TRUCKING MUSEUM: The Iowa 80 Trucking Museum
includes very rare and one-of-a-kind trucks. It's great for kids
who love playing with trucks. They won't be able to climb and
touch too much, but they'll get a kick out of seeing trucks that
came before them.

Website: https://iowa80truckingmuseum.com

Info: Cost of admission is free, but a donation to support the
museum is appreciated. Open Wednesday through Saturday
9 a.m. to 5 p.m., Sunday noon to 5 p.m. In the summer, the
museum is open Monday through Saturday 9 a.m. to 5 p.m.
and Sunday noon to 5 p.m.

Contact: The Iowa 80 Trucking Museum, 505 Sterling Dr.,
Walcott, IA 52773; (563) 468-5500.

OHIO

Ohio is located in the Midwest and the western foothills of the Appalachian Mountains. There's Lake Erie and great cities, such as Cleveland and Cincinnati, where directors love to film their movies. Films that have been shot here include *The Deer Hunter* (1978), *The Rainmaker* (1997), *Antwone Fisher* (2002), and *Captain America: Winter Soldier* (2014).

A CHRISTMAS STORY HOUSE/MUSEUM

Oh fudge! If you dream of owning a Red Ryder, carbine action, two-hundred shot range model air rifle, you are must be a fan of the iconic movie *A Christmas Story*. Released in 1983, *A Christmas Story* is based on the Jean Shepherd's book *In God We Trust: All Others Pay Cash*, a collection of semiautobiographical short stories that Shepherd wrote for *Playboy* magazine during the 1960s.

A Christmas Story centers around Ralphie Parker, a young boy who dreams of owning the air rifle, but his parents have put their foot down. "You'll shoot your eye out," his mother declares. Ralphie (portrayed by Peter Billingsley) decides to take matters

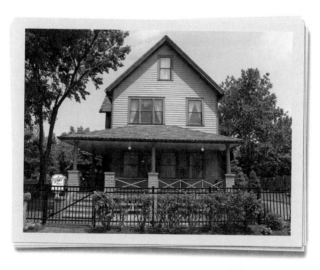

A Christmas Story House during the opening of the movie.

into his own hands, dropping hints and even visiting the jolly old man himself.

Fans of *A Christmas Story* can check out—and even stay in—the actual house where the movie was filmed in Cleveland, Ohio, which is now open for tours. The house can accommodate up to 6 guests per night. The loft area is equipped with a bedroom, living room, full kitchen, and full bath. Sleeping arrangements include a queen bed, queen sleeper sofa, and Ralphie and Randy's twin beds. Rates start at $395 per night and vary according to season. A two-night stay is required during the holiday season.

A Christmas Story House is located directly across the street from the official A Christmas Story House Museum, which features original props, including the family car, costumes, and memorabilia from the film, as well as hundreds of rare behind-the-scenes photos. The museum is now open seven days a week all year-round.

Here's an interesting note: Ian Petrella, who played Ralphie's little brother, Randy, also served as a special tour guide for A Christmas Story House and Museum, so you never know who you'll see!

And, yes, you can see the holy grail of props from the movie—the air rifle—on display at the museum. They purchased it in approximately 2015 to add to their collection.

The comedy has become a holiday classic, but if you've never seen *A Christmas Story*, don't worry. You're not out of the loop. Simply tune into the many, many, many(!) times it will be aired on television during every holiday season. According to *A Christmas Story* museum website, the cable network TNT first aired its 12-showing, 24-hour marathon as a stunt in 1988, but popular demand turned stunt into tradition. The annual marathon (now aired on TBS) starts every Christmas Eve and attracts more than 40 million people who tune in at some point to watch.

While you're in Cleveland, check out the Cleveland Play House too and see if they are doing another adaptation of the

Website: www.achristmas storyhouse.com

Info: Cost of admission: adults, $11; children (3–12), $7; children (2 and under), free; seniors (60+), $9. The museum is open year-round, 7 days a week, 10 a.m. to 5 p.m., except major holidays.

Contact: A Christmas Story House and Museum, 3159 W 11th St., Cleveland, OH 44109; (216) 298-4919.

famed movie. Performances typically run from the end of November through December 23. It's a great holiday tradition!

Every year, there is also a popular *A Christmas Story* 5K/10K Run, which benefits A Christmas Story House Foundation. More than 5,000 people run in the December race that takes you around to the locations from *A Christmas Story.* Runners have dressed up like Ralphie, run the race in a Leg Lamp Costume or jogged in the Bunny Suit! Racers receive goodies too, such as a Leg Lamp–themed shirt and free entrance to A Christmas Story House and Museum on race day. For more information, visit http://achristmasstoryrun.com.

Hotel Tip: If you're visiting A Christmas Story House and Museum during holiday time, check out The Kimpton Schofield Hotel, also in Cleveland. There is no guarantee that the hotel will offer this again, but they have previously offered a "Ralphie Suite Package" before, which included overnight accommodations in a suite that was re-created to look like Ralphie's home. The room included the Leg Lamp, Bunny Robes, a Decoder Ring, and Life-Bouy Soap. It's a bit pricey (has been priced at $679 previously) and, when they offered it before, a three-day stay was required.

⭐ **LISA'S PICK** ⭐
THE SHAWSHANK REDEMPTION DRIVING TRAIL

The Shawshank Redemption is, in my opinion, one of the best movies of all time. The 1994 movie starred Tim Robbins as Andy Dufresne, who is sentenced to two consecutive life terms in prison for the murders of his wife and her lover. Andy didn't commit these crimes, but while he is in jail, he becomes friends with Red, played by Morgan Freeman. *Spoiler alert!* Andy spends his time in jail planning his incredible escape and revenge on the jail's headmaster.

Believe it or not, the movie was actually considered a box-office flop when it was first released in 1994, earning only

This is the Ohio State Reformatory in Mansfield, Ohio, and the site of *The Shawshank Redemption*'s Andy Dufresne's cell.

$727,000 from 33 theaters. However, after being nominated for seven Academy Awards, the movie was rereleased in February 1995, where it went on to earn an additional $9 million.

Ohio is home to a 10-point *Shawshank Redemption* Driving Trail. The Ohio State Reformatory in Mansfield, Ohio, served as the fictional Shawshank State Penitentiary, and today, you can see Warden Norton's office and the Parole Board room, as well as Andy Dufresne's escape tunnel. Get your camera out and take a selfie with your favorite Shawshank character. Also on the Shawshank Trail is the Bissman Building, also in Mansfield, the location of where Brooks stayed when he went to the hotel and ultimately ended his life. However, don't expect to see the actual room they used to film when Brooks ended his life. That scene was actually filmed at the Ohio State Reformatory too.

Remember the park bench where Brooks sat while he waited for his crow Jake to return? There's a replica bench there (look for the plaque). Remember where Red walks after the gets out of the pickup truck, on his way to meet Andy? You can walk that same path, which is located in Butler, Ohio. Unfortunately, the big tree is no longer there. In 2016, the tree was toppled by heavy winds.

Save the date! In 2019, there will be a special 25th anniversary celebration of *The Shawshank Redemption,* to be held August 16–18, 2019.

Do the Shawshank Hustle!

Want to escape from prison? Put on your prison garb. Every June, the people behind The Shawshank Trail also hold an Annual Shawshank Hustle 7K. Entrants run past five filming locations used in *The Shawshank Redemption*. The monies raised from the Annual Shawshank Hustle are given to the Ohio State Reformatory Preservation Society.

WEBSITE: www.shawshanktrail.com

INFO: While there is an entire Shawshank Trail where you can see many highlights from the movie all year-round, the Ohio State Reformatory is only open April 1 through September 1, so plan accordingly.

CONTACT: Shawshank Trail, 124 North Main St., Mansfield, OH 44902; (800) 642-8282.

But wait, there's more!

The Shawshank Redemption movie is based on the story by legendary thriller author Stephen King called *Rita Hayworth and Shawshank Redemption*. He also wrote the screenplays for *Pet Sematary* and *Cat's Eye*. If you want to see where King found his motivation and ideas, flip to the section on Maine and buy a ticket for a tour by SK Tours in Bangor, Maine, which takes you to approximately 30 places that have inspired King and gives you a peek at his current residence.

CLARK GABLE'S CHILDHOOD HOME

Clark Gable was known as "The King of Hollywood," and with just cause. He was a leading man in more than 60 movies over 30 years, including some of the most iconic movies ever. He won an Academy Award for Best Actor in *It Happened One Night* and was nominated for his performance in *Mutiny on the Bounty*. Of course, he was best known for his portrayal of Rhett Butler in the classic 1939 movie *Gone with the Wind*.

Website: http://clarkgable foundation.com

Info: Cost of admission: $5.50 per person; seniors, $4.75; children (5–16), $3.25 per child. Fans should also visit the Gable Store for Clark Gable collectibles, *Gone with the Wind* memorabilia, and Gable and *Gone with the Wind* displays.

Contact: Clark Gable Foundation, 138 Charleston St., Cadiz, OH 43907; (740) 942-GWTW.

The birth home of this talented actor is located in Cadiz, Ohio, and is open for tours. Fans will see Gable's sled from his childhood, several of the actor's automobiles including a 1954 Cadillac, and more.

But wait, there's more!

If you're a *Gone with the Wind* fan, you should also plan a trip to Georgia where there are several museums, including the Margaret Mitchell House & Museum and The Road to Tara Museum, where you can see so many artifacts and behind-the-scenes displays from the movie and the books. All the information you need is in the Georgia chapter.

DEAN MARTIN'S HOMETOWN

Known as the "King of Cool," Dean Martin was born in Steubenville, Ohio, and became one of the most popular singers, actors, and comedians of his generation. He and Jerry Lewis were partners in the comedy team of Martin and Lewis, and Dean was also a member of the "Rat Pack." Dean was the host of *The Dean Martin Show*, which ran from 1965 to 1974 as well as one of the funniest television variety programs on the air at the time, *The Dean Martin Celebrity Roast*, which was on television from 1974 to 1984.

Martin was in many movies as solo star, as well as with Lewis, and with the legendary crooner, Frank Sinatra. Just some of the movies that Martin starred in include *Some Came Running* (1958), *Rio Bravo* (1959) with John Wayne, and *The Sons of Katie Elder* (1965).

Each June for the past 20 years, Dean Martin's hometown of Steubenville, which is known as the City of Murals, honors the legend with a three-day Dean Martin Festival. Step back in time with films, memorabilia, concerts, impersonators, food, a parade, and more. The Dean Martin Festival is also a fundraiser for the Dean Martin Scholarship Funds for local high school students pursuing music and the arts.

Other occasional events include a film festival, Father's Day Buffet, and the Dean Martin Horserace.

If you're looking for memorabilia on Dean Martin,

Website: www.deanmartin steubenville.com/history.html

Info: The festival is held throughout the city, and while many of the events are free, there is a charge for some.

Contact: Steubenville Convention and Visitors Center, 120 S 3rd St., Steubenville, OH 43952; (740) 283-4935.

Foodie Fact! *M*A*S*H*'s Tony Packo's

Tony Packo's gained worldwide fame when *M*A*S*H* character Corporal Maxwell Klinger, who was played by Jamie Farr, another Toledo native, made mention of it in six episodes of the show. In a 1976 episode, Klinger says, "If you are ever in Toledo, Ohio, on the Hungarian side of town, Tony Packo's got the greatest Hungarian hot dogs." With those words, Klinger put Packo's on the map. In another episode, the *M*A*S*H* hospital ordered a batch of sausage casings from Packo's to use in a blood-filtering machine. In yet another episode, Klinger spends time talking with a wounded soldier from Toledo. They share stories about their favorite places, including Tony Packo's. When the soldier returns home, he sends Klinger a shipment of Packo's hot dogs as a thank-you gift. Packo's was also mentioned in the two-and-a-half hour final episode of *M*A*S*H*. Photos of the *M*A*S*H* cast, their signed buns, and other *M*A*S*H* paraphernalia can be seen hanging in the Original Tony Packo's restaurant.

WEBSITE: www.tonypacko.com

INFO: Tony Packo's is open Monday through Thursday 10:30 a.m. to 10 p.m., Friday and Saturday 10:30 a.m. to 11:00 p.m., and Sunday 11:30 a.m. to 9 p.m.

CONTACT: Tony Packo's (The original), 1902 Front St., Toledo, OH 43605; (419) 691-6054.

DID YOU KNOW?
The Toledo Mud Hens, who were often cheered by Max Klinger on M*A*S*H, are a real baseball team! You can see them play a game on your trip to Ohio. Buy a ticket and support them! For more information, visit www.milb.com/index.jsp?sid=t512.

you can find some items on display in the Dean Martin Room of the Jefferson County Historical Museum and Library. You can also take a walking or driving tour of landmarks relevant to Dean Martin's life and career, including Dean's boyhood home and his father's barbershop as well as the church where Dean was

baptized. When you're hungry, eat at the restaurant that they say that Dean loved, Naples Spaghetti House.

And speaking of being the City of Murals, of course there is a Dean Martin Mural, located at 350 S. Hollywood Blvd. There is also the State Historical Marker in Gazebo Park on Route 7 commemorating Dean Martin Day, an official Ohio holiday.

OTHER THINGS TO SEE OR DO IN OHIO

ROCK AND ROLL HALL OF FAME: Get your groove on in Ohio's Rock and Roll Hall of Fame. Celebrate the musicians who have been inducted including ABBA, Aerosmith, The Beach Boys, Elvis Presley, Billy Joel, The Coasters, and so many more. There are exhibits, live music, and so much to do!
Website: www.rockhall.com
Info: Cost of admission: adults, $23.50; senior (65+), $21.25; youth (6–12), $13.75; children (ages 5 and under), free.
Contact: Rock and Roll Hall of Fame, 1100 E 9th St., Cleveland, OH 44114; (216) 781-ROCK (7625).

PRO FOOTBALL HALL OF FAME: Nobody said you can't like movies, television, *and* sports. I know I do (Let's Go, Packers!). If you love football, you shouldn't miss the Pro Football Hall of Fame, located in Canton, Ohio. Here you can honor the Hall of Famers who have been inducted throughout the years.
Website: www.profootballhof.com
Info: Cost of admission: adults (13-64), $25; seniors, $21; children 6 to 12, $18; children under 6, free. Hall of Fame hours in the summer: 9 a.m. to 8 p.m.; spring/fall: 9 a.m. to 5 p.m.
Contact: Pro Football Hall of Fame, 2121 George Halas Dr. NW, Canton, OH, 44708; (330) 456-8207.

KANSAS

If your house suddenly took off in a tornado, you might want it to land in Kansas, the closest you'll get to Oz. With its farms and wheatfields, there's no place like it. Filmed here over the years have been *Paper Moon* (1973); *Sarah, Plain and Tall* (1991); and, of course, *The Wizard of Oz* (1939). But that's not all that's happening in this state.

BUSTER KEATON MUSEUM

Buster Keaton was born on October 4, 1895, and became one of Hollywood's most famous actors, directors, producers, writers, and stunt performers. However, he was best known for his roles in silent films, including *Sherlock Jr.* (1924), *The General* (1926), *The Cameraman* (1928), *Steamboat Bill Jr.* (1928), and *The Goat* (1921). He had such a stoic expression about him that he became known as Buster "Stone Face" Keaton.

The Buster Keaton Museum in Piqua, Kansas, is devoted to Keaton's film career and numerous show business accomplishments. According to the museum's history, the nearby community of Iola started an annual event devoted to Keaton, and people started donating memorabilia. Today, there are posters, articles, photographs, and movies to see.

Website: www.kansastravel.org/buster keatonmuseum.htm

Info: Free admission. Museum is open Monday through Friday 8 a.m. to 1 p.m. and other hours by appointment.

Address: Buster Keaton Museum, Rural Water District 1, 302 South Hill St., Piqua, KS 66761; (620) 468-2385.

There's also an annual Buster Keaton Celebration in nearby Iola. The festival is typically held in late September, and admission is free.

DOROTHY'S HOUSE AND LAND OF OZ

Hey Dorothy, we actually *are* in Kansas! Liberal, Kansas, to be exact and this is where Dorothy's House and the Land of Oz, an interactive experience, awaits *The Wizard of Oz* fans. You'll start with a tour of Dorothy's House, which was built in 1907 and looks like the Gale farmhouse from the movie.

Website: www.dorothyshouse.com

Info: Admission (wristbands) to the OZ Museum and activities sponsored by the museum are $12 adults, $8 children ($10 military adults, $6 military children) per day. This includes unlimited time and access for the day to the museum, as well as admittance to all the speaker events at the museum and at The Columbian Theatre. Hours of the museum are (from Memorial Day to Labor Day), Tuesday through Saturday 9 a.m. to 6 p.m., Sunday 1 p.m. to 5 p.m.; Labor Day to Memorial Day: Tuesday through Saturday 9 a.m. to 5 p.m., Sunday 1 p.m. to 5 p.m.

Contact: Dorothy's House/Land of Oz, 567 E Cedar St., Liberal, KS 67901. Seward County Historical Museum, 567 Yellow Brick Rd., Liberal, KS 67901; (620) 624-7624.

If you want to experience what Dorothy did—minus being thrown by a twister, of course—this 5,000 square foot animated "Land of Oz" takes you there, with Dorothy, Toto, Munchkins, a Scarecrow, Tin Man, Cowardly Lion, and, of course, a Wicked Witch. You will walk through apple trees, and see flying monkeys and a horse of a different color (come on in!).

Dorothy's House and Land of Oz is also home to movie memorabilia, including the actual model of the home that was used in the tornado scene.

OZTOBERFEST!

In Wamego, Kansas, there's an annual celebration of Oz called OZtoberFEST that is typically held in October. It's a family-friendly celebration that includes a variety of activities such as

Website: www.visitwamego.com/events/oztoberfest

Contact: OZtoberFEST, 511 Lincoln St., Wamego, KS 66547; (785) 458-8686.

the OZ Costume Contest, Classic Car Show, Munchkinland, Tin Man's Garage, Uncle Henry's Farmers Market, Boom Battle Sports, Beer & Wine Garden, entertainment, food, children's activities, and more.

OZ WINERY

In the mood for some "Poppy Fields" wine, or how about a sip of "A Witch Gone Good," "Flying Monkey," or "Oil Can?" These are just a few of the creatively named wines made by Oz Winery in Wamego, Kansas. There are daily tastings and customers can

get two free samples. There is other merchandise as well in their store, including Drunken Munchkin T-shirts.

> **Website:** www.ozwinerykansas.com
>
> **Info:** The winery is open Sunday noon to 5 p.m. and Monday through Saturday 10 a.m. to 6 p.m.
>
> **Contact:** Oz Winery, 417 Lincoln Ave., Wamego, KS 66547; (785) 456-7417.

EVEL KNIEVEL MUSEUM

What does Evel Knievel have to do with a film and TV travel guide? If you grew up around the 1970s, you were like millions who were glued to the television to watch this stuntman and his daring attempts at breaking world records on his motorcycle. He was known for his attempt in 1974 to jump the Snake River Canyon in Idaho on a rocket-powered "Skycycle," but he didn't make it. Today, there's a museum in Topeka, Kansas, that just opened up in 2017 that honors the daredevil and his bone-breaking (literally) stunts.

> **Website:** http://evelknievelmuseum.com
>
> **Info:** Adults, $20, students, $10; children 7 and under, free; guided tour, $32.
>
> **Contact:** Evel Knievel Museum; 2047 SW Topeka Blvd., At Historic Harley-Davidson, Topeka, KS 66612; (785) 215-6205.

The huge 13,000-square-foot, two-story museum includes some of Knievel's motorcycles, leathers and helmets, and his "Big Red" tractor-trailer. There's a virtual reality motorcycle jump, actual X-rays, and an exhibit where you can plan your own virtual jump, even over sharks.

The museum is attached to the Historic Harley Davidson in Topeka, Kansas. It's open 10 a.m. to 6 p.m. Tuesday through Friday and 9 a.m. to 5 p.m. Saturday.

DWIGHT D. EISENHOWER LIBRARY, MUSEUM, AND HOME: Learn more about the 34th president of the United States at the library and museum that has 30,000 square feet of artifacts from Eisenhower's career.

Website: www.eisenhower.archives.gov

Info: Cost of admission: adults, $12; seniors (62 and over), $9; military (retired/disabled), $9; student (with ID), $9; children (6–15), $3; children (ages 5 and under), free; military (active With ID), free.

Contact: Eisenhower Presidential Library, Museum & Boyhood Home; 200 Southeast Fourth St., Abilene, KS 67410; (785) 263-6700 or (877) RING IKE.

ILLINOIS

If you're looking for a list of movies filmed in Illinois, it's probably shorter to find a list of films that weren't. Some of the funniest, most iconic movies in the 1980s were filmed there, including *The Blues Brothers* (1980), *Planes, Trains and Automobiles* (1987), *The Breakfast Club* (1985), *Weird Science* (1985), *Sixteen Candles* (1984), *Wayne's World* (1992), and *National Lampoon's Vacation* (1983). However, its entertainment history goes back even further.

JACK BENNY'S BOYHOOD HOME

Ladies and gentlemen, this is Jack Benny talking. There will be a short break while you say, who cares?

Jack Benny once said this famous line, but the truth was that Americans did care. Benny was a beloved comedian who starred in his own radio and television show, *The Jack Benny Program* that ran for more than three decades. He was born in Waukegan, Illinois, and it is here that you will find a historic marker at Benny's boyhood home, located at 518 Clayton St. He didn't live here long, but he did leave here to go on to become a star of vaudeville, radio, film, and television, making audiences laugh all over the world. This is the last of his childhood homes still standing.

Website: www.waukeganparks.org/arts-general-information

Info: The center is open Monday to Thursday 10 a.m. to 9 p.m., Friday 10 a.m. to 5 p.m., Saturday 9 a.m. to 4 p.m. There are classes available and performances, so check the times.

Contact: Jack Benny Center for the Arts, 39 Jack Benny Dr., Waukegan, IL 60087; (847) 360-4740; (847) 360-4740.

Statue Alert! Jack Benny

Fans of Benny should also head to the Jack Benny Memorial Park, located at Genesee & Clayton in Waukegan, Illinois, to visit the Jack Benny statue.

Memorabilia from Jack Benny's career can be found at the Jack Benny Center for the Arts. Here, there's an exhibit that includes photographs, programs from performances, and autographed items from Benny, Mary Livingstone, and others. You can read about his career here as well.

OZ PARK

Fans of *The Wizard of Oz* take note: In Chicago, Illinois, there is an Oz Park that honors the works of author L. Frank Baum, who wrote the book that the movie is based on and lived in the area for a period of time. There's a section of the park called "The Emerald Garden," a playground called "Dorothy's Playlot," and sculptures of the Tin Man, Cowardly Lion, Scarecrow, Dorothy, and Toto.

Website: www.chicago parkdistrict.com/parks/ Oz-Park

Info: Park hours are 6 a.m. to 11 p.m.

Contact: Oz Park, 2021 N. Burling St., Chicago, IL 60614; (312) 742-7898.

MUSEUM OF BROADCAST COMMUNICATIONS

Sometimes, one of the best things that a television fan can do is to go back in time and see where it all began. The Museum of Broadcast Communications' mission is to collect, preserve, and present historic and contemporary television content as well as educate, inform, and entertain the public through its archives, public programs, screening, exhibits, publications, and online access to its resources. Located in Chicago, Illinois, you can see such exhibit highlights as rare artifacts from children's television program history, video of the final public appearances of film critic Gene Siskel and actress Audrey Meadows, and information on Milton Berle, Steve Allen, Dick Clark, Don Cornelius, Larry King, Edie Adams, Bob Saget, Betty White, and more.

Statue Alert! Richard Pryor

Comedian Richard Pryor grew up in Peoria, Illinois, and went on to have one of the most successful careers as a stand-up comic. He passed away in 2005, and ten years later, in May 2015, a bronze, 7 feet 6 inch high statue was unveiled to honor his life and career. It is located on SW Washington Street in Peoria.

The museum includes 85,000 hours of video and audio content where you can watch such legendary shows as *The Tonight Show with Johnny Carson.*

Website: www.museum.tv/index.htm

Info: Cost of admission: adults, $12; seniors (65+), $10; children (4–12), $6. Museum of Broadcast Communications is open Tuesday through Saturday 10 a.m. to 5 p.m. Closed all federal holidays.

Contact: Museum of Broadcast Communications, 360 North State St., Chicago, IL 60654-5411; (312) 245-8200.

VOLO MUSEUM

Car aficionados will absolutely love the Volo Museum, located in Volo, Illinois. Here you can find your favorite television and movie cars, such as the General Lee from *The Dukes of Hazzard,* the original *Miami Vice* Daytona, and Paul Walker's Subaru from *Furious 7.* There are iconic TV cars like the Munster-mobiles and more. You'll also see Duck from *Indiana Jones and the Kingdom of the Crystal Skull,* the actual custom chopper used in *Ghost Rider,* the foot-pedaled Flintstones' car, the 1989 Batmobile from the Michael Keaton–led *Batman,* and the DeLorean from the 1984 *Back to the Future.*

Website: www.volocars.com

Info: Cost of admission: adults, $15; children 5–12, $9; seniors (65 and over), $13; veterans and military with ID card, $12; military in uniform and children under 5, free. Volo Auto Museum is open seven days a week 10 a.m. to 5 p.m.

Contact: Volo Museum, 27582 Volo Village Rd., Volo, IL 60073; (815) 385-3644.

GROUNDHOG DAY WALKING TOUR AND ANNUAL EVENT

Groundhog Day is a 1993 Bill Murray classic flick where he portrays TV weatherman Phil Connors, who is forced to live the same day–February 2– over and over again until he gains some insight into his life. Much of the movie was filmed

Website: www.woodstock groundhog.org

Contact: (815) 334-2620.

in Woodstock, Illinois, which now offers a walking tour and a yearly Groundhog Day event, including a showing of the film (again and again and again). Other activities include bowling, a dinner dance, a cook-off, beer tasting, and more.

The year 2018 will be the 25th anniversary of the filming of the movie. If you're visiting Woodstock, make sure you find the engraved plaques that refer to spots where the movie was filmed.

SOUTHEAST

NORTH CAROLINA.

North Carolina has an impressive film and television history. Fans flock to the area to check out locations for *Dawson's Creek* and the CW's *One Tree Hill.* North Carolina was also home to home to FOX's *Sleepy Hollow.* Many notable films have been shot here, including *The Color Purple* (1985), *The Last of the Mohicans* (1992), *Dirty Dancing* (1987), *Days of Thunder* (1990), *Iron Man 3* (2013), *Tammy* (2014), *The Conjuring* (2013), and *The Hunger Games* (2012).

ANDY GRIFFITH MUSEUM

Andy Griffith was one of the most beloved actors in television history, well-known for his portrayal of Andy Taylor on *The Andy Griffith Show* in the 1960s. He also portrayed attorney Ben Matlock on *Matlock*, from 1986 to 1995. Griffith was also a Tony Award nominee for two Broadway roles and had roles in many television films, including *The Strangers In 7A* and *Go Ask Alice.*

Griffith was born in Mount Airy, North Carolina, which is also home to the Andy Griffith Museum. Here you will see props from *The Andy Griffith Show* and *Matlock* that were donated to the museum by Andy Griffith as well as items donated by other cast members. You can listen to Griffith's speeches at the 2002 Andy Griffith Highway Dedication, the 2004 Unveiling of the TV Land Landmark Statue of Andy and Opie Taylor, and more. There is also an exhibit on Betty Lynn, who portrayed Barney Fife's girlfriend Thelma on *The Andy Griffith Show*, in the lower level of the Andy Griffith Playhouse.

Also note that every September, the Surry Arts Council hosts the annual Mayberry Days in Mount Airy. There's "The Emmett"

Statue Alert! Andy and Opie

Go ahead and whistle the opening theme song to *The Andy Griffith Show* while you take a selfie with the bronze statue that honors Andy Taylor and his son Opie. It's located right outside the Andy Griffith Museum in Mount Airy and was first erected in 2003 in Raleigh, North Carolina.

Website: www.andygriffithmuseum.com

Website: www.surryarts.org/mayberrydays/index.html

Info: Cost of admission: $6 per person with a $2 audio guide (plus tax). The Andy Griffith Museum is open 7 days a week all year long except on Thanksgiving and Christmas, and there's a gift shop on the premises that includes Christmas ornaments, totes, and visors. Open Monday through Saturday 9 a.m. to 5 p.m. and Sunday 1 p.m. to 5 p.m.

Contact: Andy Griffith Museum, 218 Rockford St.; Mount Airy, NC 27030; (336) 786-1604.

golf tournament and singing at the Blackmon Amphitheatre, as well as a parade, silent auction, food, and games.

But wait, there's more!

Are you looking for something that honors Don Knotts, who portrayed Andy Taylor's sidekick Barney Fife? Then head over to West Virginia, where there's a statue of the funnyman in downtown Morgantown. There's also the Mayberry Café in Danville, Indiana.

AVA GARDNER MUSEUM

The story goes as follows: In 1941, Al Altman, the head of MGM's New York talent department, sent a telegram to Louis B. Mayer, head of the studio. It said, "She can't sing, she can't act, she can't talk, she's terrific!" They were talking about the stunning actress Ava Gardner, who was given a contract with MGM later that year. She became one of the most popular actresses of her time and went on to star in *The Killers* (1946), playing the femme fatale Kitty Collins; *Mogambo* (1953); *The Barefoot Contessa* (1954); *Bhowani Junction* (1956); *The Sun Also Rises* (1957); *On the Beach* (1959); and *The Night of the Iguana* (1964). She was nominated for a BAFTA and a Golden Globe award for her performance in *The Night of the Iguana*.

It was Thomas M. Banks who was behind the Ava Gardner Museum, located in Smithfield, North Carolina. As a 12-year-old boy, Banks would play on the campus of the Atlantic Christian College, where Ava was studying at the time. He and his friends would pick on Gardner and she would chase him. Later, when Ava got the call from Hollywood, Banks became fascinated that he knew someone who went to Hollywood and started clipping articles on the actress. He later became a publicist for Columbia Pictures but continued collecting Ava's memorabilia for more

Website: www.avagardner.org

Info: Adults (ages 18-64), $10.00; seniors (65 and up), $9.00; military, $9.00; teens (13-17), $9.00; children (6-12), $6.00; children under 6, free. The museum is open Monday through Saturday 9 a.m. to 5 p.m. and Sunday 2 p.m. to 5 p.m. Closed December 24-25, Easter Sunday, and Thanksgiving.

Contact: The Ava Gardner Museum, 325 East Market St., Smithfield, NC 27577; (919) 934-5830.

Did you know?
There's also a statue of Ava Gardner in Tossa de Mar, Spain. The statue was erected in her honor for her work on the 1950 film *Pandora and the Flying Dutchman*, which was filmed in Tossa de Mar.

than 50 years. It was Ava who said that the collection ultimately belonged in North Carolina, so the Ava Gardner Museum was born in Smithfield. The museum opened in October 2000 and every year more than 12,000 visitors walk through the doors.

At the Ava Gardner Museum, you can see costumes, movie posters, and awards and even peek into "Ava's Closet" with personal clothing worn by the glamorous starlet, as well as Ava's accessories, jewelry, gloves, shoes, and pocketbooks. The library was named after the museum's founder Tom Banks.

Make sure you walk the Ava Gardner Heritage Trail, where you'll see Ava's birthplace, as well as the Brogden Teacherage where she also lived with her family, the Howell Theater where she watched movies, and the grave site where she is buried. There are other important sites along the walk as well. For more information, visit http://avagardner.org/index.php/ava-gardner-heritage-trail.

LAND OF OZ

Raise your hand if you have secretly wished that you could, or maybe you have already pretended to, skip down the Yellow Brick Road? Okay, put your hand down and grab your mouse to make your reservations to see the Wizard at Beech Mountain, North Carolina. It's here where you'll find the real-life Land of Oz.

The Wizard of Oz is one of the most popular movies ever made, and it really needs no description. However, if you are one of the holdouts who have not seen the movie yet, here's a little background: It was released in 1939 and was based on the 1900 novel *The Wonderful Wizard of Oz* by L. Frank Baum. The movie

stars Judy Garland as Dorothy, as well as Ray Bolger, Jack Haley, Bert Lahr, Frank Morgan, Billie Burke, and Margaret Hamilton.

Website: www.landofoznc.com

Info: In 2018, the Land of Oz will celebrate the 25th Annual Autumn at Oz Festival.

Contact: Land of Oz, Yellow Brick Rd., Beech Mountain, NC 28604; (800) 514-3849.

Fans of *The Wizard of Oz* will love this Land of Oz park, which was once open from 1970 to 1980, but ultimately closed. Remodeling the park to its current shape, according to the Land of Oz history, took 150 local artisans, two years' worth of time and a budget of $5 million. Of course, there's a yellow brick road that is nine acres long and made up of a whopping 44,000 glazed yellow bricks.

You can only visit the family-owned property when it is open for either the annual three-day Autumn at Oz Festival in September or if it is open for special events and rentals throughout the year. One such special event is their summertime Land of Oz presents Journey with Dorothy where attendees ride a chairlift to the Land of Oz.

During the Autumn at Oz Festival, which is the only other time they open, this family-friendly event is about fun with Dorothy, the Scarecrow, the Tin Man, and the Cowardly Lion. The park also includes the Gales' Kansas farm and the twister, as well as Munchkins, Flying Monkeys, and even Toto.

But wait, there's more!

Oz fans, there's so much more for you to see in the United States dedicated to your favorite movie. First, head over to the section on California to learn about Egghead's, the restaurant where everything on the menu is *Wizard of Oz*–themed.

Of course, there's no place like home, so if you're a fan of Oz, the obvious place to be is Kansas–where else?–where you can learn about the Oz Museum, located in Wamego. The Oz Museum is home to over 2,000 artifacts dating from 1900 to the present day. For more information, visit the Kansas section.

Finally, there is an entire museum dedicated to actress Judy Garland, who played Dorothy. Flip the pages to Minnesota where you will read about The Judy Garland Museum in Grand Rapids. The Museum has Garland memorabilia, offers a tour of her childhood home, and holds an annual *Wizard of Oz* Festival. You can also purchase a spot for your name on the Yellow Brick Road.

Finally, travelers can head to New York, where they can honor L. Frank Baum, the author of *The Wizard of Oz* book. Chittenango is the location of the All Things Oz Museum and the International L. Frank Baum & All Things Oz Historical Foundation.

WRIGHT BROTHERS NATIONAL MEMORIAL: Located in Manteo, North Carolina, the Wright Brothers National Memorial is the place where it all happened. Here, you can visit the locations where Wilbur and Orville Wright changed the world. You'll step back in time to the early 1900s and see what the place looked like when the Wright Brothers made history and stand on the same spot where the siblings once stood. The park has an interpretive program on the brothers, where you can also see replicas of the 1902 glider and 1903 flyer and look at portraits of other famous aviators. You can also climb Big Kill Devil Hill to see the nation's monument commemorating the brothers' historic achievement. Here's an interesting tidbit from the memorial Twitter feed: The original 1903 Wright Flyer was sold to the Smithsonian National Air and Space Museum in 1948 by Orville Wright's estate for only $1.

Website: www.nps.gov/wrbr/index.htm

Info: Wright Brothers National Memorial is open seven days a week, year-round, 9 a.m. to 5 p.m. The only day the park is closed is Christmas Day, December 25.

Contact: Wright Brothers National Memorial, 1401 National Park Dr., Manteo, NC 27954.

SOUTH CAROLINA

With its miles of coastline, gardens, historic sites, and plantations, South Carolina has been the backdrop for more than 100 feature films and over 70 TV movies, series, and pilots, going back to the Edison Company's *The Southerners* (1914), Pathe Company's *How Could You, Caroline?* (1918), and Cecil B. DeMille's *Reap the Wild Wind* (1941).

HOUSE OF CARDS PHOTO OP

Rep. Frank Underwood, the main character on the Netflix *House of Cards* series is played by actor Kevin Spacey. Frank Underwood comes from the South Carolina area, and the Peachoid—a giant water tower that is painted to look like a Georgia peach—is often mentioned in the show. If you want to get a taste of what Frank Underwood's childhood and early years as a politician would look like, head to Gaffney, South Carolina, and reenact the photo the actor took while filming on location.

> **Contact:** Peachoid Rd., Gaffney, SC; (864) 488-8800.

KENTUCKY

And they're off! In Kentucky, it's all about the races. The Kentucky Derby in Louisville at Churchill Downs is held the first Saturday in May and really draws a crowd. The beautiful fields of Kentucky also draw the Hollywood crowd to the area, filming such movies over the years as *The Kentuckian* (1955), *Raintree Country* (1957), *Secretariat* (2010), and *Coal Miner's Daughter* (1980).

ROSEMARY CLOONEY HOME TOUR

First, if her last name sounds familiar and you're not old enough to know who she is, yes, Rosemary Clooney is related to heart-throb actor George Clooney (hang on though, there's something about him in this too). First, Rosemary Clooney is George's aunt, but she was also a well-known singer and entertainer in the 1940s and 1950s, while also appearing in the film *White Christmas* with legendary crooner Bing Crosby. Rosemary also had her own half-hour syndicated television musical-variety show, *The Rosemary Clooney Show*.

> **Website:** www.rosemaryclooney.org
>
> **Info:** Cost of admission: $5. The Rosemary Clooney House is open Monday through Friday by appointment only. Saturday it is open 10 a.m. to 5 p.m., and Sunday it is 1 p.m. to 5 p.m.
>
> **Contact:** The Rosemary Clooney House, 106 East Riverside Dr., Augusta, KY 41002; (502) 384-5346.

Rosemary's home in Augusta, Kentucky, is open for tours. Here you can see how she lived as well as exhibits that include childhood photos, movie memorabilia, and a large collection of *White Christmas* memorabilia, including costumes worn by Bing Crosby and Bob Hope.

If you are more a fan of George's and not Rosemary's, stop by anyway because there are exhibits dedicated to George's career throughout the House.

THE BIG LEBOWSKI ANNUAL FESTIVAL

Talk about a cult classic. In the 1998 movie *The Big Lebowski*, written and directed by the Coen brothers Joel and Ethan, a pothead bowler is mistaken for a deadbeat philanthropist. The

hilarious movie stars Jeff Bridges, John Goodman, Steve Buscemi, and Julianne Moore and has been a fan favorite for years. If you're a fan of the movie, you might be excited to know, dude, that there has been an annual traveling fest, The Big Lebowski Fest, which has graced Louisville, Kentucky, as well as New York City. It's a great way to mix and mingle with other fans of the movie. Past fests have included such special guests as Leon Russom (who played the sheriff of Malibu), Jim Hoosier (Liam), Robin Jones (Ralph's checkout girl).

Website: https://lebowskifest.com

Info: Come in costume and join the Bowling Party, participate in trivia contests, a movie party, garden party, lunches, and more. The Achiever's Weekend Pass is approximately $50, not including your accommodations.

Contact: The Big Lebowski Fest, 414 Baxter Ave., Louisville, KY 40204.

OTHER THINGS TO SEE OR DO IN KENTUCKY

KENTUCKY DERBY MUSEUM: The museum honors the long-standing tradition of Kentucky horse racing and the jockeys and the horses that have become legendary at the Run for the Roses. It's truly worth a visit if you're in the area.

Website: www.derbymuseum.org

Info: Cost of admission: adults (15–64), $15; seniors (65+), $14; children (5–14), $8; children (under 5), free. During summer hours (March 15–November 30), the museum is open Monday through Saturday 8 a.m. to 5 p.m. and Sunday 11 a.m. to 5 p.m. During the winter (December 1–March 14), the museum is open Monday through Saturday 9 a.m. to 5 p.m. and Sunday 11 a.m. to 5 p.m.

Contact: Churchill Downs® Racetrack, 704 Central Ave., Louisville, KY 40208; (502) 637-1111.

LOUISIANA

Jezebel (1938), *A Streetcar Named Desire* (1951), *Easy Rider* (1969), *Live and Let Die* (1973), *The Big Easy* (1986), and, of course, *Steel Magnolias* (1989) have all been filmed in the Creole State. Louisiana has also hosted the production of more than 400 other motion pictures, as well as numerous television series and documentaries, including *American Horror Story* (2011–present), *Dallas Buyer's Club* (2013), *Jurassic World* (2015), *Pitch Perfect* (2012), and *Fantastic Four* (2015).

STEEL MAGNOLIAS BED & BREAKFAST

You can stay at the house that was used in the comedy-drama movie *Steel Magnolias,* which starred such acting legends as Sally Field, Dolly Parton, Shirley MacLaine, Julia Roberts, Olympia Dukakis, Daryl Hannah, and Tom Skerritt. Julia Roberts was nominated for an Academy Award for Best Supporting Actress. The Steel Magnolia house is located in Natchitoches, Louisiana, was built in the early 1800s, and history states that it may have played a part in the Underground Railroad.

Foodie Fact! Saints & Sinners

Actor Channing Tatum owns this restaurant-bar, located on Bourbon Street in New Orleans' Burlesque district. Tatum starred in *Step Up, Coach Carter,* and *Magic Mike,* and calls this restaurant a "wicked good time." The menu includes such items as alligator's tail, cheese kurtz, mac and cheese, gumbo, shrimp and grits, pizza burgers, and more.

WEBSITE: http://saintsandsinnersnola.com

INFO: The restaurant is open Monday and Thursday noon to midnight, Tuesday and Wednesday 4 p.m. to midnight, Friday and Saturday 11 a.m. to 2 a.m., Sunday 11 a.m. to midnight.

CONTACT: Saints & Sinners, 627 Bourbon St., New Orleans, LA 70130; (504) 528-9307.

The Shelby Room was inspired by Julia Roberts' character and is decorated in pink.

> **Website:** www.steelmagnoliahouse.com
>
> **Info:** The room rates start at $225 per night.
>
> **Contact:** Steel Magnolia Bed & Breakfast, 320 Rue Jefferson, Natchitoches, LA 71457; (318) 238-2585.

ALABAMA

Down south, Alabama is home to some of the most significant landmarks from the civil rights movement. Movies such as *42* (2013), *Sweet Home Alabama* (2002), *Talladega Nights* (2006), *Selma* (2014), and *Norma Rae* (1979) were filmed here.

TO KILL A MOCKINGBIRD COURTHOUSE TOUR

To Kill a Mockingbird is a novel by Harper Lee that was published in 1960 and has become a staple in middle and high school literature education. It won the Pulitzer Prize and is loosely based on an event that occurred near her hometown of Monroeville, Alabama, in 1936.

The book went on to become a movie of the same name in 1962, starring Gregory Peck as Atticus Finch and Mary Badham as Scout. The film won three Academy Awards, including Best Actor for Gregory Peck, and was nominated for eight, including Best Picture.

Website: www.monroecountymuseum.org/old-courthouse-museum

Info: Admission: $5 per person. Old Courthouse Museum hours are Tuesday to Friday 10 a.m. to 4 p.m., Saturday 10 a.m. to 1 p.m. Closed most holidays.

Contact: Old Courthouse Museum, 31 North Alabama Ave., Monroeville, AL 36460; (251) 575-7433.

The Old Monroe County Courthouse was the model for Lee's fictional courtroom settings in *To Kill a Mockingbird*. Although the movie was not filmed here, it is said that the set designer came to Monroeville to measure, photograph, and draw the courtroom before recreating it. Tour the courthouse and sit in the balcony, witness chair, judge's bench, or at the tables used by the prosecutor and defense attorney.

At the Monroe County Museum, you can see exhibits on author Harper Lee and *To Kill a Mockingbird*, as well as the book and the movie. The museum's exhibit is told almost all in Harper Lee's words and includes photos and drawings, as well as a documentary film.

Foodie Fact!

Okay, say it with me, "Sooooouuulllll Patrolllll!" The man behind the Soul Patrol movement, Taylor Hicks, was the winner of *American Idol*'s Season Five, and if you think he hasn't been busy since his victory, think again. Not only did his self-titled album go platinum, but he was the first male *Idol* winner to be featured on a Grammy Award–winning album, Jimmy Fallon's *Blow Your Pants Off*, which took home the 2013 Grammy for Best Comedy Album. He starred on Broadway in *Grease* as Teen Angel and then went on tour with the company. He starred in his own residency in Las Vegas for a couple of years and has performed with Willie Nelson, Snoop Dogg, Gladys Knight, Earth, Wind & Fire, and The Allman Brothers, appearing in concerts worldwide.

Today, he hosts the INSP original series *State Plate* where he visits farms, ranches, markets, festivals, and other exciting locales to uncover the stories and legends behind the state's unique food traditions. During his premier season, he visited Arizona, Illinois, Wisconsin, Maine, Florida, Texas, and Louisiana. He also samples crab cakes in Maryland, peaches in Georgia, chili in Texas, and potatoes in Idaho.

Hicks is a self-professed foodie and now co-owns Saw's BBQ, with several locations throughout Alabama, and while you may or may not spot the singer in one of the locations, you can definitely get a taste of his southern roots. Enjoy pulled pork, ribs, stuffed taters, and more. Definitely worth a stop and a taste.

WEBSITE: www.sawsbbq.com

INFO: The restaurant is open Monday through Saturday 11 a.m. to midnight.

CONTACT: Saw's BBQ, 1115 Dunston Ave., Birmingham, AL 35213; (205) 745-3920.

Plan your visit to Monroeville to coincide with the annual performances of *To Kill a Mockingbird*, which are held for a month, mid-April through mid-May.

VIRGINIA

They say that Virginia is for lovers, but Virginia wants you to know that it's for film and TV lovers too. You might have the time of your life when you visit here, because it's where the iconic scenes in *Dirty Dancing* (1987) were filmed. Virginia can also be seen in *Evan Almighty* (2007), *Lincoln* (2012), *Minority Report* (2002), and many, many others.

★ LISA'S PICK ★
DIRTY DANCING WEEKENDS AT MOUNTAIN LAKE LODGE

Okay, say it with me, "Nobody puts Baby in a corner." I know *Dirty Dancing* by heart. Every word. Every sentence. I don't know what it is about this coming-of-age musical, but I've watched it more times than I can count. I am one of those film geeks who once wished that one day I could do "something" related to this movie. Now I can.

First, if you haven't seen *Dirty Dancing*, this Patrick Swayze and Jennifer Gray film came out in 1987 and focuses on one summer in the Catskills for the Houseman family. Frances "Baby" Houseman, played by Gray, falls in love with Johnny Castle (Swayze), but there are, of course, problems along the way. The movie won an Academy Award for Best Original Song for "I've Had the Time of My Life."

Website: www.mtnlakelodge.com

Info: The itinerary can change, but the 2018 package includes breakfast, lunch, and dinner at Harvest throughout your stay, as well as a *Dirty Dancing* movie walking tour; *Dirty Dancing*–themed scavenger hunt; group dance lessons; and dance party in Mary's Barn. The 2018 *Dirty Dancing*–themed Weekend Dates are April 27–29, June 22–24, July 27–29, and August 24–26.

Contact: Mountain Lake Lodge, 115 Hotel Cir., Pembroke, VA 24136; (540) 626-7121.

Did you know?
There is a Hollywood Cemetery in Richmond, Virginia, but don't expect it to be filled with the grave sites of celebrity notables. It is filled with the grave sites of historical figures, though.

Every year, the location where the movie was actually filmed, Mountain Lake Lodge in Pembroke, Virginia, turns into Kellerman's Mountain House for four *Dirty Dancing* weekends. The resort hosts movie film tours, dance lessons, Saturday night parties, and much more. You will have the time of your life (you saw that coming, didn't you?). Mountain Lake Lodge is set in the middle of a 2,600-acre nature preserve and surrounded by Appalachian Mountains.

Look for the Patrick Swayze *Dirty Dancing* Memorial Rock near the Lake Lodge. The rock sits next to the lakefront gazebo with the hanging lanterns.

POE MUSEUM

If you're a fan of *The Raven* (1963), *The Pit and the Pendulum* (1964), and *Dark Shadows* (1966–1971), you might also be a fan of poet Edgar Allan Poe, who wrote the stories that were the basis for these films. The Poe Museum in Richmond, Virginia, pays homage to the writer, and it holds more of Poe's personal possessions than any other institution in the world, including Poe's boyhood bed, clothing, and hair. On the tour of the museum, you will also see manuscripts, Poe's memoir and letters, and so much more. There's also an enchanted garden where you can sit and contemplate your own muse, as well as a Poe store so you can take home a souvenir T-shirt or knickknack.

Website: www.poemuseum.org

Info: Cost of admission: adults, $8; seniors (60+) and AAA members, $6; youth (7-17), $6.

Contact: The Poe Museum, 1914-16 East Main St., Richmond, VA 23223, (804) 648-5523.

OTHER THINGS TO SEE OR DO IN VIRGINIA

THE BYRD THEATRE: I don't know about you, but I love old movie theaters, so if you're in the Richmond, Virginia, area, you need to stop by and see a movie at The Byrd Theatre. Built in 1928 and named after William Byrd, one of the founders of Richmond, the opulently designed theater is both a State and National Historic Landmark. It has 1,300 seats and a "Mighty Wurtlitzer Organ" that operates on Saturday nights. The entire experience takes you

back decades in your moviegoing experience. The theater plays a combination of new releases and old favorites.

Website: http://byrdtheatre.com

Info: Byrd Theatre regular features are $4.00/person ($3 admission + $1 facility fee).

Contact: The Byrd Theatre, 2908 W Cary St., Richmond, VA 23221.

WEST VIRGINIA

West Virginia gave us the amazing Don Knotts, and it was also the backdrop of many movies including *Lassie* (1994), *Win a Date with Tad Hamilton* (2004), *The Silence of the Lambs* (1991), and *Coal Miner's Daughter* (1980).

DON KNOTTS' HOMETOWN

He was the lovable, bumbling Barney Fife on *The Andy Griffith Show*, as well as the goofball Ralph Furley on *Three's Company*. He appeared in *The Ghost and Mr. Chicken* (1966) and *The Incredible Mr. Limpet* (1964), in which he plays a talking fish. Born in Morgantown, West Virginia, Don Knotts was one of the most adored actors in Hollywood and won Emmy Awards for his role on *The Andy Griffith Show*. There is a statue that honors the star located outside the city's Metropolitan Theater. When you're in the area, make sure you take a walk on Fife Street in the name of Mayberry's finest.

> **Website:** www .morgantownmet.com
>
> **Contact:** Metropolitan Theater, 371 High St., Morgantown, WV 26506; (304) 291-4884.

MOTHMAN MUSEUM

Once upon a time, after Richard Gere was an officer and a gentleman and took care of a pretty woman, he starred in *The Mothman Prophecies* as newspaper columnist John Klein. Debra Messing played his wife Mary. The movie also stars Laura Linney and Will Patton and has become a cult classic. In the film, the couple is involved in an accident and Mary ultimately passes away, but leaves drawings behind of creatures that she had seen. The film is based on events that took place between November 1966 and December 1967 in Point Pleasant, West Virginia.

The Mothman Museum in Point Pleasant has the largest collection of props and memorabilia from the movie, including historical documents from the Mothman eyewitnesses themselves, press clippings and photographs of the Silver Bridge disaster, and more. The museum has books, novelties, clothing, and more.

Every year on the third weekend in September, The Mothman Festival is held to honor the man and the *possible* legend. This

Website: www.mothmanmuseum.com

Info: Cost of admission: adults, $3; kids 10 and under, $1. The museum is open Monday through Friday noon to 5 p.m., Saturday 11 a.m. to 5 p.m., and Sunday noon to 5 p.m.

Contact: The World's Only Mothman Museum, 400 Main St., Point Pleasant, WV 25550; (304) 812-5211.

family-friendly event includes vendors, live bands, festival food, tram tours, cosplay, entertainment for kids of all ages, and more. Don't forget to take a selfie with the statue of the Mothman outside of the museum. Really, what was the Mothman?

MARYLAND

Maryland has so much to choose from when it comes to filming. There are mountains, rolling hills, farmlands, beautiful waterfronts, beaches, and incredible architecture. Television shows such as *House of Cards* and *VEEP* regularly film here. In addition, *The Immortal Life of Henrietta Lacks* (HBO), *The Social Network* (2010), *He's Just Not That Into You* (2009), *The Pelican Brief* (1993), and so many other movies have been filmed here.

SLEEPLESS IN SEATTLE LIBRARY

The George Peabody Library is an exquisite building that has been used as a setting for many films, including the ultraromantic

Website: http://peabodyevents.library.jhu.edu

Info: The library stays open Tuesday to Friday 9 a.m. to 5 p.m.

Contact: The Peabody Library, 17 East Mount Vernon Place, Baltimore, MD 21202; (443) 840-9585.

Statue Alert! Jim Henson

A statue of Jim Henson and Kermit the Frog sitting on a bench is located in front of the Adele H. Stamp Student Union at the University of Maryland. Together the statue and bench comprise the Jim Henson Memorial, a gift of the class of 1998. The bench can be found in front of the Henson Memorial Garden.

WEBSITE: www.jimhensonlegacy.org/about/legacy -events/58-jim-henson-statue-dedicated-university-of -maryland-md.

INFO: Memorial Park, 2126 Campus Dr., College Park, MD 20740.

BUT WAIT, THERE'S MORE!
If you can't get enough of Henson and the Muppets, flip back to the New York section where the Museum of the Moving Image will be home to a permanent exhibition on Henson. It's going to be a must-see for any fan.

Sleepless in Seattle, a 1993 movie written by Nora Ephron that starred Tom Hanks and Meg Ryan. In fact, you will find many more amazing things, even books to enjoy.

NORTHWEST

WASHINGTON

Washington's filmography dates back to 1932 with *Believe It or Not* and 1933 with *Tugboat Annie*. From there it's been an explosion of filming in the area. Washington was used in such movies as *The Call of the Wild* (1935), *The Wizard of Oz* (1939), *Twilight* (2008), *WarGames* (1983), and more and was home to the hit television series *Northern Exposure* (1990–1995).

NORTHERN EXPOSURE MEMORABILIA AT THE ROSLYN MUSEUM

Don't head to Alaska looking for *Northern Exposure*, because it was filmed in this former coal mining town. The television show that aired from 1990 to 1995 was filmed in Roslyn, and the Roslyn Museum has some memorabilia from the show, including the Ausburg clock created by the crew for one of the episodes and later donated to the museum.

> **Website:** www.roslynmuseum.com
>
> **Info:** The Roslyn Museum is open every day but Thursday. Hours of operation vary so call in advance.
>
> **Contact:** Roslyn Museum, 203 W. Pennsylvania Ave., Roslyn, WA 98941; (509) 649-2355.

BING CROSBY HOUSE

Actor and singer Bing Crosby has entertained audiences for years. The crooner is best known for his rendition of Irving Berlin's "White Christmas."

On television, Crosby had his own show, *The Bing Crosby Show*, a 28-episode sitcom on ABC. He is also known for his Christmas special, where he performed with David Bowie a duet of "The Little Drummer Boy" and "Peace on Earth."

In the movies, Crosby starred in *Going My Way* (1944), *White Christmas* (1954), and *The Bells of St. Mary's* (1945), and he also starred with Bob Hope and Dorothy Lamour in *Road to Singapore* (1940), *Road to Zanzibar* (1941), *Road to Morocco* (1942), *Road to Utopia* (1946), *Road to Rio* (1947), *Road to Bali* (1952), and *The Road to Hong Kong* (1962).

Crosby was raised in Spokane, Washington. His childhood home was built by his father and two uncles, and it's available for fans to tour. It's right near Gonzaga High School, where Bing went, and includes 200 items such as gold records, trophies, awards, and Bing's Academy Award for *Going My Way*.

TWILIGHT'S FORKS FESTIVAL

Forks, Washington, is the setting where Stephenie Meyer's book *Twilight* was turned into a movie series. This incredibly successful movie is about high school student Bella Swan (played by Kristen Stewart), who meets mysterious teen Edward Cullen (Robert Pattinson).

Forks is also here where an annual three-day festival takes place to honor fans' love of the movie. In previous festivals, there have been auctions of original props, costumes, and set decoration pieces used in the saga. More than 900 lots from the making of the five films were sold.

OREGON

Check out *Everything Sucks*, *Portlandia*, and *The Librarians* and you'll be watching several shows that were filmed in Oregon. Fans of *The Wizard of Oz* (1939) will want to book a trip to OzCon International, and *Goonies* (1985) fans will be happy to know that this state honors their most popular movie.

Statue Alert! Beverly Cleary

Beverly Cleary, one of the most beloved children's authors of all time, is honored in Portland, Oregon's Grant Park. There you can find three of Beverly Cleary's most well-known characters—Henry Huggins, Ribsy, and Ramona Quimby—as statues. Cleary grew up in McMinnville, Oregon, so snap a pic with some of her most beloved fictional characters. The *Ramona and Beezus* (2010) movie was adapted from the novels written by Cleary and starred Selena Gomez, Hutch Dano, Ginnifer Goodwin, John Corbett, Bridget Moynahan, and Josh Duhamel.

WEBSITE: www.portlandoregon.gov/parks

INFO: Park hours are 5 a.m. to midnight.

CONTACT: Grant Park, NE 33rd Ave. and US Grant Pl., Portland, OR 97212; (503) 823-2525.

OZCON INTERNATIONAL

Oz fans have been meeting every summer at the OzCon International in Portland, Oregon, for over 50 years to celebrate L. Frank Baum and the Land of Oz. Typically held at the end of June, visitors come to trade and sell new and vintage Oz books and merchandise, including from the 1939 MGM film, *The Wizard of Oz*. OzCon's family-friendly event also includes quizzes, a treasure hunt, show-and-tell, special guests, panels, a riverboat cruise, and more.

Website:
www.ozcon
international.com

But wait, Oz fans, there's more!

If you're an Oz fan, make sure you flip back to the Kansas section for information on the Oz festival in Wamego. Then go to North Carolina, where there is information on a real-life Land of Oz park in Beech Mountain. There's also Egghead's, a *Wizard of Oz*-themed restaurant in California. There's also The Judy Garland Museum in Grand Rapids, Minnesota, which also hosts an annual Wizard of Oz festival. So much to do!

GOONIES TOUR

After producing both *E.T. the Extra-Terrestrial* and *Poltergeist* in 1982, *The Twilight Zone* in 1983, and *Gremlins* in 1984, the wildly successful producer and director Steven Spielberg released *Goonies*, which he wrote with partner Chris Columbus (who would go on to produce *Home Alone* and several Harry Potter movies).

Goonies starred Sean Astin, Josh Brolin, Jeff Cohen, and others and focused on a group of preteens who lived in the Goondocks of Astoria, Oregon. The group wants to save their home from being demolished, but they find a Spanish map that leads them on an adventure to find a seventeenth-century pirate. Unfortunately, others want the treasure too.

Website: www.thegoondocks.org

Contact: Astoria Warrenton Area Chamber of Commerce, 111 West Marine Dr., Astoria, OR 97103; (503) 325-6311.

The movie was actually filmed in Astoria, Oregon, and is honored every year on June 7 on "*Goonies* Day," so make plans to visit and meet other *Goonies* fans! This date is special because it is the anniversary of the day the film was released into theaters in 1985. There are trivia contests, cosmic bowling, skate nights, and more.

However, don't expect to see the *Goonies* house though. It is now a private residence that can only be viewed from certain spots in Astoria. The Astoria Warrenton Area Chamber of Commerce has a map on their website that tells you what those spots are. They seriously urge visitors to not attempt to visit the house, but instead enjoy the other things to do in the area.

OREGON FILM MUSEUM

There have been hundreds of movies besides the *Goonies* that were filmed in Oregon, including *The General* (1926), *The Great Race* (1965), *One Flew Over the Cuckoo's Nest* (1975), and *Animal*

Website: www.oregonfilmmuseum.org

Info: Cost of admission: adults, $6; children (ages 6–17), $2. The museum is open October to April 11 a.m. to 4 p.m. daily and May to September 10 a.m. to 5 p.m. Closed: Thanksgiving, Christmas, and New Year's Day.

Contact: Oregon Film Museum, 732 Duane St., Astoria OR 97103; (503) 325-2203.

House (1978). The Oregon Film Museum, located in Astoria, honors this state's film history with exhibits, an interactive green screen, a Goonie gallery, and a Hall of Quotes.

IDAHO

It's not just about potatoes; Idaho is known for its landscapes and outdoor recreation areas too. It's also known as the place where the television was invented (see below). Film producers have come here to make such movies as *Dante's Peak* (1997), *Heaven's Gate* (1980), *Bronco Billy* (1980), and *Napoleon Dynamite* (2004).

FARNSWORTH TV AND PIONEER MUSEUM

Did you know that the television was invented in Idaho by resident Philo T. Farnsworth? How can a fan of television not go see where the boob tube was invented? Stop by the Farnsworth TV and Pioneer Museum, which features 14,000 square feet of exhibitions and profiles including one on Farnsworth, as well as the first television tube and more. The

Contact: Farnsworth TV and Pioneer Museum, 118 W 1st St., Rigby, ID 83442; (208) 745-8423.

museum also exhibits on local writers such as Vardis Fisher, who wrote *Mountain Man*, which was made into the 1972 film *Jeremiah Johnson*, starring legendary actor Robert Redford.

PHOTO CREDITS

Page 27: Courtesy The Niles Essanay Silent Film Museum

Page 47: Photo courtesy of the Santa Monica History Museum. Photographer: Fabian Lewkowicz.

Page 69: Roxbury Motel

Pages 80, 82, and 89: Lisa Iannucci

Page 101: The Barker Character, Comic & Cartoon Museum

Page 102: The Witch's Dungeon Museum

Page 124: The Tallahassee Automobile Museum

Page 125: Air Force Space & Missile Museum Archives

Page 138: *Gone with the Wind* Museum

Page 175: Used with permission by *Field of Dreams* Movie Site, Dyersville, IA

Page 179: *A Christmas Story* House & Museum

Page 182: Destination Mansfield—Richland County

ABOUT THE AUTHOR

Lisa Iannucci is a professional writer, founder of "The Virgin Traveler," and host of her *Reel Travels* podcast (blogtalkradio.com/reeltravels). She is a regular contributor to TravelPulse.com and has written travel articles for the *Los Angeles Times*, Content That Works, the *Poughkeepsie Journal*, and other publications as well. She contributes film/TV articles to ReelLife-WithJane.com and FF2Media.com and has interviewed hundreds of celebrities. She has coauthored 17 books on a wide variety of topics, including biographies of Will Smith and Ellen DeGeneres. She lives with her family and five televisions in Poughkeepsie, New York.